The World of Ottoman Art

Michael Levey

The World of Ottoman Art

with 107 illustrations, 11 in colour,
and 2 maps

Thames and Hudson London

For Kate and Craig

1 (*Frontispiece*) Iznik tile decoration in the imperial *loge* of the Selimye mosque in Edirne, designed by the greatest Ottoman architect, Sinan, in the reign of Selim 'the Sot' (*cf.* p. 87)

Printed in Great Britain by Jarrold and Sons Ltd, Norwich
Colour Plates printed by W. S. Cowell Ltd, Ipswich

Contents

When I came within the Dore, that which I did se was verrie wonderfull unto me . . . the sighte whearof did make me almoste to thinke that I was in another worlde.

Thomas Dallam at the Sultan's Court, 1599

Introduction

*But those that have faith and do good works
shall not lose their reward. They shall dwell in
the gardens of Eden, with rivers rolling at their
feet. Reclining there upon soft couches, they shall
be decked with bracelets of gold and arrayed in
garments of fine green silk and rich brocade.*

THE KORAN. Ch. 18

Ottoman art really does create a complete world, one rather similar to the paradise promised in the words of the Koran quoted above, but actual and accessible fortunately to us all, regardless of our beliefs.

To call it paradise is more than a sloppy way of paying tribute to its directly sensuous appeal or its intensely pleasurable achievements. It is very much a paradise in the word's original meaning: an enclosed park or garden, consciously devised for relaxation or contemplation, with every suggestion of coolness and peace after heat, noise and dust – coolness of water and peaceful retreat in the shade of trees or tent; and where, amid so much agreeable occupation for the senses, time itself seems suspended.

That paradise is easy enough to slip into, and this book's purpose is to encourage entry. Part of its appeal lies in the fact that it is strange – strange, rather than alien – and refreshingly different in its aims and conventions from those of Western art throughout the five centuries or so up to 1900 during which Ottoman art also existed. The over-all factor in Ottoman art is the religion of Islam, and the paradise of the Koran is of course no Ottoman speciality. The arts of other Islamic lands, of Persia particularly, offer many affinities – just as affinities exist among the arts of various Christian countries. Just as with them, however, it is possible to detect, define and respond to individual national accents.

The character of Ottoman art remains its own, when every influence and indebtedness has been explored – not surprisingly, because it is closely bound up with a once-great empire, from beginning to end ruled by a single dynasty. But serious appreciation of it was for long delayed and one may suspect that even now it carries nothing like the prestige of, say, Persian art. Certainly it brings with it no agreeable cultural connotations – rather the opposite – but then culture and art are not necessarily synonymous. Perhaps too, in Europe, the Turks have never quite been forgiven for taking Constantinople. Still, the very fact that Ottoman art is if not positively neglected at least not over-familiar or over-esteemed gives to any book on the topic a certain justification.

Among the differences to be encountered on entering the Ottoman artistic world is the total absence of sculpture. Its architecture too is distinctly different. Even the most decorated mosque is bare and uncluttered compared with a typical Italian Roman Catholic church. The essence of the Ottoman palace is something quite unpalatial: a kiosk in a garden setting. The concept had originated perhaps in a nomadic age of tents but it was still actively at work late in the nineteenth century when the last effective ruler, Sultan Abdül Hamid II, devised the complex of the Yıldız Park at Istanbul. And although the well-watered garden in reality, as well as an ideal, naturally haunts the whole Middle East, a passion for gardens, the open air and flowers is traditionally Turkish; it was commented on by most early travellers and is patently apparent today. The Ottoman garden seems always to have been less formal in lay-out than the Persian one, lacking the typical crossing of two water channels and apparently never creating pools in pavilion interiors.

Ottoman painting, one of its underestimated arts, offers a surprising variety of vivid scenes and images, including portraits (despite the traditional disapproval of figurative depiction) but no triumph of oil-painted pictures, any more than altarpieces or fresco cycles. Its world is one of miniatures, more earthy and less elegant than Persian ones, often amusingly vigorous but never – even in depicting battle campaigns – realistic by contemporary European standards. Famous individual painters existed (in mid-seventeenth-century Istanbul at least a hundred decorative painters had shops) but scarcely a Rubens or a Velazquez.

Ottoman art is free therefore from many of the pressures which for long instigated, and shaped, Western art; and though such freedom is in itself attractive, it can also be disconcerting. We have been deeply conditioned to look behind art for 'explanations', whether the personal dynastic obsessions which produced Versailles or the communal religious ones which resulted in the Gothic cathedral and the baroque church. Many masterpieces of Western painting require a great deal of extraneous knowledge before we can feel we see them with full understanding (and even now several of them await an entirely convincing 'explanation'). The least learned spectator confronted by pre-twentieth-century European pictures, sculpture, and similar artistic objects, expects them to contain references beyond themselves as art and to have usually a strong illustrative element – to represent a mother and child, say, even if not positively the Madonna and Child. The eventual breaking of this convention in the West caused notorious problems, by no means vanished today, though it is a remarkable fact that the average person, bewildered still by 'modern art', will have no difficulty in making firm aesthetic judgments about colour and design in curtains, carpets or wallpaper, regardless of representational content.

And, in many ways, it is better – or, at least, simpler – to enter the world of Ottoman art expecting a furnishing-store (a bazaar, perhaps) rather than the typical museum-gallery, to be prepared to look and enjoy without straightaway puzzling over subject-matter, meaning and importance. After all, it remains difficult to explain what exactly is the meaning or
1 importance of a sheet of Iznik tiles, though their beauty may well ravish the

eye not just momentarily but with sufficient fascination to draw one back again and again (probably the sole criterion, ultimately, of a work of art).

Like the apparent absence of subject-matter, the sheer colour of Ottoman art is at once attractive and yet possibly alarming, as it is certainly surprising, on first encounter. The concept of such fierce colour is perhaps even somewhat suspect, associated with cheap or childish taste and not quite proper therefore to serious art. The very pleasure it instinctively gives may seem too sensuous to be enjoyed without repression, and it is fair to add that the taste for flaunting unexpected colour is indulged in modern Turkey just as much as any love of nature.

If the rose-garden cafés of Edirne are now the nearest cheerful equivalent to the sultans' private paradises, so the stunningly bright walls of tile, the stained-glass and sumptuous jewel-studded artefacts of Ottoman creation survive in the more mundane forms of peasant houses colour-washed violet or sky-blue, puce-tinted glass tumblers and brooms with bristles dyed mauve, pink and green. From the sultan's throne there used to hang pendants of pearl and emerald more valuable but scarcely more glittering or more highly wrought than the baubles dangling at the windscreen of every Turkish taxi and lorry – and often at the rear window as well.

None of this is to imply that Ottoman art is basically brainless – all trinkets and bursts of hectic colour – and still less that it is lacking in significance. Colour finds its justification and place most often in an interior, to give importance to the Mecca-oriented mihrab niche in a mosque or to evoke a garden truly of paradise in the tomb of some prince. The conventions of Islamic culture and the Mohammedan religion significantly shaped the architecture: a palace is for the ruler's retreat, not display; a mosque is a prayer-hall, not a sacred shrine. The individual ambitions and ideas of different sultans, other members of the sultan's family (women, as well as men, it is worth noting) and highly placed officials certainly played their part too in the building particularly of mosques, and it is in its mosques that Ottoman art shows its most severe, but also serene, intellectuality. Complex effects inside and outside effortlessly control space and mass, almost always with a buoyant sense. The achievements of the most famous architect, Sinan – Palladio's near-contemporary – are undoubtedly the finest of all but they are by no means alone. The variety to be extracted over the centuries from the basic unchanging formula of domed prayer-hall is itself remarkable enough. Different sites, different levels, and different tastes also, combined with constant invention, produced a range of mosques which retained well into the nineteenth century total validity as works of art; the Nusretiye complex at Istanbul, completed in 1826, is not quite the last but it is one of the most graceful, elegant and novel – to English eyes virtually a Regency-rococo variation of the theme.

Ottoman architecture forms the central, essential framework, within which the other arts must be accounted lesser, beautiful though they are. Its restraint and usual outer sobriety of material are in contrast to the brilliantly coloured exteriors of the Safavid mosques at Isfahan or the inlaid marble effects of Mughal monuments in India, like the Taj Mahal. The very design of the Ottoman mosque suggests a different climate from the open

2

vaulted halls and vast courts typical of mosques in Persia. On a grey day in Istanbul (where a grey day is, in fact, no rarity), the mosque exteriors can look grey to a forbidding degree; and then inside a sudden rich glow of tiles will the more tellingly make its effect.

In itself, Ottoman architecture – the architecture, that is, not just of mosques, but of tombs, fountains, bridges, baths, hospitals, markets and inns – is perhaps the best demonstration of how seriously art was taken. More important than any convention of Islamic culture is the reliance on the convention of sheer art, and a patent delight in it. The results may be as luminously austere as in the ingeniously planned spatial interior of some mosque or as ornamented and frankly sybaritic as in a kiosk designed for a sultan's pleasure, but in both what is insisted on is the artfulness of art.

The paradise created is by no means merely a natural one, despite all the memorable beauty of those gardens so often brought into alliance with architecture, enhancing the royal tombs in the Muradiye at Bursa or sometimes, as at Manisa, sheltering the fountain courtyard before a mosque. The most brilliant flowers of Ottoman devising – even in the 'Tulip Age' – were probably always those which spring multi-hued from vases in stained-glass windows or blaze with turquoise and tomato fire amid crisp blue foliage on the tiled walls of a pavilion. Perhaps it is significant that coloured lights once illuminated the real tulips in the sultan's garden at night.

16
52

To enjoy all that fortunately survives from this wonderful artistic world, boldness of eye and a lack of preconceptions are more valuable than knowledge. Nevertheless, enjoyment is bound to prompt some inquiry about not only its development but the nature of the society in which it developed. One is all the more likely to need some information since the Ottoman Empire makes notably rare incursions into standard accounts of European history and is anyway seen at such moments very much as the enemy and the aggressor – not, of course, without justification.

Altogether, the 'image' of Turkey and the Turks has seldom been a good one. The *Oxford English Dictionary* gives 1536 as the earliest date for the use of 'Turk' in the sense of someone cruel, savage or tyrannical, qualities already attributed to the nation. That association has had long usage in Europe. It has been so deeply absorbed that the typical behaviour of the individual Turkish people one meets today – courteous, kind, gentle and helpful – is likely both to surprise one and to make one ashamed of being surprised. Nevertheless, these experiences cannot cause a rewriting of history; nor can Turkish behaviour always indicate character, to judge from a nineteenth-century expert on the country, Lord Eversley, who found Abdül Hamid II 'had the manners of a gentleman' though mean, cunning, untrustworthy and cruel. Lord Eversley thought him indeed the most extreme example of all the latter traits in the whole Ottoman dynasty – which would admittedly be a considerable achievement.

Even when the more lurid accounts of harem intrigues, debauched rulers, revolting Janissaries, strangulation of princes and massacres of infidels have been put aside, the story of the Ottoman Empire is seldom inspiring and often bloody, making all possible allowance for the nature of empires. The Roman emperors were not a more motley lot than the Ottoman

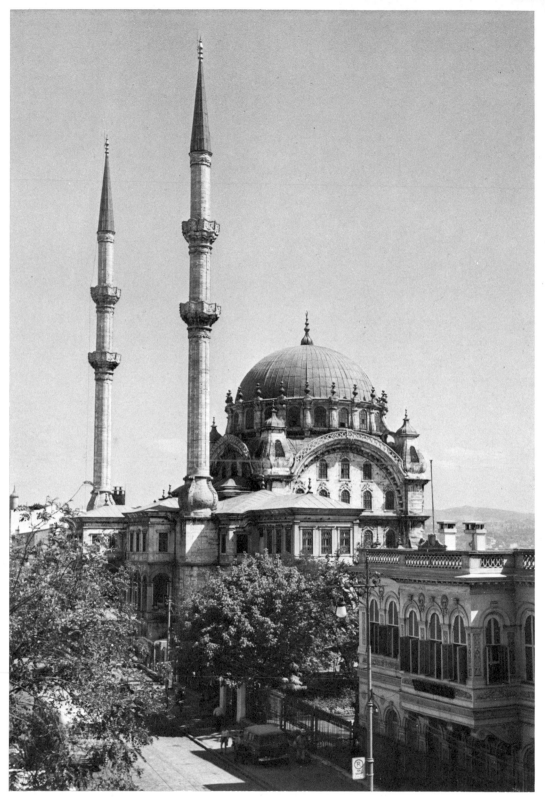

2 The Nusretiye mosque, Istanbul

sultans, and their empire was a good deal more competently organized than the Ottoman one, at least in its last two declining centuries. It is understandable that far from fostering links with the past, Atatürk should have done everything to break with the tradition of Turkey's imperial rule – even to making Mohammedanism no longer Turkey's state religion.

Yet it is necessary for outsiders to be careful. To begin with, massacres and inhuman cruelty were never an Ottoman monopoly. Disgusted by the custom of fratricide practised by the sultans, we may forget the habits of the Byzantine emperors who blinded and otherwise disfigured their rivals. The history of Christian Europe is not exactly lacking in tyranny and atrocity, sanctioned at times by the successor of St Peter; and St Bartholomew's Eve and Glencoe are in themselves words to make us reflect on Western standards of civilization. And then, compared with the constant changes of and challenges to Western royal dynasties, with internal wars, usurpers and pretenders, the Ottoman one was remarkably stable and its line of succession never broken. At the same time, in a crude form, a sort of democracy existed in so far as sultans could be deposed, even executed, if they were judged unsuitable, without any of the fuss attendant on such affairs in the West; no fewer than seventeen sultans were so judged and deposed.

A further fact of human nature needs to be faced, in Ottoman art as in the art of other countries: the great enlightened patron is seldom the most effective ruler, and his artistic patronage may well be associated at the period with extravagance, instability or sheer unsuitability as a sovereign. There are indeed exceptions; the most famous Ottoman one is Süleyman 'the Magnificent', a High Renaissance figure to put beside such of his contemporaries and correspondents as the Emperor Charles V and François I of France.

But some of the later sultans, like Ahmed III in the opening years of the eighteenth century, present the more typical case. Intensely pleasure-loving, though also peace-loving, the Sultan and his son-in-law, the Grand Vizier, created an elegant, artistic court which had distinctly Western overtones and which fortunately survives in such small but enchanting monuments as the Sultan's dining-room (with its painted panels of fruit and flowers), his invitingly light, airy library and the fountain outside the main gateway to Topkapı.

XI
74, 75

Ahmed III's reign was the culturally triumphant 'Tulip Age', in which ideas were borrowed particularly from the French court, whence the Ottoman Ambassador returned agreeably burdened with engravings of garden-plans as well as with five hundred bottles of Burgundy; and one result of these contacts was a series of pavilions built by the Sultan and his courtiers round the valley of the 'Sweet Waters of Europe' at the end of the Golden Horn. Most of those pavilions were victims, along with the Grand Vizier and the Sultan himself, when this carefully cultivated *douceur de vivre* was abruptly broken by the Shah of Persia's successful invasion of Ottoman territory. The people and the Janissaries revolted against court indolence and luxury, destroying what symbols they could of Western decadence, while calling for the head of the Grand Vizier and other

ministers – offered them ineffectually and in cowardice by the Sultan, whose attempt at appeasement brought nothing but his own deposition. He passed from the open-air pleasures of tulip-gardens and riverside pavilions into virtual imprisonment for the rest of his life in the grim 'Cage', the cramped, secluded area of the Topkapı Saray where he had already spent sixteen years before coming to the throne.

Political and even social history may only sometimes rightly describe as feeble or cruel figures who are admirable heroes in terms of artistic encouragement. The chief fault of Ahmed III, one may suspect, had been to prefer peace to war, leaving the Janissaries dangerously unemployed; and perhaps had he first led them to some glorious victory, however pointless in fact, he might have been largely left to enjoy cultivating the arts in as luxurious a manner as he pleased. Anyway, as often happens with such rulers, the art Ahmed III fostered lives on, whereas his panicky cowardice in sacrificing faithful ministers has dwindled simply to a historical fact – one of little significance and less novelty (death being something of an occupational hazard for those governing on any sultan's behalf).

The personalities of the sultans, and the character of their reigns, have been only rather cursorily or allusively treated in the few surveys of Ottoman art which exist in English. Turkish history may seem a forbiddingly specialized subject, and certainly the sultans' patronage would serve as a complete theme in itself. Nevertheless, some sort of historical thread is positively useful in guiding one coherently through any account of art created over several centuries, all the more since in Turkey we encounter few distinct artistic personalities and no art which springs up without direct patronage. The sultans were always the chief patrons and it is their names that are commemorated in the mosques they built. The chapters which follow therefore try to touch, however briefly, on some of these figures, if only to suggest that there was evolution and change in what at first glance might seem a single, static style.

There must be a little more to history, even within the loose context of art, than merely a dynastic table of rulers, just as something more needs to be said about the Ottoman sultans than that they descended from Osman, a warlike tribal leader of thirteenth-century Anatolia. And indeed, although this latter indisputable fact occurs honourably and early in nearly every account of Ottoman history and Ottoman art, accounts of both tend to grow blurred, if not hasty, with the coming of the later centuries. Those were the years of imperial decline, a decline which had its origin in a variety of complex reasons, among them a loss of personal authority by the sultan, financial crises and the ever-threatening existence of large, not easily controlled bodies of troops. Even the reign of Süleyman 'the Magnificent' (who died in 1566) has been seen as containing the first signs of dissolution which were patent by the time of his grandson, Murad III, who ascended the throne in 1574; and Murad III was only the twelfth sultan in the line from Osman.

At nearly every point during the subsequent three hundred years, artistic history is fortunately in contrast to political history, even when the art created is not ethnically pure Ottoman – a fact for which it is not necessary nowadays to apologize. The climate (cultural as much as, if not more than,

physical), the environment, the increasingly exotic anachronism of the sultan and his bizarre requirements, all combined to affect what was created even if the artists were Western European and the results intended to appear typical of Western Europe. After all, no sultan had actually visited Paris or London before the middle of the nineteenth century; and one may recall that in 1869 (when Turkey was already a 'sick man') the Empress Eugénie met at Istanbul two of the Sultan Abdül Aziz's daughters, one of whom was being brought up 'in the English style . . . [she] spent her days riding round and round in a small courtyard of the palace trying to be what she imagined English girls to be like. The other daughter was brought up as a French girl . . .' (recorded in Agnes Carey's *The Empress Eugénie in exile*, 1922, p. 294). Some of the nineteenth-century buildings are as hybrid as these two un-happy girls but more successful products of such blending, and even the less successful have their own fascination and beauty of setting.

The Empire which took so long to die remained artistically alive there-fore almost until the end. If, in artistic terms, its beginning is harder to trace, we can yet be sure that a determination to create splendid monuments characterized it from very early on. In the fourteenth century the Ottoman tribe had swept westwards (urged on not only by hopes of conquest but by the need to escape from Mongolian oppression in the east) far into the Byzantine Empire whose cities crumbled so rapidly that Constantinople itself was rumoured to be falling – a century or so before the Ottomans finally took it.

Among the first cities to fall was Bursa, in 1326. That city, a great trading centre, especially for the silks produced there, became the capital of the new Empire under Osman's son, Orkhan, and a few years later a traveller re-marked admiringly on its fine bazaars and wide streets. On the crowning height of the citadel Orkhan buried his father in a tomb which was called 'Silver', because of its dome of gleaming lead. On the citadel too was his own palace, of wood, and unfortunately destroyed by fire at the beginning of the eighteenth century. Down in the centre of the city Orkhan built a mosque, more than once rebuilt and restored but still inscribed as ordained by him, 'The Sultan of the Warriors and Champions of the Holy War'; and round it he grouped a soup-kitchen for the indigent, two public baths and an inn.

Such buildings are as typical of later sultans as any kiosks for personal pleasure and represent enlightened public carrying-out of a central tenet of Mohammedanism: the helping of the poor and the unfortunate. 'Show kindness,' the Koran enjoins, '. . . to the orphans and to the needy, to your near and distant neighbours, to your fellow travellers, to the wayfarers, and to the slaves whom you own.' At the same time, Orkhan's title indicates another duty, specifically laid on the sultan, and rather less attractive: leading his troops against the infidel in a perpetual war, always presumed holy.

In some ways, an outline of Ottoman art is given by the progress of the capital city: first the establishment and embellishment of conquered Bursa; then the shift of capital to Edirne in Europe when the frontiers of the apparently invincible Empire were pushed beyond Asia; culminating in

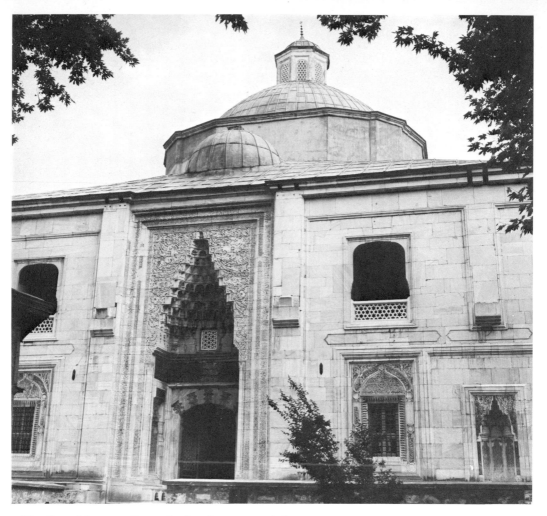

3 The Green Mosque at Bursa, the first Ottoman capital

what is usually called the 'fall of Constantinople' but which for the purposes
of this book is better represented as the rise of Istanbul. Yet the story is more
than the replacement of one city by another, for Bursa retained – perhaps
even increased – its prestige, despite fire, rapine and the earthquakes which
have so often ravaged it. Later sultans built there and all were buried there
before Istanbul became the capital. Although Osman's own 'Silver Tomb'
has disappeared (owing to the earthquake of 1855) and a commonplace
structure stands on the site, the associations of Bursa are, even today, with
the early years of the dynasty and the Empire he founded, as well as with
its early splendour.

 Nothing better crystallizes that than the Green Mosque, so elaborately *3*
beautiful inside and out, though now lacking the exterior tiles which are
described as having once made its dome and minaret caps sparkle in the sun
like emeralds. 'This noble place . . . a building such as no nation has been
presented with since the sky began to turn,' says an original inscription over
the main doorway, is a 'reflection of the Infinite Garden of Delight.' There
indeed paradise may seem to begin.

The Ottoman world

1 Early cities and style

The building of the Green Mosque at Bursa was completed by 1420. It is the perfect, almost final flower of the first phase of Ottoman art, still redolent of the central Asian culture out of which Osman's tribe had emerged little more than a century before, and distinctly different in many ways, including scale, from the great achievements of the subsequent century when Istanbul was established as the imperial capital.

The territory on which the Ottoman Empire began, rapidly spreading east and west, was Anatolia where the city sites were of great antiquity. Bursa itself had a long tradition. It was the ancient Prusa, founded probably by Prusias I, King of Bithynia; in early Byzantine times Justinian had built a palace there and a bathing establishment which still exists; later it was fought over by the Byzantines and the first wave of invading Turkish tribesmen, the Seljuks. They took their name from an outstanding chieftain, Seljuk, and in their progress west they had already established an independent kingdom in Persia. Bursa remained in Byzantine hands but other Anatolian cities fell to the Seljuks, including in the north Iznik (Nicaea), their capital until it was recovered by the Crusaders in 1097, whereupon they selected Konya (Iconium) in the south.

For some two centuries up to 1300 the Seljuk kingdom of Anatolia survived, at times triumphed and held its awkward position sandwiched between the shrinking Empire of Byzantium and constant threats from the east, culminating in invasion by the Mongols. Under this last fierce pressure, the Seljuk state collapsed, splintering into a number of small principalities of which the Ottoman one quickly became dominant; and dominance was very soon to carry it across the Straits of Gallipoli, deep into Europe, conquering Sofia (in 1385) and penetrating as far as Niš in present-day Yugoslavia.

Although the Seljuks as a ruling power disappeared for ever, they left behind an impressive array of monuments which form as it were a prologue to Ottoman art, all the more apt since they, like Ottoman buildings, are not of brick but stone. These already prepare us too for the emphasis on certain types of building: the mosque (itself ranging from small oratories to huge Friday prayer-halls for assembly on the day all the Faithful were obliged to attend), the 'medrese' (a teaching institution for Islamic theology), the 'han' (a substantial inn for travellers) and the chapel-like tomb for rulers and other highly placed dignitaries. Even more significant than any type of individual building is the concept of grouping them together – rather like the medieval monastery complexes of the West – so that a large-scale medrese may adjoin a mosque, and perhaps have a hospice attached, as well as its founder's tomb near by.

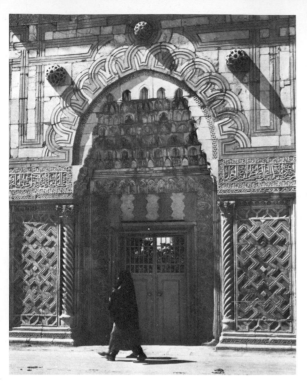

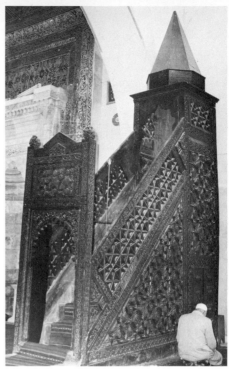

4 The Karatay Medrese at Konya

5 Carved mimber in the Ala al-Din mosque, Konya

What the Seljuks built might look rather different from what would eventually become typical of the Ottoman style, but in the early years especially there was bound to be influence as well as close affinity. Thus the decorating of the exterior of buildings with tiles – as, for example, originally on the Green Mosque at Bursa – was clearly derived from Seljuk practice; and the characteristic early Ottoman tiles of unpatterned turquoise, deep blue and black seem to belong in this Seljuk culture.

Even when existing only in ruins, the buildings of that culture testify to magnificence and refinement. The architects were far from being anonymous craftsmen but proudly recorded their names on what they built, repeating the artist's traditional belief at all periods in the immortality of his art. On the mid-thirteenth-century so-called 'Tiled Medrese' at Konya, with its rich though now-incomplete decoration of predominantly bright blue faience, the architect is named and an inscription once on it claimed, 'What I have created is unrivalled throughout the world; I shall pass away but this shall remain for ever.' As a capital city Konya was rich in medreses, designed often with thrilling effects inside as well as out. The Karatay
4 Medrese has a highly patterned porch of almost ripplingly light relief in stone, suitable prelude to its interior where the dome shimmers with firework-like stars or suns in a sky of turquoise and black tiles, supported on four fan-shaped bursts of similarly coloured squinches. Tiling here is used with consciously architectural effect, not just covering surfaces but playing up the way the building is planned.

Elsewhere, in tombs as well as medreses, the variety of geometrical patterns emphasized archways, doorways and windows with equal coherence. The elaborate stone-carving, at times of lace-like delicacy, and the carefully planned expanses of tiling were accompanied by doors, lecterns and pulpits no less elaborately devised and carved; wood-carving was a further highly developed aspect of Seljuk art. And to the richness of effect in a furnished interior, whether of religious or secular kind, has in the mind's eye to be added the boldly geometric, sober yet strong-coloured carpets which today rarely survive except in fragments.

All that is known of the Seljuk palaces, sometimes sited beside a lake, suggests yet greater refinement, with tiled pavilions, laid-out gardens, fountains, mosaic pavements and throughout a much greater concern with figurative representation (even some sculpture) than was to be typical of Ottoman art. More truly palatial, however, than any existing remains of their palaces are the vast, fortified Seljuk hans, several built by the sultans, along the main inter-city routes. These usually provided, as well as accommodation for travellers and animals, baths, a library, a mosque and medical services of all kinds; one at least also had a resident band of musicians to entertain the guests. The accommodation itself may have been simple enough but the grandeur of these castle-cum-cathedral structures and especially their high, carved entrance portals anticipate Ottoman achievements. The gateway to the forecourt of Sinan's Süleymaniye Mosque is more elegant and linear, yet scarcely more impressive than the Sultan Han

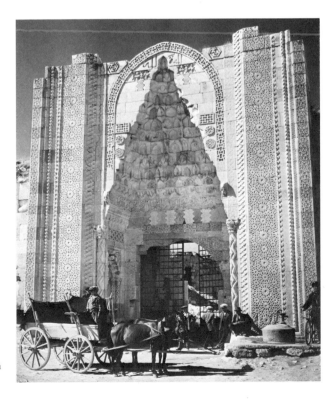

6 Portal of the Sultan Han, 1229–36

portal with its pounced and fretted framework of carved stone, its zigzag pillars and steep, deeply indented stalactite niche. As the entrance to a lodging-house for caravans it is almost wilfully ornate but was perhaps only the more welcome in its soaring beauty when sighted at the end of a dusty day's journey through lonely, possibly dangerous, countryside.

From what remains of its art, we can recover some concept of Seljuk existence in Anatolia. That is all the more useful as a prelude to early Otto-man achievement since – some architecture apart – we know little that can be characterized as distinctly Ottoman from the first years of the new dynasty. The 'life-style' of Orkhan, for example, is really less clear than that of the Seljuk sultans, but perhaps it was not so very distinct or different.

The fixed points of the whole culture remained remarkably the same. Over the centuries, religious and state requirements were scarcely to alter; and to some extent the ordinary individual's place within them was frail, circumscribed and minute. An impersonality in the Islamic religion, a lack of respect if not for life then for independence or individualism, and a cur-rent of fatalism, coloured what was created. Although certain types of civic building were always dutifully put up, there was never to be much grasp of the over-all concept as such of 'the city'. Streets, boulevards, or even squares, were seldom planned. Private houses huddled, as they still do in parts of Istanbul, where space happened to be available; and though the sites on which major mosques were built are frequently praised for having been well chosen, the areas round them have often remained extraordinarily haphazard and lacking in any sense of organized approach.

The culture itself prevented or discouraged the idea of the individual prosperous merchant's dwelling, of the type already apparent in fifteenth-century Europe, or the planned row of opulent middle-class houses typical of later European cities. Certain conventions, like the rigid seclusion of women, governed the hovel just as much as the palace (as well as the mosque), and dictated the interior arrangements of any home. There were no dining-rooms or banqueting-halls, since food was served where one sat, and scarcely bedrooms as such. Ottoman society had its own extremes of power and poverty, but fewer intervening grades of aristocracy, rich bourgeoisie and long-established families than in the West. It possessed a certain sim-plicity and regularity, and even faint intimations of equality (for men only), all of which can not too fancifully be found in the art it needed and produced. Everything dwindled before the power represented by the mosque; and thus the mosque represented the greatest of artistic challenges.

And within it, we may suppose, the average person experienced his pro-foundest aesthetic sensations, blended with whatever overtones religion gave them. The ritual of public ablution before entering the prayer-hall proper, like the discarding of footwear and covering of the head, is already a preparation for heightened experience, a break from the normal and the prosaic – as is easily detected in the typical demeanour of worshippers today preparing to enter a mosque. The experience of space and silence immediately on stepping inside can be shared by anyone, but must be all the keener for those coming from a cramped, noisy environment. Whether praying or listening to a sermon, the worshipper is induced to contemplation by the

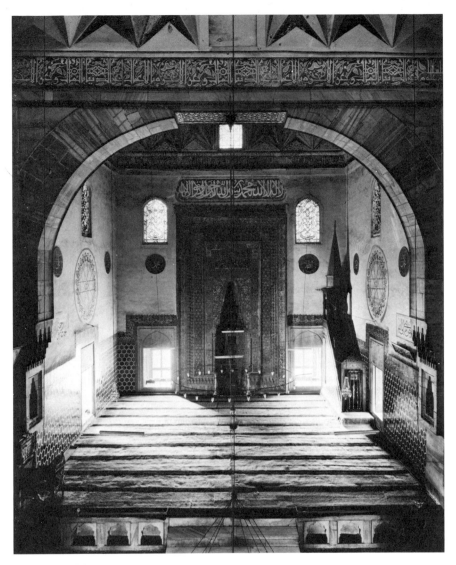

7 Interior of the Green Mosque at Bursa

calmly yet elaborately patterned world around him – an apparent eternity of intricately woven surfaces – which symbolizes ideal beauty and order. In that cosmos he finds his place, whether alone or among a packed congregation, already glimpsing something of the future steadily promised to good men in the Koran: 'They shall recline on green cushions and rich carpets.' That experience becomes the real one, under a dome suggestive of, often intended as, the universe, with the mihrab niche perhaps rising – as in the Green Mosque at Bursa – between wall-bosses representing the sun and moon.

In that mosque it is very much as if the order of heaven and earth had been brought into one harmonious confrontation: the sultan's *loge* or royal box over the entrance directly faces the mihrab, with below on each side

7

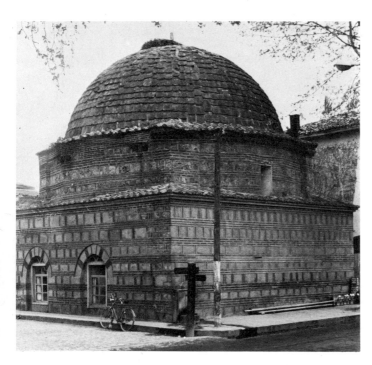

8 The 14th-century Hacı Özbek mosque at Iznik

tiled recesses – virtual rooms – which could accommodate court officials, and elsewhere in the mosque other lobbies may have been occupied by some Dervish sect or simply by people waiting to petition the sultan. But all is oriented, literally, towards Mecca, and before that significance the sultan, like his humblest petitioner, had to prostrate himself.

The mosque as such is inevitably the beginning and also the end of Ottoman art, since from Orkhan onwards nearly every sultan built and gave his name to one. By the mid-nineteenth century the need was less to glorify the individual than to try and reawake associations of past Ottoman glory and greatness. Thus, some of the last imperial mosques and other religious buildings put up or extensively repaired and restored are in the places where Ottoman history had begun. Abdül Aziz built a grandiose mosque of his own at Konya in 1872, and it was in his reign that some early mosques at both Bursa and Iznik were restored. Whatever their vicissitudes, these still represent the first phases of Ottoman art. The small, simple, compact structure of the Hacı Özbek mosque at Iznik, dated 1333, is as it were the absolute essence of mosque: a dome raised on a rectangle, providing a luminous peaceful interior for prayer. The form is well enough that also of the Ottoman tomb – a form hardly changing down the centuries. And mosques and tombs are among the chief monuments surviving to characterize these early years.

Iznik had fallen to the troops of Orkhan just two years before the date of the Hacı Özbek mosque. The city's absorption into the rising new Empire was achieved smoothly, without the massacre or harsh constraint of its citizens. The church which had sheltered the Council of Nicaea (at which the Nicene Creed had been formulated) was converted into a mosque. New

mosques, baths, a public soup-kitchen and some tombs were built there during the fourteenth century and the city became, next to Bursa, the most important in the expanding kingdom. Its buildings often contain distinct echoes of the Seljuk style, especially through the use of tiled minarets, but mingled with experiments in the disposition of space and size and disposition of domes, which make Iznik something of a nursery for future developments. Two of Orkhan's sons had work done there, one of them setting up the soup-kitchen foundation in memory of his mother, Nilüfer Hatun, who had herself ruled as Regent at Iznik in her husband's absence. She also was a builder and clearly a strong-minded, able woman, given opportunities to govern which would never have been hers in the later Ottoman Empire.

The concentrated nut-like shape of the Hacı Özbek mosque is expanded, almost trebled, in the Nilüfer Hatun building, with its deep, impressive portico and bubbling silhouette of several domes – pointing the way already across the centuries to the superb complex effect of the Blue Mosque at Istanbul. As well as providing food for the poor, the Nilüfer Hatun foundation was in origin a lodging-house, connected with a special sect, but it is as grand as a mosque – far grander and larger, in fact, than any mosque at Iznik. Its T-shaped plan, with large rooms on both sides of the main domed area, relates it indeed to the new type of mosque being built in the fourteenth century at Bursa, of which the Green Mosque is the most choice example.

9

64

9 Exterior of the Nilüfer Hatun hospice, Iznik

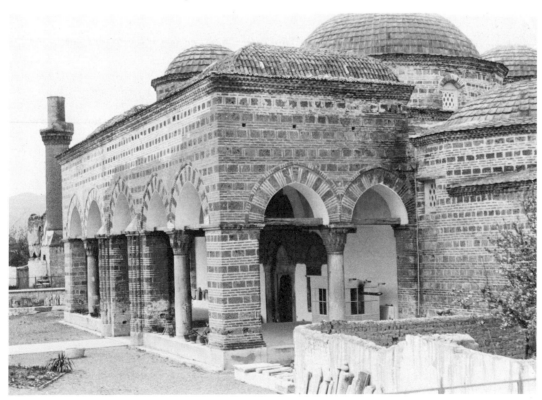

Iznik as a city suffered the fate of its nursery-status: it was left behind. No later group of monuments joined its nucleus of early ones, some now ruined. In the sixteenth century it became famous for the superb tiles its workshops then produced (though the tradition of Iznik pottery was much older), but its reputation did not increase its importance or its size. Despite its attractive position at the end of the huge Iznik Lake, it took little advantage of its setting, remaining – as it still does – very much within the double Roman walls, today almost its finest, certainly its most memorable, feature. Dusty and deserted-seeming, Iznik has dwindled to be the shadow of a familiar, if not great, name.

Altogether larger and more active (now as then), straggling over a wide area of remarkably varied terrain, and much more capable of conveying the effect of early Ottoman culture is the first capital, Bursa. It is certainly the key city for that period, but elsewhere in Anatolia there were cities flourishing under independent rulers, the beys, hereditary leaders of tribes like Osman's. Eventually, by the end of the fifteenth century, these principalities were forced – often after bitter struggles – to submit and become in turn part of the Ottoman Empire. What was thenceforward built in such cities can be described as totally Ottoman. In the years of their independence, when Iznik and Bursa alone were the chief Ottoman centres, those cities shared a general Islamic culture, tinged naturally with Seljuk colour, but they might also possess their own individual character, commercial prosperity and splendour.

At Birgi, today a village, the Aydın princes had a palace where the pages dressed in silk impressed an early fourteenth-century traveller; the palace has gone, but a large mosque and tomb remain. At Manisa, the capital of the Sarukhan beys, a 'great' mosque was built high along the hill above the town proper. On this exciting, steep site, the single-domed mosque is preceded by a spacious, arcaded courtyard – common enough in later mosque-buildings, but not found at Iznik or Bursa, and something of a novelty anywhere in the country at the date (1376). Adding to the sheer bulk and extent of the building is the cavernous medrese adjoining, with the tomb of the founder behind a doorway decorated with carved interlaced patterns like entwined snakes. The complex forms perhaps the grandest of all non-Ottoman fourteenth-century Anatolian monuments and it breathes a sense of antiquity which is neither fanciful nor merely the result of approaching it after seeing fully sixteenth-century mosques in the town below. The capitals, and probably the columns too, of several of the courtyard pillars are re-used Hellenistic or Roman work, a reminder that Manisa was old when this mosque was built: a Byzantine capital before it was a Sarukhan one, a Roman conquest before that, and in origin a Greek city, Magnesia ad Sipylum.

A cosmopolitan present – as well as past – characterized the more important cities and was given to them through trade. In commercial centres like Balat (Miletus) and Ayasolug (then the name of Ephesus) there were Venetian consuls and prosperous Christian merchants. While Turkish silks and cottons were especially prized by the West, certain materials – woollen cloth, for example – were sought in exchange. Opportunity for those

10

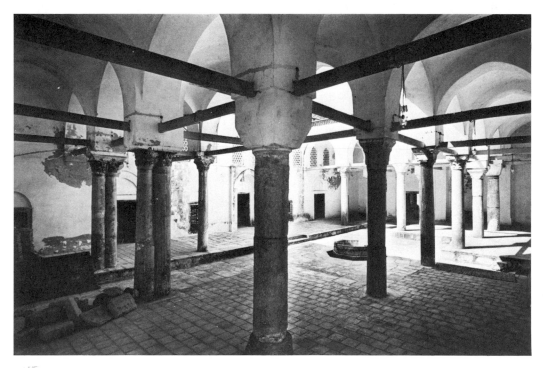

10 Courtyard of the 'great' mosque at Manisa

Western influences in Ottoman life and art, later violently rejected at times of violent nationalism, had really existed in some form or other from the first. When occasionally in the pre-1500 period a building suggests affinity with Venetian architecture, this may not be entirely coincidence. In Manisa, as well as in Balat and Ayasolug under the beys, silver coins were specially minted, on Neapolitan models, to facilitate trading with Italian merchants. The Venetians, the Genoese and the Greeks especially must be thought of as very much an element present in Ottoman life; the necessity of trading with them was to be recognized by most sultans. Although faith might give priority to the mosque, in practice the bazaar was hardly less vital.

Bursa's importance was basically commercial, and it retained that importance as trading-house and meeting-point for West and East long after it had ceased to be the capital. Like Iznik, it had its factory production – with the advantage that what it produced was consumed internationally. Its luxurious textiles of velvet, brocade and silk were woven for the court, above all for the sultan himself (caftans associated with many sultans survive) but were also eagerly bought for export to the West, along, of course, with other Eastern materials. In the early sixteenth century Bursa was big enough to contain more than a thousand weaving workshops.

By then it was no longer the capital, but its particular semi-sacred status was well established. Trade had made it prosperous and cosmopolitan. What the sultans built there gave it character. Orkhan had created a tradition by burying his father there and by building his own mosque. He himself was

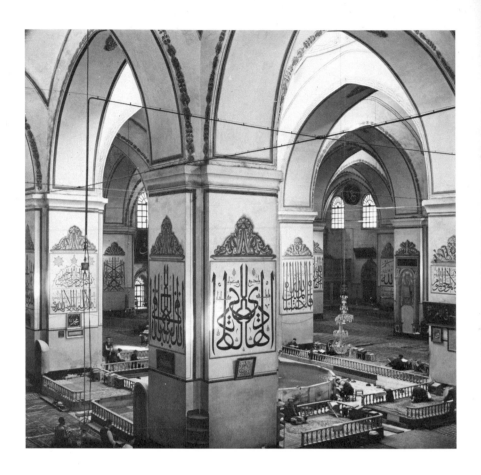

to be buried quite close to his father's tomb. Other sultans selected other sites, though always within the environs of Bursa; and each built at least one mosque there up to virtually the time of the taking of Constantinople. Nevertheless, in certain ways, it remained the city of Orkhan who had captured it and first given it its Ottoman nature. Under his son Murad I, some new mosques were begun at Bursa and the Sultan is recorded as having had Christian workmen employed on them. The course of his own 'Hüdavendigar' (Dominator or Lord) mosque in the environs certainly proceeded with remarkable slowness, unlike Murad's military achievements. More famous than any building associated with him is his creation of a new style of conscript army, the Janissaries, whose privileged position was ultimately to prove – rather like that of the Praetorian Guard of the Roman emperors – a menace to the power it was meant to serve.

It is not surprising if Bursa is little marked by Murad I's activities. Although he receives a warm testimonial from Gibbon ('mild in his temper, modest in his apparel, and a lover of learning and virtue'), the Sultan's attention, like his actual person, was normally engaged in energetically extending the frontiers of the Ottoman Empire – both east and west. Under him some of the independent bey-ruled states were forced into joining the Empire. More daringly, he carried war into Europe, conquered Adrianople

11 (*left*) Interior of the Great Mosque at Bursa

12 (*right*) Portico of the Beyazid mosque, Bursa

(modern Edirne) and invaded the Balkans. In the neat, semi-industrial Bulgarian town of Plovdiv there is still a mosque which he is claimed to have built, after capturing the town. He took Sofia and a year later entered Serbia and seized Niš. And all this territory remained part of the Ottoman Empire up to the nineteenth century.

Within the new territory he had conquered, Murad felt the need for a new, European capital and he settled on Edirne. Nevertheless, it was to Bursa that he finally returned as a corpse, having been assassinated in 1389 on the field of battle at Kosova (in Yugoslavia), his last victory. In front of his 'Hüdavendigar' mosque his tomb was built and he earned a fresh title, 'Martyr' – one not to be applied to a sultan again until some three hundred years later.

Another title, a unique one, had already been given to his son who succeeded him, Beyazid 'the Thunderbolt': a vivid epithet won by his speedy crushing of hostile armies. He seemed to have inherited all his father's military ability, with even greater daring and ruthlessness. His ambitions as a builder were greater too. In the centre of Bursa he built the Great Mosque, 11 vast rather than subtle perhaps, with its unprecedented twenty domes which are said to represent the prudently modified vow of the impetuous Sultan who had sworn to build twenty mosques if victorious in a battle. Possibly

something of a thunderbolt also to his builders, Beyazid saw the huge mosque completed in about four years and ready for use by 1400. Inside it is inevitably spacious but loosely organized, vaguely unfocused, even bewildering: size has been achieved by reduplication of a single, simple unit rather than by any over-all plan, and the interior effect is neither beautifully austere nor exquisitely decorative. The prominent fountain encountered on entering (thus very different from the fountain courtyards in front of later mosques) increases the slightly bewildering air. Outside, however, the massive block of sun-bleached honey-coloured local stone forms an impressive monument in the very heart of the city, significantly close to the still highly active bazaar and remaining unrivalled in size as a mosque at Bursa.

Beyazid built elsewhere in his apparently ever-triumphant Empire: at Bergama, at Alaşehir and at Balıkesir. None of his mosques in these places equalled the 'great' mosque at Bursa, and it was there – beyond the city limits – that he had also built a 'Thunderbolt' complex, the first Ottoman large-scale royal foundation, including mosque, medrese and, finally, the founder's tomb. Much of the original grandeur has crumbled away and several other buildings in the complex have gone. But the T-shaped mosque survives, with its side rooms and raised, clearly defined, luminous prayer-hall, anticipating the refined mood of the Green Mosque to be built by Beyazid's son. More remarkable is the exterior, providing the novelty of a façade pierced by a tall portico, not just a series of simple archways as in the Nilüfer Hatun building, but a screen opened up virtually to the height of the façade, each bay helping to frame the windows behind, capped by its own dome. It is this style of portico – of almost weightless effect, elegant through its very spareness – which was to become a typical feature of the Ottoman building. There is already something courtly about Beyazid's own mosque in its secluded setting, differentiating it from the big, civic, 'popular' place of worship which he had built down in the city.

Its royal aspect is increased by the presence of the Sultan's tomb, on a close-by site perhaps always intended for it but not to be utilized for several years. Invincible as Beyazid seemed, he was in fact to be defeated and horribly humbled by the great Tartar leader, the lame Timur (the Tamburlaine of Marlowe's two plays), who took him prisoner at the Battle of Ankara in 1402. The Sultan may not have suffered all the indignities Tamburlaine inflicts on Bajazeth, caged, fed on scraps and driven eventually to suicide. Yet he certainly died Timur's prisoner and certainly his wife had been captured with him, as in the play. A few years later one of his sons was permitted to bring his body back for honourable burial.

The disasters which ended Beyazid's reign proved, ironically, of artistic benefit to Bursa. Three of his sons uneasily partitioned what remained of the Empire, having first sworn allegiance as vassals to Timur. But they warred with each other, fighting particularly for possession of the rival capitals of Bursa and Edirne. The third of them, Mehmed, Beyazid's youngest son, eventually defeated his brothers and re-established an undivided Empire. He created also a highly cultured, literate court – the first sultan to do so. He is also the first sultan known to have had a trade as a hobby – something

12
9

which became traditional; he was a maker of strings for bows. It was he who built the Green Mosque and also had its companion building of the Green Tomb completed for himself, just forty days before his death in 1421. They proclaim a new exquisiteness of taste and have a new elaboration of decorative richness which well accord with the sophisticated ideals of an Ottoman ruler who had shown himself as able as he was cultured. Yet Mehmed I was by birth the least likely of all Beyazid's sons (of whom there were at least five) to succeed to the throne in ordinary circumstances. The custom of fratricide had already been introduced into the dynasty, and strangulation on his father's death would almost certainly have been Mehmed's fate had Timur not invaded the kingdom.

Mehmed did not live to see the decoration of the Green Mosque completed, but even this decoration is indirectly due, at least in part, to Timur. The artist-designer Ali, who signed the tiles in the Sultan's *loge*, was one who had gone with Timur on the long journey to Samarkand, where he had learnt the decorative refinements so beautifully displayed in the Green Mosque and in the near-by tomb. Timur was himself a great artistic patron and the exterior of his own tomb at Samarkand is a far more virtuoso piece of design than the Green Tomb; rectangular carpet-like patterns of brick and tile decorate the walls and windows and the tomb is topped by a crinkled, fluted, bulbous dome of predominantly turquoise faience. Timur's may be the most beautiful, but other Timurid tombs in the necropolis near Samarkand show the same delight in patterned exteriors and gleaming blue-green domes of tile. *13, 14*

No Ottoman buildings had been like this, and it is easy to realize that what could be seen at Timur's capital of Samarkand represented not merely technical achievement but a revelation of the subtle uses of coloured tiling as an architectural element. Dissatisfied with the insufficient grandeur of one building he had commissioned, Timur had the architect put to death. Timur planned another even more grandiose capital, a complete so-called 'Green City', today in ruins: a colossal place of tiled and patterned gateways that might have stirred Marlowe to some vivid lines conveying the sheer bold splendour of a city suitable for such a conqueror to inhabit. There too would have been inspiration for what, on much less extensive scale, was to be done at Bursa; and it was perhaps Ali on his way back from Samarkand who stopped at Tabriz, a centre of Persian pottery production, whence workmen were certainly brought to help execute the gilded ceramic richness of Mehmed's mosque and tomb – exotic, unparalleled achievements on Ottoman territory.

Notable amid the richness of the Green Mosque is, first, an absence of green in its ornament – despite the impression given by the average colour postcard on sale only a few yards from it, showing an interior so liberally tinted green as to suggest it has been attacked by some virulent form of mould. Very different is the actual, and also intensely controlled, effect for which some preparation is given by the subtly delicate façade and even by the subtle siting of the mosque on its own spur of sloping hillside, amid feathery trees. Nearer to the city than the 'Thunderbolt' complex, and yet set apart, it has much of the air of certain exquisite fifteenth-century Italian

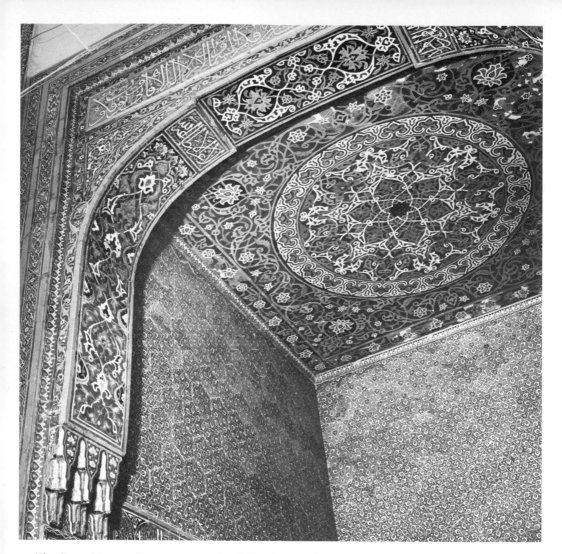

13 The Green Mosque, Bursa; an example of tiling in one of its recesses

religious buildings, the Pazzi Chapel at Florence, for instance, or S. Maria dei Miracoli at Venice.

Despite the fame of its beautiful and brilliant decoration, the Green Mosque is a triumph of, above all, architectural harmony. Its disposition of space remains intimate rather than grand, and very much related to human scale. There is no sense of immensity or eternity dwarfing mankind; and even the two domes over the entrance area and prayer-hall proper are far from the soaring baroque achievements of Sinan, being in style closer to what in Europe would be recognized as 'early Renaissance'.

3 The laws of harmonious proportion are already declared by the graceful façade (seen all the better for the fact that its planned portico was never built) with firmly framed lines of window, lightly incised but richly decorated on the lower level, and, on the upper, open apertures with pierced, star-patterned balconies. The slim, single doorway – unlike many later mosques there is only one entrance – sets the direction of the building,

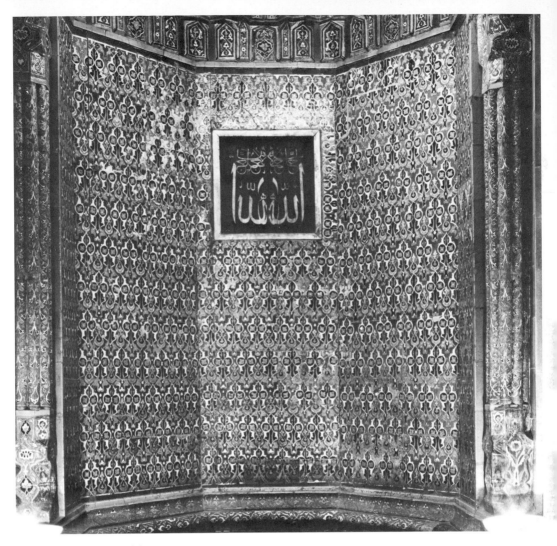

14 The mihrab niche of the Green Mosque

guiding one into an interior proportioned between expanses of plain stone
and decoration. The fountain in the entrance area is no less neatly propor-
tioned to its space, concentrated and simple in comparison with the promi-
nently large object in the Great Mosque. The Green Mosque seems easily and
agreeably to accommodate people, positively inviting one to occupy the
deep, tiled, carpeted recesses on each side of the entrance: rooms like kiosk-
retreats in a palace, exuding both repose and luxury. Lined half-way up with
plain, hexagonal and, in fact, dark turquoise tiles – turquoise once stencilled
over with gold now rubbed faint and yet still fitfully gleaming like the worn
tooling of a book-cover – these recesses break in their upper part into neat
geometric patterning which reaches an inlaid mosaic intricacy and elabora-
tion on their ceilings.

Ensconced within these completely tiled pavilion-like boxes – themselves
echoes of the Sultan's own *loge* overhead – one gazes straight into the prayer-
hall, with its wainscot surround of similar hexagonal turquoise tiles leading

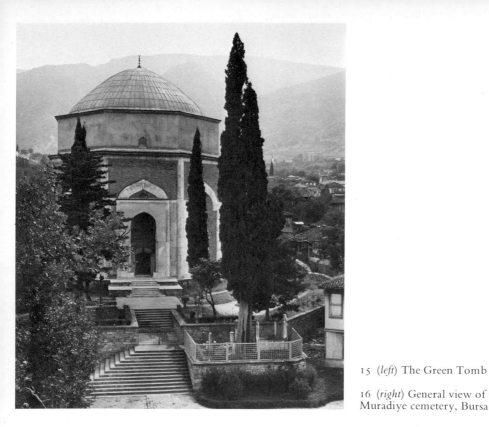

15 (*left*) The Green Tomb at Bursa

16 (*right*) General view of the Muradiye cemetery, Bursa

to the great vertical central strip of mihrab: a shimmering expanse of bright faience as if a multi-coloured, embroidered hanging had been unrolled virtually from ceiling to floor. And with all its suggestions of porch and

14 gateway (gateway to another world), the mihrab also takes on associations of a cloth of honour when so highly patterned as here; it recalls the tents, carpets and canopies particularly in Persian manuscripts. Blue and yellow and white of the tiles are intermingled until it becomes almost impossible to trace their motifs; the effect seems meant to dazzle and to astonish, conveying a sort of fierce visionary richness. If this is a paradise-garden, it is one where the flowers bloom not merely with unnatural vividness but in an unnaturally tight-packed parterre.

The cool-glazed white background of typical sixteenth-century Iznik tiles is far away in mood from this less elegant and accomplished faience, so much more closely worked and lacking the glassy, lustrous surface – that effect of being sealed under water – which makes the finest Iznik ware so sensuous. Yet this strange, almost moulded, semi-matt tiling of the Green Mosque, and of the Green Tomb also, is part of the fascination of a still early Ottoman world, artistically not entirely autonomous but creating its own splendour, with its own charm of manner, to be lost – one could argue – amid later sophistication.

No later Ottoman tomb would be covered outside with anything re-sembling the surprising bright turquoise tiles which decorate the exterior of

15 the Green Tomb (and which are at least in part original). Few tombs, too, would occupy such a dominant site, higher up the hillside above the mosque, approached by a long flight of steps. The tomb is the perfect complement

to the mosque – like baptistery to cathedral in an Italian town. Its mihrab
is even more splendid than the mosque's, with a crest of carved, feather-fan-
like shapes and thick borders of varying blue and yellow tiles, some toothed,
others made of interlaced lettering; and pillars guarding, as it were, the
inset tiled niche that shows a lamp hanging between two tall candles amid a
profusion of flowers, as though hung in Paradise. If that lamp does not
symbolize the dead Sultan's soul, it must symbolize divine light along with
the solemn companionship represented by the burning candles in holders
inscribed with the names of Allah and Mohammed. A passage of the Koran
seems apposite: 'His light may be compared to a niche that enshrines a lamp,
the lamp within a crystal of star-like brilliance.'

As if such richness was not enough, the Sultan's symbolic coffin stands on
a raised platform totally covered with a blaze of blue and gilded yellow
inscriptions, like a treasure-chest at the centre of the room. The room is –
or, at least, was – a sacred treasure-house, no less splendid within than
without, where everything was wrought to suggest a shrine of art; its
crisply carved wooden doors form an ideal entrance, a promise of what is
contained inside and almost a bridge between that splendour accumulated in
a small space and the airy exterior of shrubs and trees – cypresses among
them – which still preserves a garden setting for the tomb.

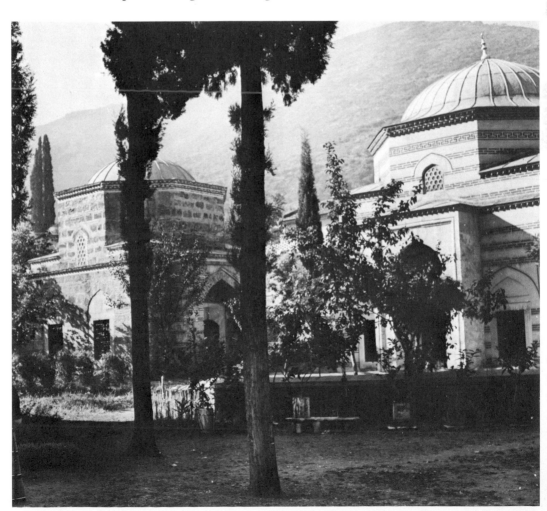

16 A garden-cemetery was to be the most memorable foundation at Bursa by Mehmed's son, Murad II, himself the last sultan to be buried in the city and the last to concern himself much with it. But nothing could come as a greater contrast to the sumptuous Green Tomb than the simple structure Murad devised for himself: a large but plain, cream-coloured, stone chamber left open to the sky so that the rain might fall on the heaped earth below which he lay. The early seventeenth-century English historian of the Turks, Richard Knolles, already seized on this poetic detail, 'which they say he commanded to be done in his last will, that the mercy and blessing of God might come unto him with the shining of the sun and moon and falling of the rain and dew upon his grave.'

The suggestions conveyed of austerity in Murad's character are borne out by the fact that he abdicated (though forced by circumstances to return to the throne) and seems to have been drawn – like another Charles V – to an ascetic religious life after the weariness of wielding great power. It was not an allurement to be felt by later sultans; no other successfully or voluntarily abdicated, and even Murad's attempt lasted less than two years.

Like his father and grandfather, Murad II selected a fresh site for his own complex of buildings, with a mosque, a medrese and the royal burial-ground which he perhaps thought would serve for his successors as sultan. For some reason, the land chosen was on the very opposite side of Bursa to that where Mehmed I and Beyazid 'the Thunderbolt' had built, and it must have been far beyond the city boundaries. Its sense of retirement and distance is still strong, emphasized by its low-lying nature, the terrain being, for Bursa, comparatively flat. Murad's brick-built mosque is simpler in every way than the Green Mosque, and less successful as a building. But the near-by fine medrese, with its soaring archway, shows a new use of brickwork in decorative patterns and seems a suitable place for the sultan himself to study or meditate.

The half-wild, half-melancholy garden is what really distinguishes the complex, for nowhere else was such an extensive series of tomb buildings to be set up together – like so many summer-houses along the paths, between cypresses and plane trees, oleander bushes and roses. In his own tomb Murad buried two of his sons, two whom he probably preferred to the one who became his heir – the future conqueror of Constantinople, Mehmed II – and whose deaths may well have increased his weariness with the world. When he abdicated it was in fact Manisa to which he chose to go, far from the royal dynastic associations of Bursa. Yet, as an extension of the medrese, the Muradiye garden of the dead – no cemetery in the Western sense of white marble effigies, granite chips and cropped grass – seems now remote enough, and pleasant enough, to serve the ex-Sultan's purpose. There are echoes of court life in tombs of female relatives – even a tomb of concubines – and an echo of grim reasons of state (as they appeared) in the tomb of Murad's young brothers whom he had had blinded at his accession. Vanity and cruelty could almost be forgotten in this peaceful setting when the tomb doors stand open on an autumn afternoon and the sandy pink and white brick structures glow amid the tangled shrubs and a few late-flowering roses.

Other tombs were afterwards to be added, in very similar style, though far richer inside than Murad's own, like that for the unhappy Prince Cem whose wanderings, imprisonment and eventual death in Europe form one of the saddest, strangest stories of the Ottoman Empire. Here too is buried Prince Mustafa, Süleyman the Magnificent's admired heir, slain at his father's command through the instigation of Roxelana, jealous mother of a rival son. It is as if the graveyard were to be reserved for minor, if not embarrassing, personages connected with the dynasty, shuttled off to Bursa for burial after the establishment of Istanbul as the capital; and then even this use ceased. The Muradiye marks the end of the first phase of Ottoman activity. No further complexes of this kind were built at Bursa, and the last sultan to linger there at all was Murad himself when in 1446 he was urgently summoned from his retirement at Manisa to resume the throne. At Bursa he made his will. Five years later his body returned to the unadorned, open structure which he had carefully prepared for it.

Another city had long before replaced Bursa as the capital: Edirne (Adrianople), in the European portion of the Empire and close to the modern Bulgarian border. There, in notably flat, lush countryside intersected by rivers, was a city which one of Beyazid I's sons had made his capital at the time of the struggles that followed the conquests of Timur. Unlike Bursa, Edirne did not lose its importance and status; even after the rise of Istanbul, it remained an alternative, summer, capital and it was there in the sixteenth century that Sinan's greatest masterpiece, the imperial mosque of the Sultan Selim II, was to be built.

Neither cradle nor grave of the dynasty, Edirne actually possesses greater continuity than Bursa or Istanbul, though it must be much less visited than either. Its associations need to be stirred at the sight of some mosque or tracked down amid the few remaining ruins of the Sultan's palace on an island in the Tunca River, a palace Murad II began as a single kiosk which was frequently extended and restored in later centuries until tragically blown up. Its landscape of water-meadows and willow trees, its forlorn museum, even its beautiful bridges (one, at least, attributed to Sinan) are not strictly anything to do with the early years of Ottoman art, but may reasonably colour one's concept of Edirne's history.

Murad II built there much more ambitiously than at Bursa. Although his reign was never long free of wars or internal threats, its aim was peaceful and the period one of prosperous consolidation. Under him the city benefited through being treated as the centre of his court, a court recognized by both foreigners and natives as highly cultured. At Edirne, as the seat of his government, Murad received ambassadors and – in his island-palace – celebrated splendidly the circumcision of his sons, traditional occasion for a festival.

Religious architecture alone survives to convey the splendours and the culture, but the dramatic bulk of Murad's huge 'Three-balconied Mosque', *17* with its four thrillingly tall minarets, is one of the great Ottoman monuments and a quite unprecedented achievement. If Murad II had built nothing else, he would be remembered for a mosque which is really more profoundly part of Edirne than Sinan's superb yet slightly peripheral

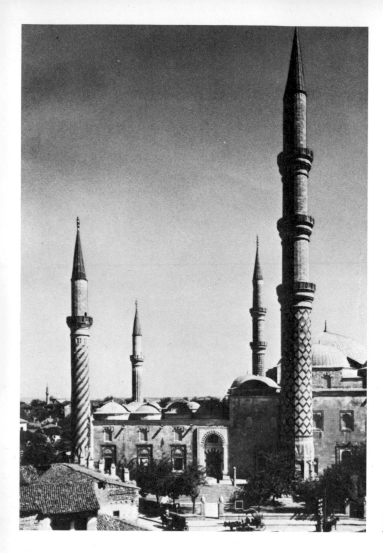

17 The 'Three-balconied Mosque' at Edirne

masterpiece. The total novelty of the 'Three-balconied Mosque' (a name derived from the minor novelty of having a triple-balconied minaret) is made patent by comparing its exterior with that of 'Old' Mosque, built at the very beginning of the fifteenth century and whose name implies its relegation. There the general style, including the porch, recalls what had already been built at Bursa – not the elegant T-shaped Green Mosque but the simpler mass of the Great Mosque.

Yet the 'Old' Mosque is itself more concentrated and uncluttered than that, and far from being merely a large, unorganized space. Inside it is indeed more luminous and effective than the interior of the 'Three-balconied Mosque', despite its thick, substantial piers. Dreadfully incongruous ornament in the form of swags of painted curtain has to be thought away – and cannot, as it is, spoil the firm, four-square harmony of its straightforward plan. Probably no elaborate decoration was intended. Whitewashed surfaces carrying a few beautifully bold flourishes of calligraphy in deepest black would be – and in certain parts of the building certainly are – decoration enough, enhancing its spacious air. Old in the sense of coming before

the architectural achievements of Murad's reign, the mosque represents a
type of building rapidly to be found old-fashioned, but in its own quiet
style it is assured and highly accomplished.

It cannot, however, prepare one for the unprecedented and also un-
repeated bravura of the 'Three-balconied Mosque', begun in 1438, twenty-
four years after the older mosque's completion. The excitement of this
begins with its four individual minarets of differing heights each differently
patterned in chequer-work, lozenges and twisting strips of reddish-pink
stone. These stake out, like giant pegs, the courtyard in front of the mosque, *18*
a long space of red and white striped arches reached dramatically through a
high doorway at the top of a steep flight of wide steps. This grand approach
and unexpected vista of grand courtyard must have seemed startlingly
new, though something of it can be seen foreshadowed in the layout of the
mosque at Manisa. By Sinan's time, the courtyard in front of a mosque, *10*
the use of flights of steps to approach it and the creation of soaring minarets
became standard features (though not until his own work was a minaret
built to rival the tallest of the 'Three-balconied Mosque'). At Edirne in the

18 Courtyard of the 'Three-balconied Mosque'

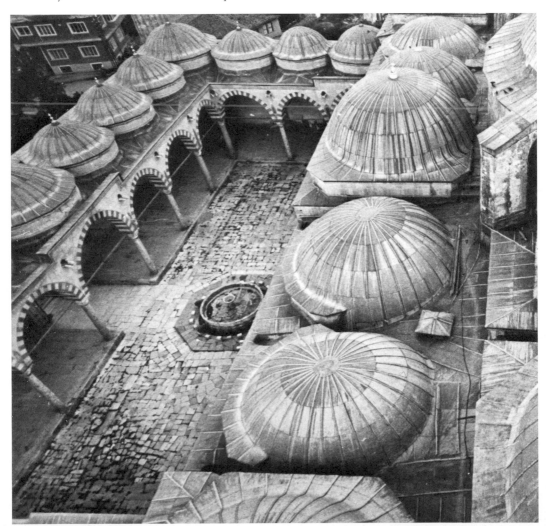

mid-fifteenth century nothing comparable had existed before; and the almost flaunting boldness of the mosque – bold in colour as well as design – still makes itself felt in the centre of the present-day city.

After the untrammelled extent of courtyard, the mosque interior (smaller, anyway) is disconcertingly shallow, restricted and rather oppressive. In fact, it represents the first centrally planned mosque of any real size. Yet what on the outside appears an ebullient grouping of smaller domes round a dominant central one (here supported by the device of flying buttresses) – a silhouette to become very familiar in Ottoman architecture – turns heavy inside, partly because of the crushingly low arches which make cavernous the area under the central dome. Still, the achievement is unmistakable. The next step is to raise the supporting arches, lift the dome higher and set it floating far overhead. Suitably enough, Edirne was to be the location of the ultimate development of this principle, in Sinan's imperial mosque.

More graceful Ottoman minarets than those of the 'Three-balconied Mosque' were certainly to be put up, but the vigorous, assertive quality of this varied quartet was perhaps never quite recaptured. The minaret as a form was no novelty, although in all very early Islamic mosques – except that at Damascus – there is only a single minaret. In different countries there grew up very different forms of what is basically a tower from which the Faithful are summoned to prayer: an essential construction which developed artistically far beyond its original purpose. Like the campanile, the minaret serves by its actual presence to proclaim the existence of a creed, symbolizing perhaps also that creed's lofty splendour and its inescapable, all-seeing, and even over-seeing, role in the life of man. The pointed minaret also happens to be the ideal complement to the swelling shape of the typical mosque – a combination virtually of Gothic and baroque which is still capable of pleasing in the humblest village version.

At Iznik and Bursa, as elsewhere in the Ottoman Empire, the minarets which today stand beside the early mosques are very often rebuilt or entirely later additions. Original or not, a pair was the most which was likely to exist – flanking the façade – before the idea of a courtyard became general. Four minarets always remained the mark of a royal mosque of special grandeur. It was a unique departure, though logical, when in the seventeenth century Sultan Ahmed I's Blue Mosque and courtyard received six minarets – a record never to be repeated.

The minarets of the 'Three-balconied Mosque' are not only an inherent part of its boldly innovatory plan but are in effect the public witnesses to it. Whatever they proclaim about faith, they also proclaim a new artistic achievement: thrusting higher into the sky than any Ottoman building had previously attempted four towers from which the Empire might be surveyed in every direction. They seem to announce a capital city. And though Murad himself, and members of his court, built other mosques in Edirne, nothing approached the scale, silhouette and bulk of the building guarded and given character by these mighty pointing fingers.

Much smaller and more remote is the Muradiye mosque which the Sultan built as part of the foundation of a Dervish order (and which was

64

19 Tiles in the interior of the Muradiye mosque, Edirne

rebuilt in the eighteenth century). The mosque itself is in plan an echo of what can be found in Bursa, but its deserted setting high on a hill helps to give it individuality. Dervishes or hermits might still find this a suitable spot, with its crumbling, grass-grown courtyard, its sense of detachment, and its wonderful view across to the worldly grace of Sinan's mosque. Inside, the Muradiye contains the delicate surprise of Chinese-style blue and white tiles, quite unlike the Green Mosque and Tomb faience, and *19* anticipatory (if they are really mid-fifteenth century) of later blue and white ware from Iznik. Nothing comparable is in any other mosque at Edirne.

The peaceful backwater air of the Muradiye on its hilltop might symbolize the essentially peaceful character of Murad II. His successor is better represented by the large-scale insistence of the 'Three-balconied Mosque'; like it, the new young Sultan proclaimed almost unprecedented assurance – in himself. On his father's death he returned hastily from Manisa, crossed the Dardanelles and, after pausing to allow suitable celebrations to be arranged for him in the capital, entered Edirne as Mehmed II early in 1451. Little more than two years later he had entered a new capital, Istanbul, so long the goal of Ottoman conquest, successfully stormed by him. Sancta Sophia was instantly transformed into a mosque at the Sultan's command and in his presence. He himself became the first great Sultan of history, Mehmed 'the Conqueror'.

The city that he had taken was already a work of art, yet it needed not merely conversion to Ottoman and Islamic requirements but positive new buildings to enshrine the new faith, new prosperity and its new significance as the Sultan's capital. Mehmed II gave as much personal care to achieving this as he had to seizing the city. It was he who began the Grand Bazaar on its present site and he who chose Seraglio Point for building the palace which is now the Topkapı Saray. Above all, the rise of Istanbul coincided broadly with the new achievements of Ottoman art.

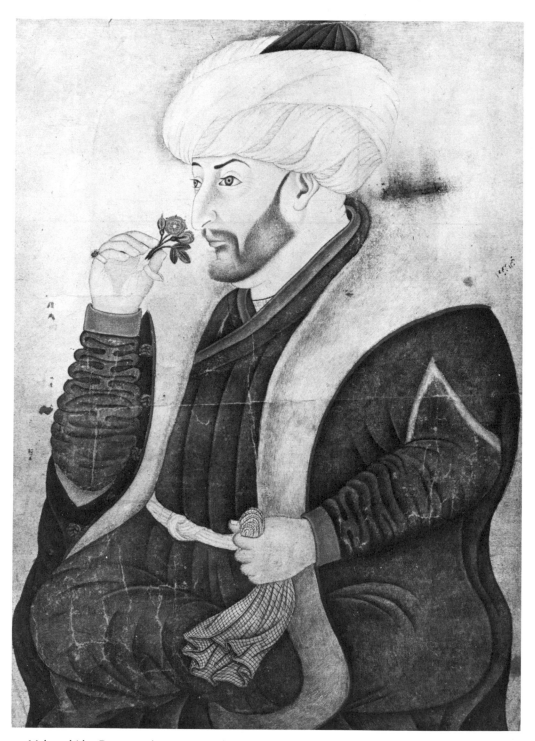

20 Mehmed 'the Conqueror'; portrait attributed to Sinan Bey

2 Istanbul: creation of a new capital

We know the city taken and turned into a capital by Mehmed 'the Conqueror'. It was already world-famous: an ancient, imperial, maritime centre on a superb site, but grown poverty-stricken, under-populated and partly ruined by the time it fell to the Ottomans. Yet, even in that state, it proved an inspiration rather than incitement to destruction; and one of the Sultan's small but significant first acts on entering it had been to prevent a soldier from hacking up the marble floor of Sancta Sophia.

Instead of destroying the old Christian city, Mehmed re-created and reanimated it, making it once again truly the centre of a great empire. And for the first time its site was to be fully exploited, as domes and minarets rose in silhouette on the crests of its hills. What he began, later sultans were to continue. The result is in the Istanbul of today, where – compared, say, to London or Paris – little has been radically altered, though much added, since the fifteenth century. Mehmed 'the Conqueror' might marvel if he returned, but the fixed points of the city he knew – some of them set by him – remain remarkably the same.

It happens that we also know the Sultan much better at least than we do any of his predecessors. His appearance is probably the first at all authentically recorded likeness of any Ottoman ruler, and the vivid miniature of him traditionally attributed to Sinan Bey indicates as well a new aspect of art, one much encouraged under Mehmed II. Even if this is not a fifteenth-century picture, it is an acceptable likeness. Other portraits confirm the Sultan's commanding, rather crafty physiognomy, with hooked nose and arched eyebrows, but hint also – as does here the exquisite gesture of smelling the rose – at his connoisseurship in sensations. *20*

In Mehmed II met all the fairy-tale requirements for an Oriental potentate, even down to abrupt emergence as a gifted young ruler after a feeble, perhaps miserable, childhood. The humiliation of being unable to manage the Empire when his father abdicated must have marked him deeply, and it is scarcely too fanciful to suggest that he was determined to wipe out memories of his youthful ineffectualness by proving himself the strongest of all sultans. The simple title of *Fatih* (The Conqueror) was given to him alone in the whole dynasty, though a few other sultans were to be called conquerors of particular places. He alone was also called 'Father of Conquests.'

His military ability, in organization as well as in fighting, was only one aspect of strength – if not positively violence – of character. He ruled as resolutely as he fought. Other titles that were usually honorifics of a sultan became realities under him; he was the Dominator and the Commander of the Faithful, creating a personal authority much more extreme than that

of his predecessors, absolute instigator of severe laws and at times capriciously cruel. He stipulated that future sultans had the right to execute their brothers on accession, 'for the order of the world'. The order of the world, as he saw it, included intense pursuit of his own pleasures. As well as the traditional female harem, he had a notorious predilection for beautiful boys, some of whom, however, seem to have preferred death to him. He cultivated other tastes – for literature, languages and the visual arts. Western artists were welcome at his court; the painters Gentile Bellini and Constanzo da Ferrara, the latter better known as a medallist, both made images of him which probably influenced native depictions. Not content with being a lover of gardens, like so many of his countrymen, the Sultan was himself a gardener; he is recorded as having spent his leisure between campaigns at work in the various palace gardens – a final, agreeable touch in a complex character.

The most public and most useful art Mehmed patronized was architecture. He was anxious to repopulate Istanbul, activating as well as beautifying it. In building a major mosque-complex, two palaces and a bazaar, he provided virtually the main constituents of a royal Ottoman city. He had already built the fortress of Rumeli Hissar on the shores of the Bosphorus, a European-style castle which had been the key place for assembling his troops before besieging Istanbul; and some other towers and fortresses were to be put up by him to protect the city he had taken. Rumeli Hissar may make a picturesque stop on a boat-trip up the Bosphorus, but it has little to do with Ottoman art. It is chiefly notable because Mehmed himself is said to have taken a hand in its actual construction – presumably to set his workmen an example and yet also perhaps because of his eager, constant concern with building and buildings. We know that he assembled at Istanbul masons and stone-cutters, selected materials, inspected and even directed building operations. Some contemporary rulers in the West – like his opponent Pope Pius II, who dreamt vainly of a crusade to regain Istanbul – might take a comparatively active interest in architecture, but seldom on the scale of the Conqueror's plans.

At first Istanbul did not become the capital. The government remained at Edirne, where Mehmed completed his father's palace with a massive pavilion topped by a polygonal tower containing an observation-room or possibly an actual observatory. There is something suitably all-embracing about the building's name, 'World-view Pavilion'. A retreat for the Sultan, it was also perhaps a stimulus to his increasingly global ambitions. In the penultimate year of his life, he stamped his foot savagely on the heel of Italy and captured Otranto. The next step was presumably to move up the peninsula and for the conqueror of Constantinople to seize Rome. He was also planning, it seems, expansion eastwards, assembling an army to advance into Asia. But Mehmid died suddenly in 1481, at the age of forty-nine, a victim officially of gout, conceivably of poison.

Perhaps, like several later sultans, he preferred Edirne as a residence, but Istanbul was his monument and inevitably he was the first to be buried there. What buildings already existed in the city, however dilapidated, must have been a challenge not only in their grandeur but in their imperial

21 Istanbul in the mid-16th century; engraving by M. Lorichs showing the original Fatih complex

associations. For his own mosque and its numerous dependencies, Mehmed chose a prominent hill site occupied by Justinian's Church of the Holy Apostles. Materials from this ruined building, where the Byzantine emperors had been buried, were incorporated into the Sultan's mosque. He himself was to be buried just behind – a piece perhaps of deliberate association once again with Istanbul's long imperial past. Although the original Fatih mosque had to be rebuilt after an earthquake in the eighteenth century, early engravings confirm its massive shape, bulking high along the *21* city's skyline, very much as the later building still does today. It was the first major piece of Ottoman architecture in Istanbul and something of an assertive complement in silhouette to Sancta Sophia at the other end of the city.

Nothing as vast as the Fatih complex had been attempted before in *22* Edirne, Bursa, Iznik, or elsewhere, and vastness remains its over-all effect in a city not now lacking in large-scale buildings. The rows of multi-domed dependencies which lie along the hillside, the huge arcaded courtyard, avenues, archways and steps, all on entering suggest a miniature city – one inside which there seems always plenty of human activity – and this to some extent is what the Sultan created. Within the complex were not only the traditional soup-kitchens, baths and a hospice for travellers but the most

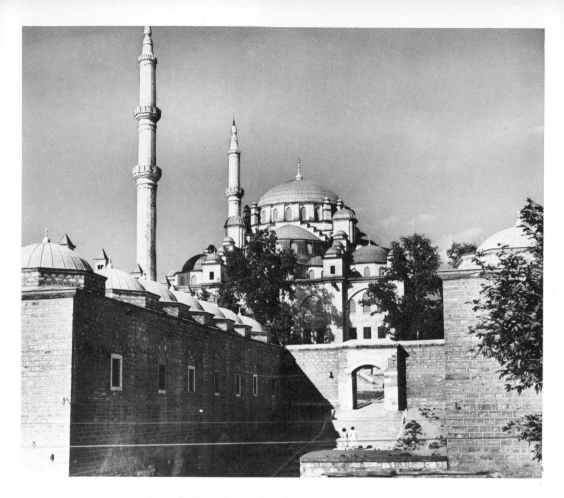

extensive of all medreses (teaching jurisprudence in addition to theology), as well as a big leather-market. Caravans of considerable size could be accommodated there. When every building fulfilled its original function, a complete life could have been lived within the Fatih agglomeration. Once again, there is some analogy with the larger units of Western monasticism; just as with those, the true focal point is the place of the worship.

22 Everything in the Fatih complex was exceptional for size and scale, and the dome of the mosque was the largest the Ottomans had yet built – larger
17 even than that of the 'Three-balconied Mosque' of Edirne. With this new sense of sheer monumentality went a new severity. The Fatih mosque was probably never remarkable for gracefulness or decoration, but its achievement lay in providing a tremendous space of unified domed prayer-hall, far more sophisticated in its spatial planning than the Great Mosque at Bursa and far more grandiose than the Green Mosque there. Originally there may well have been hardly any faience tiling, and even what now exists is very discreet.

 Its setting and approach remain among the grandest ever to be devised, making splendid use of the inclined ground, and the effect is quite without that rather casual air of having been planted down of some of the greatest, later mosques. At Fatih the mosque is planned to be at the very centre of its complex, reached after climbing past an outer line of subsidiary buildings

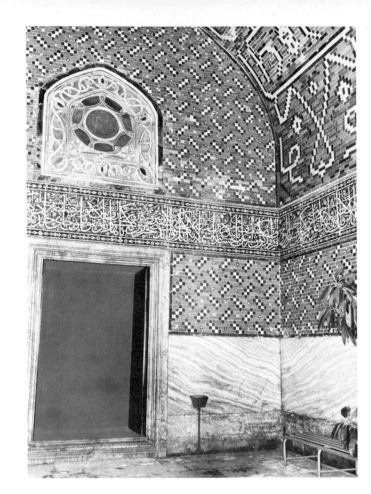

22 (*left*) View of the Fatih complex today

23 (*right*) Tiled decoration of the entrance to the Tiled Kiosk

24 (*below*) The Tiled Kiosk, Istanbul, built during the reign of Mehmed 'the Conqueror'

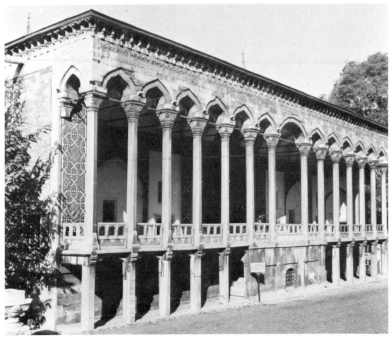

to the platform where a courtyard of size equal to the mosque prepares the worshipper for quitting the noisy world of caravans, soup-kitchens and so on, to enter a space of mental and physical tranquillity. Thence onwards the concept of an arcaded courtyard in front of a mosque – proposed first at Manisa, and formulated at Edirne – became standard.

The Conqueror's eye for a dramatically effective site seems confirmed by his selection of Seraglio Point for a palace, still one of the most beautiful of locations. In fact, what was put up there was his second palace in Istanbul, the first being built much more centrally – almost exactly half-way between Sancta Sophia and the Fatih complex – on ground now occupied by the University. As well as the near-by Bazaar, the Sultan built barracks for the Janissaries and, outside the city, close to the Golden Horn, the first mosque of Eyüp, to commemorate this companion of the Prophet; like so much of the actual fabric of Mehmed's buildings, both barracks and mosque disappeared before modern times. Associating him architecturally with a certain massive forcefulness, and with the large-scale, increases the un-expected aspects of one of the rare buildings to survive approximately as 24 he knew it, the Tiled Kiosk in the grounds of his Seraglio Point palace.

Nothing could be less monumental than this pavilion, built in 1472, and now almost the earliest existing building of its royal, secular kind. Enchant-ing, elegant, slight-looking though actually quite extensive, the pavilion suggests the other side of the Sultan's character, with its almost wantonly 23 sensuous decoration of patterned tiling of alternating blue tones, inside and out. Set in vestiges of what was once probably a garden of paradisal nature, it appears virtually a rococo product, a *turquerie*, rather than typical of its true period. Nor, as far as can be judged, was anything stylistically com-parable to be built – still less to be decorated – in a way so strongly suggestive of central Asia and Timurid taste. That it has ended up as a museum of ceramics is certainly suitable, since its rooms by themselves are partly dis-plays of ceramic decoration.

If earlier Ottoman palaces included kiosks like the Tiled one, their disappearance is all the sadder. Although a museum and more than once restored (slim stone pillars thus replace the original wooden ones along the narrow portico), it retains a sense of being both habitable and unchanged. It is a suite of first-floor rooms, not a complete palace, a place almost to be occupied only as the mood might take one, raised above but accessible on all sides to its garden surroundings and looking out at the back towards the Bosphorus. Rooms with white plaster ceilings and high-arched porch-like windows lead off regularly on all sides from the central, domed area. Their whiteness and brightness excitingly contrast with the dark glazed walls of alternating deep blue and black tiles, cool in summer heat but also rich enough to suggest snugness for a winter retreat – and indeed prominent, pointed fireplaces occur in the rooms. Easily enough can one imagine Mehmed II relaxing here, having achieved something as islanded from the rest of Istanbul as his palace at Edirne was from that city.

Around the Sultan were men often no less cultivated, some his personal favourites, fond of the arts and patrons of architecture who left their own, normally smaller, monuments in the new city, ranging from a fountain to a

25 Mahmud Pasha's
tomb at Istanbul

mosque. One of the bigger complexes was built by the Grand Vizier
Mahmud Pasha, himself a poet, and a protector of poets and musicians.
His mosque and baths survive, and also his tall, octagonal tomb with a tiled
exterior, untypical again of future Ottoman taste but rather similar to the 25
inlaid effects of the Tiled Kiosk; it is perhaps no accident that the tomb dates
from only one year after the kiosk. Every improvement to the city was
doubtless encouraged by Mehmed. Several of his ministers built mosques,
as did also his Master-Gunner. The practice of setting up pious foundations
(*waqfs*) resulted in a steady series of public buildings and services being
constructed and maintained. Mosques, almshouses, schools and hospitals
were often created through these deeds, which had to receive government
approval.

A map of Istanbul from about the turn of the fifteenth century shows the
city crowded with new buildings. The 'old' palace on the present-day
University site still existed. The large area occupied by the grounds of the
'new' palace – now the Topkapı Museum – was already walled round and
contained within it a number of pavilions. Baths, bazaars, fountains and
mosques – especially the dominating bulk of the Fatih mosque complex –
all must have subtly changed the character of Istanbul, even while bringing
it back to active life. It might have seemed that there were few spots left for
fresh buildings; and it is scarcely surprising that another of Mehmed's
ministers, Rum Mehmed Pasha, by birth Andrew Palaeologus, a member of
the Byzantine imperial family, should have chosen to build his mosque
away in the Üsküdar suburb, across the Bosphorus on the shores of Asia.

No single phrase will serve to sum up the architectural style practised under Mehmed II. But the imposing massiveness of much that was then built is unmistakable. Ambition to pile stone on stone, creating unprecedently bold monuments, seems the keynote. And yet, in a way, it is interim work, at least as far as mosque-design is concerned; the problem of achieving a balanced, totally luminous and unrestricted interior, on a large scale, still remained. A significant advance was to be made under Mehmed's son, Beyazid II, a great builder but also something of a puritan, it seems, where the other arts were concerned. Not for nothing was his title to be 'the Pious'. There are stories of his selling the *objets d'art* his father had collected and even destroying Italianate frescoes in his father's palaces. Yet Beyazid is also recorded – and perhaps more reliably recorded – to have had in his employment no fewer than ten painters. Maybe it was only in comparison with Mehmed II's Epicureanism that he seemed austere.

The years covered by the reigns of father and son – Beyazid lived until 1512 – are those when something much more distinct begins to emerge about several arts of which painting is only one. Such emergence cannot be credited directly to the taking of Istanbul, but the establishment there of the expanding capital and the sultan's fixed residence in a palace where treasures of all kinds could accumulate over the centuries, meant that Istanbul became the focal point for consumption as well as production. The city was never, for example, to produce in its own Golden Horn factories ceramics equalling those of Iznik, but its demands on the Iznik kilns stimulated, and eventually exhausted, their inventive brilliance. Conversely, the textile industry – originally concentrated at Bursa – was successfully set up also at Istanbul after the conquest, and certain types of fine satin, tricoloured cloth and interwoven gold and silver brocade became splendid specialities of the capital. Where the sultan and his court were settled was bound to become the artistic centre. Just as with court patronage elsewhere in the world, the fashions set by the ruler were likely to be followed by the leading figures around him – perhaps not reluctant sometimes to rival him in patronage; thus the most sumptuously tiled of all mosque interiors are not imperial ones but those commissioned by grand viziers.

The artistic culture fostered under Mehmed II – and probably not significantly discouraged under his son – has, in visual terms, to be reassembled from scattered evidence. We must refurnish the settings in which the Sultan moved, and add his personal possessions, including clothes and armour, which are very much part of the period's art. No interior exists today carpeted as it would have been when Mehmed or Beyazid sat within it, the former turning perhaps the pages of some album of miniatures, the latter more probably meditating a poem of his own – for, like other Ottoman princes, including his brother Prince Cem, he was himself a talented poet.

Although the settings must have been splendid enough in total effect, the individual objects are often, if not quite austere, at least severe and geometric in pattern compared with the literal flowering of designs in the full sixteenth century. A certain stiffness in the splendour may be detected, where later ages would prefer more supple, more sheerly virtuoso, often

1 Mihrab niche in the Green Tomb at Bursa

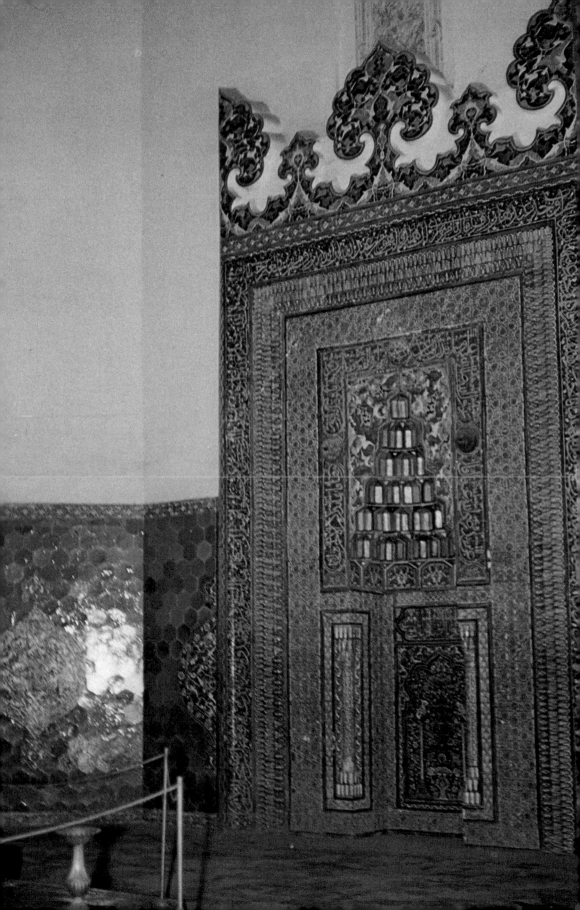

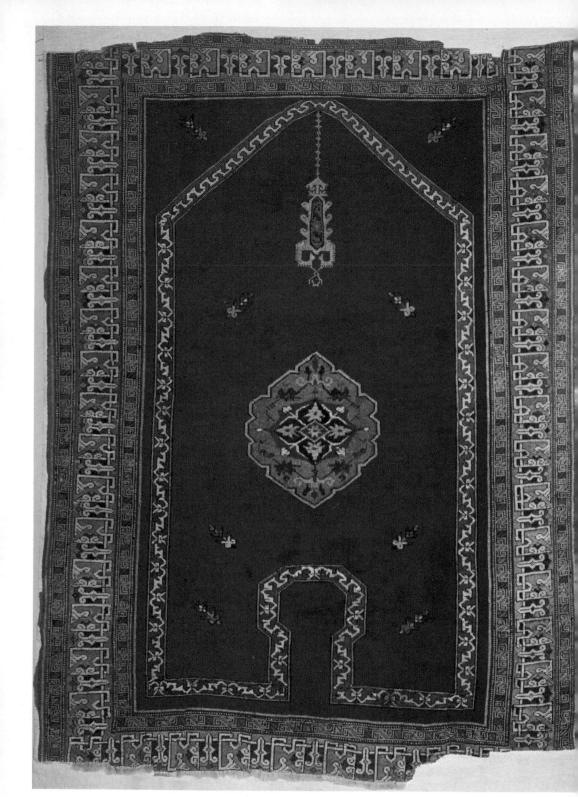

more naturalistic, motifs and patterns, as well as yet richer combinations of colour.

There was not – could hardly be – one single artistic style under which everything from mosques to caftans was subsumed. The conquest of Istanbul marked the beginning of a new Ottoman era which had artistically to develop its own idiom – virtually to forget, as it were, Bursa and become totally oblivious of Konya. At the same time, there was something to be learnt architecturally from the Byzantine city captured. There was a vague internationalism in the other arts encouraged by the Conqueror, whose artists came from Europe and from Asia. Early blue and white Iznik ware suggests a strong Chinese influence. The exterior faience of the Tiled Kiosk seems Timurid-style. Timurid, Chinese and Persian character can be detected in the miniatures. A Western-style, naturalistic medallion of the Sultan was produced by Constanzo da Ferrara. But none of these hints of stylistic dependency was to be acted on profoundly, because Ottoman art developed its own 'Ottoman' character. It largely ceased to owe anything to Chinese or Timurid art, and not again for some two centuries or more did it show any real response to European example.

An interior, whether of mosque or palace, would have been almost furnished when it was carpeted. And carpets were perhaps the most truly indigenous artistic products of the period, recognized and prized in Europe as well. The earliest Anatolian rugs showed highly stylized patterns of animals or birds; today these rugs survive best in European pictures (one as early as about 1384). Gradually, it seems, geometric patterns replaced birds and animals. Stars and lozenges, rosettes and arabesques – in yellow, blue, green, red or white – pattern the carpets contemporary with Mehmed II. By early in the sixteenth century Turkey carpets appear in Venetian paintings and the term itself occurs in English by 1546; well before that Cardinal Wolsey received sixty Turkish carpets. Rich colour – often, though not always, including a glowing, powerful red – is combined with a deliberate restriction of angular, abstract motifs in prayer-rugs which may skeletally suggest the mihrab niche, a lamp suspended within it. Compared with the conventional and not so erroneous idea of a typical Persian carpet, this early Ottoman example could be called architectural rather than *II* floral, making its impact by boldness rather than elaboration. It is rapidly 'read' in contrast to the extreme, jungle-like efflorescence of the finest Persian carpets, amid which birds may perch and gazelles graze – nervously graceful fauna strayed from the pottery or the intensely refined and rarefied miniatures of Persia. Beside that wantonly fragile imaginative ethos of almost exaggerated sensibility, Ottoman works of art – miniatures especially – may at times appear straightforward to the point of being prosaic. In fact, part of their sensuous quality lies in their boldness and directness.

The very rug illustrated here starts by being an expanse of deep, 'Turkey', red: a pool of sealing-wax still warm and uncongealed on which the patterns seem economically stamped – central medallion, black and white narrow outline of mihrab, wide border of entwined, angular, Kufic lettering – positively to enhance the over-all sense of total, lambent redness, as if lit from within. Such a carpet might well appeal to any painter,

II 'Bellini-style' prayer-rug, early 16th century

Eyüp

■ 9

Golden Horn

■ 24

■ 8

■ 10

Atatürk Bridge

■ 23

Galata Bridge

Seraglio Po

■ 22

■ 11

■ 21

■ 20

■ 12

■ 19 ■ 18

■ 17

■ 16

Sancta Sophia ■ ■ 13

■ 14

■ 15

S e a o f M a r m a r a

0 0·5 1 2 kms

ISTANBUL: Map showing principal monuments mentioned in the text

1 Mihrimah ('Jetty') Mosque

2 Valide Mosque

3 Mosque of Selim III

4 Beylerbey Palace

5 Dolmabahçe Palace

6 Yıldız Park

7 Rumeli Hissar

8 Nusretiye Mosque

9 Piyale Pasha Mosque

10 Azapkapı Mosque

11 Yeni Valide Mosque

12 Topkapı Saray

13 Fountain of Ahmed III

14 Ahmed I ('Blue') Mosque

15 Sokullu Mehmed Pasha Mosque

16 Nuruosmaniye Mosque

17 Beyazid II Mosque

18 Laleli Mosque

19 Pertevniyal Valide Mosque

20 Şehzade Mehmed Mosque

21 Süleymaniye complex

22 Rüstem Pasha mosque

23 Fatih complex

24 Mihrimah mosque

26, 27 Two caftans traditionally associated with Mehmed 'the Conqueror' and his son Beyazid II

especially a Venetian one. That a closely similar carpet should be seen at the feet of the Doge of Venice and other dignitaries in a picture by Giovanni Bellini, Gentile's brother, is doubly apt.

A certain restrained, choice splendour marks other artistic objects of the period, the pottery particularly. This was not yet extensively multi-coloured; it lacked notably the tomato-red occurring in the most familiar Iznik pottery. Its designs tended to be formal rather than naturalistic, sprigged lightly when floral, and quite without the big jagged tongues of curling leaves, spiky tulips and fringed carnations which animate so much of the later ware. Something of the same distinction can be seen in com-

26, 27 paring two caftans, traditionally those of Mehmed 'the Conqueror' and of his son Beyazid. Beyazid's opulent garment almost writhes and bristles with motifs of interlaced leaf, fruit and bursting, full-blown blossom, suggesting pomegranates and peonies. No less intentionally opulent is the caftan associated with Mehmed, but its repeated diapered design is much simpler in every way and as a pattern does not avoid monotony.

There are restrictions amounting to limitations in a good deal of the early Iznik ware, when perhaps a distinct style as such was – consciously or not –

28 being sought. A bowl, a jug, an ink-stand or a mosque lamp – all typical forms – would have been made usually in a blue and white ware very much under Chinese influence. The sultan's palace inventories show that Chinese porcelain was accumulating there around the turn of the fifteenth century; by 1505 twenty-one pieces had been collected, whereas in 1495 the number

29 was only five. A single fine bowl of early Iznik ware seems, and probably was, sufficient ornament for a room; and though at first glance its exterior might suggest almost too patent a homage to Chinese example, the

54

28, 29 Early Iznik ware; a mosque lamp (*c.* 1500) and a bowl (early 16th century)

interior of clear-cut cobalt-blue ogee shapes declares its true origin and has even a hint of characteristic architectural flair.

To the pottery, textiles and carpets from the early years of Istanbul must definitely be added painting, even though at first several painters were foreign and the most remarkable surviving album of miniatures – supposedly belonging to Mehmed II – is overwhelmingly influenced by Timurid and Chinese art. Just as Chinese porcelain reached the sultan's palace, so Timurid manuscripts came to Istanbul, brought thither by an exiled prince from his father's library. It is also impossible to forget a permanent Persian influence; and Persians were among the mid-sixteenth-century court artists. Earlier, there are mentions of local native painters (one from Bursa is said to have worked for Mehmed's father) but it seems right to see the first significant patron in the Conqueror himself. And the portraits of him already point to an Ottoman preference, which would increase, for the factual rather than the fanciful, for history rather than poetry, to be illustrated. The story of battles, the appearance of a city, the occasion and celebration of festivals – such become typical subjects. Fables, legends and other stories are also illustrated; yet it seems suitable that one of the early illustrated manuscripts dedicated to Mehmed II should be a book of surgery, with graphic miniatures for instructional purposes. 20

Factual subject-matter does not preclude imaginative freedom in treatment. Some of the almost harsh grasp on actuality results in witty effects; and the colours – as might be expected – are often stunningly brilliant and strong. The pages glow like stained glass on a small scale, with little of the patterning and over-patterning which can make precious – in more than one sense – Persian miniatures. The Turkish taste for realism is what is

sometimes said to characterize the Fatih album miniatures, many of them
the work of an artist whose nickname was 'Black Pen'. A marvellous minia-
30 ture like the *Procession of Falconers* is, however, far too subtle to be called
realistic and it actually displays a calligraphic delicacy not at all typical of
later Ottoman painting. Indeed, the artist may well not be Turkish. The
frieze of differently coloured, lively horses – with its suggestion of gradual
ascent up a stony hillside – is intensely sophisticated in drawing, and rather
wintrily coloured in greys and browns.

Other miniatures in the album confirm the sophistication and especially
the keen observation of animal life which extends here beyond the horses
to the economic, arched shape of the droopy dog and the exuberant fore-
ground leopards who seem safely couched despite plodding mankind
close by. Elsewhere 'Black Pen' appears to find human beings as absurd as
animals are sympathetic. Later Ottoman painters certainly produced some
enchanting animals of their own, but never achieved quite the blended
grace and strength of the best Fatih album miniatures. If the Conqueror
really owned these (as is by no means established), he would certainly have
appreciated also their Western equivalent in the work of Pisanello.

Whether or not there were Italianate frescoes which Beyazid was to
destroy at his accession in 1481, there must have been from early on painters
who were qualified to execute decorative work in buildings. Interiors were
probably to modern taste disconcertingly coloured and patterned, with
niches and archways and vaults picked out in an elaborate way. The tomb
where eventually Beyazid's brother and rival, Prince Cem, was buried
provides a presumably authentic example of such highly coloured, calli-
31 graphic richness, the last distorted echoes of which lie in the often ghastly
modern decoration of mosque interiors. The original style of mural
painting, in which writing plays a prominent part, is really related to

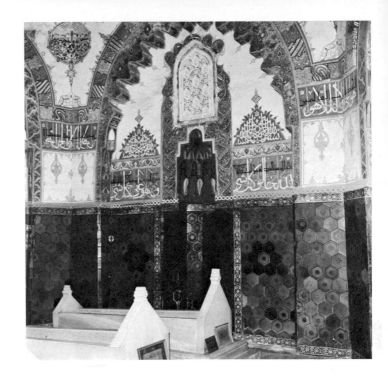

30 (*left*) Miniature of
Procession of Falconers, by the
artist known as 'Black Pen'

31 (*right*) Interior of Prince
Cem's tomb at Bursa

32 (*below*) Examples of Sheikh
Hamdullah's calligraphy
(*Thuluth* and *Naskhi*)

another aspect of Ottoman art, calligraphy as such – an art always esteemed
in Islam much more highly than painting.

Perhaps this truly indigenous and partly sacred art appealed to Beyazid
more than representational pictures. He himself was taught calligraphy by
the greatest master of the period, Sheikh Hamdullah, who created and
codified various styles and was responsible for the inscription on the main
doorway of the Sultan's mosque at Istanbul. The Sheikh produced also a
number of Korans and other manuscripts, signing them as his work, and
it is easy to admire as a piece of virtuoso penmanship his flowingly bold
writing, where angularity has been replaced by a literal cursive of nearly
musical fluency. Beyazid's respect for his great teacher is recorded by a
notable act of Ottoman royal condescension: while the Sheikh drew, the
Sultan would hold his inkpot.

32

ورو غان الثعلب وصبر الكلب على الجراة

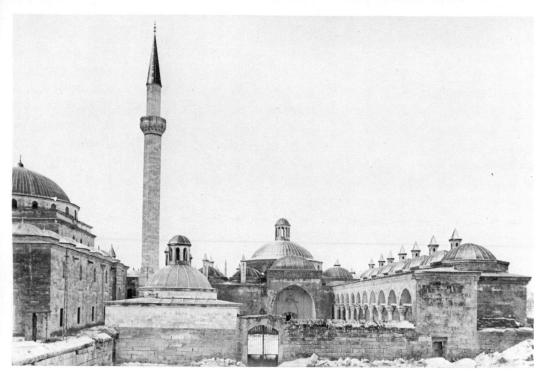

33 The complex of Beyazid II at Edirne

Nevertheless, it is as a patron of architecture that Beyazid is most remarkable. Major buildings at Amasya and Edirne, culminating at Istanbul, reveal something of his passion and, probably, his consistent use of the same architect. Other work commissioned by him exists elsewhere. Ironically, for a ruler with such a serious interest, his reign saw Istanbul devastated by an appalling earthquake, in which the architectural casualties included 109 mosques and the dome of the Sultan's own newly built mosque, as well as the walls of the Topkapı Saray.

Beyazid had been Governor of Amasya (Sheikh Hamdullah's native city) before he came to the throne and it was there that the first of his complexes was completed, with its mosque at the centre. The plan aims at a unified interior, with two high domes closely linked to give a sense of light-filled space. More important and always much bigger was the still-surviving riverside complex at, or rather outside, Edirne – in setting, scale and preservation perhaps the most impressive of all such groups of buildings. Doctors, surgeons, oculists and a dentist were among the large staff Beyazid required in his deed of foundation. The establishment included an asylum as well as a hospital and a medical school. At some later date treatment included frequent concerts each week for the inmates – not necessarily an Ottoman novelty in dealing with the mad or depressed; only about *33* three years before Beyazid began his Edirne complex, music had been tried as a cure for the deranged painter Hugo van der Goes in the monastery he had entered.

Although the low-lying ground at Edirne offers no striking advantage of setting, it allows for coherent planning and close relationship of each

building to the other; the sense of organization is in this way tighter than elsewhere, and emphasized by the walls surrounding the whole complex. Nothing in the flat countryside interferes with the concentrated grandeur of the grey, stone silhouette, made up of regular massed domes all dominated by the steep cube of mosque topped by its own quite shallow-seeming dome.

The mosque itself occupies a comparatively small area of the whole complex (after all, it is only the foundation's chapel, as it were) and proves less exciting than the broad pillared courtyard in front of it where the plaster interiors of the small cupolas are unexpectedly whorled or twisted into shell-like shapes. But inside, the mosque has its quiet surprise. The dome springs powerfully upward from the walls, arching high over the whole interior in one single sweeping curve, with a sense of new achievement. And in the centre of Istanbul, Beyazid and his architect (possibly but not certainly the same as at Edirne) consolidated that achievement in an imperial mosque, on an imperial scale. There is no overlooking the imposing exterior of this building, with its two tall but widely spaced minarets *34* flanking a buttressed dome, approached through grandiose, finely wrought gateways.

If the sober, rather dark interior cannot quite sustain the promise from outside, it nevertheless provides a new spatial effect by balancing half-domes on two sides of the main dome – derived from the example of Sancta Sophia. Sinan was to do more, much more, with the device, inside and

34 The Beyazid II mosque in Istanbul

out. Yet the Beyazid mosque altogether represents the prototype of what was to follow, not least in its beautifully finished details and use of marble as well as stone. Only by the standards of what Sinan and his successors would achieve is it prosaic or ordinary; and it enjoys what few of the later great mosques have, an effectively open piazza-style approach to emphasize its monumental character.

The earthquake of 1509 which brought the collapse of its dome was only one of several portents, physical and political, clouding the end of Beyazid's long reign. At the time of his father's death he had not been too pious or unworldly to take every step to keep his energetic, gifted younger brother, Prince Cem, from seizing the throne. The defeated Prince ended his days as a prisoner in Europe, Beyazid paying well for his retention there though burying his body in a splendid tomb at Bursa. By 1511 the Sultan seems to have been willing to abdicate, if he could choose which of his three sons should succeed him. But the viziers and Janissaries disputed his choice, preferring his youngest and most ambitious son, Selim. It was Beyazid's turn to be defeated. In 1512 Selim seized Istanbul and deposed his father. The ex-Sultan set off for his birthplace of Dimetoka, but died on the way, possibly at his son's orders.

The character of the new ruler, Selim I, may seem succinctly conveyed by his epithet, 'the Grim'. His ambitions were summed up in a letter announcing that he intended to be another Alexander the Great, ruler of the East and the West; if he did not quite achieve that, he enlarged the Ottoman Empire to take in both Syria and Egypt (thus becoming Caliph as well as Sultan), fought hard against Persia and executed his own chief ministers with speed and regularity.

Not much would be built in such a reign. Yet the Sultan was probably less wantonly cruel than his grandfather, the Conqueror, from whom he had perhaps inherited rather a love of learning. Himself a poet, he was by no means indifferent to culture. When he occupied Tabriz, it was a levy of skilled craftsmen (a thousand of them) that he required, most of them doubtless sent to Istanbul. Even the imperial collection of Chinese porcelain benefited from his conquests; the twenty-one pieces listed in his father's time had by 1514 become eighty-three. Still, these were by-products of an essentially warlike and fairly brief reign. It was under his son, Süleyman 'the Magnificent', that a great artistic age was to begin, an age associated especially with the architectural achievements of Sinan, whose career had unexpectedly begun by fighting in Selim's foreign campaigns.

3 The Age of Sinan

The middle years of the sixteenth century belong historically to Süleyman, 'the Magnificent', probably the greatest of all sultans, but artistically they belong to Sinan, the greatest of all Ottoman architects.

As artist and patron the two men deserve to be linked together at least as much as, say, Bernini with Pope Urban VIII. Though Sinan was, in official phraseology, 'Architect of the Abode of Felicity', he was also very much more: designer and inspirer of buildings and engineering works throughout the huge Empire, clearly a strong, respected personality – and a long-lived one. He did not die until 1588, reputedly aged one hundred and undoubtedly very old. Like Bernini, he survived his best-known patron, whose tomb he built, and went on to serve that patron's successors. Sinan will always be thought of primarily as the architect of the vast Süleymaniye mosque-complex at Istanbul – his most famous and familiar achievement – and it seems fitting that he should be buried near by, in a tomb designed by himself. Something of his status is indicated by the fact that in old age he dictated autobiographical writings, very briefly but acutely summing up the main stages of his own career.

Yet although Sinan dominates the age artistically, he represents only one aspect – major though it be – of the period's confident artistic achievements. Any uncertainties, stylistic wavering or technical faltering disappear from the arts of an age no less accomplished and brilliant than its High Renaissance equivalent in Europe. Just as there, command of materials seemed newly confident and totally complete. Every category of art benefited.

It was now that the Iznik factories evolved tiles which were never to be equalled in range and depth of tone, richness and variety of pattern – making it possible to sheet the interior of a whole building with this gleaming decoration. A new colour, a red between tomato and flame, was introduced around the mid-century, so viscous that it slightly stands out in relief from the rest of the design; the colour was perhaps inspired by that of the wild tulip, itself probably the 'red lily' noticed by a sixteenth-century traveller in Turkish gardens. This colour glaze was not to be paralleled elsewhere, despite attempts. With the addition of it, the standard Iznik palette was virtually complete. No longer were the tiles, plates and jugs restricted to pastiche effects of Chinese blue and white, no longer restricted even to the more typically Ottoman combination of blues, purple and olive-green. The bold new colour – showing the character of its inventors perhaps by its boldness rather than refinement – contrasted excitingly with the previous predominantly cool tones and shone out against the lustre of white backgrounds.

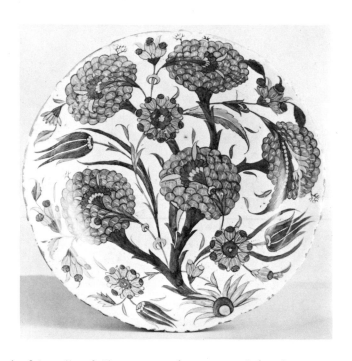

Wonderful walls of tiles were to be – one might almost say – woven round rooms, always preserving a strong sense of formal pattern and balance. Wilder, more reckless-seeming, were the jugs, bowls and particu-

35, III larly plates which began to be produced, where every motif is floral and the main area is swept by curling stems of sprouting carnation, hyacinth and tulip, vigorously conceived as growing there but entwined in artistic, not naturalistic, pattern. There is an almost shocking boldness about such effects, often so similar and yet rarely the same, both in colour and design – and utter confidence in the result.

Everywhere in art there was comparable confidence and something new – nearly always richer – to report. Control of line and display of colour remained the basic goals, and could be achieved with an easy, supple virtuosity, from which all striving is absent. The preferred geometrical basis of carpet designs was reinterpreted to give a much more complex sensation to the eye. The prominent star and medallion motifs of Ushak

36 carpets (manufactured at Ushak in southern Anatolia, not far from Konya) occur amid over-all flower patterns, and there seems no end to the permutations of reading the design. Now the blue diamond- and spade-shaped medallions touch and float over the strong red ground like stylized snow-flakes, each medallion containing its own interlocking series of concentrated motifs. Now it is the ground which predominates, seen to be not loosely scattered with flower-heads but supporting in effect a trellis-pattern on which are stretched and pinned tight sprays of regular leaf and blossom. Richer surfaces (of velvet-like bloom) and more richly, naturalistically, floral designs were to come later in the century with the suitably named Ottoman Palace or Court carpets: luxury objects for a frankly luxurious age.

35 (*left*) Iznik ware; an example from its greatest period, the mid-16th century

36 (*right*) A rug from Ushak (end of the 16th century)

Extremes of visual brilliance were to be reached in manuscript illuminations done in the reign of Süleyman's grandson, Murad III, a lover of fine books and the last sultan for whom Sinan worked. But the miniatures painted in Süleyman's lifetime are strongly coloured, even if they lack the sophistication and gilded splendours of later work (often illustrative of events in his own reign). Delight in radiant colour was to be typified by another medium, glass, no novelty in itself to the Ottomans but newly developed in the stained-glass window – at least as created for the Süleymaniye by the craftsman who signed himself Ibrahim 'the Drunkard', intoxicated perhaps by his own achievements. Little unrestored early stained glass has survived, and it must always have been less elaborately patterned than, say, the finest carpets or Iznik faience. Its technique was mosaic-like, set in plaster framework, always less large-scale than in the West and at times perhaps rather garish. Yet the appeal of the medium to a culture that loved light and colour is obvious; and a mosque which has lost its original glass is robbed of a certain mystery, as well as splendour.

If the jewelled effect of stained glass represents, with jewellery itself, love of colour at its most patent, the equally instinctive feeling for design is best represented perhaps in the imperial calligraphic emblem, the 'tuğra', a long-established traditional monogram of the Sultan's which appeared on documents. So much Ottoman art seems to originate in calligraphy, and the combined boldness and minuteness of one of the most splendid of Süleyman's tuğras is no bad symbol of its aims, as well as of the Sultan's personal grandeur. Taut, sweeping pen-strokes lay the basic lines of the monogram on the page; around and between them is spun a delicate, spiralling web of tiny flowers, closely similar to the decoration on some Iznik ware of the period. But the essence of the monogram lies in its firm, bravura sureness. It positively demands an expanse of blank space round it, in which its almost twanging resonance can be sensed. The tuğra had originated in a bow, beneath which the Sultan's name was to be written. In a tuğra like this of Süleyman's that origin seems remarkably apt.

Sinan was probably three or four years older than his future patron, Süleyman, who at the age of twenty-six in 1520 ascended the throne. In the previous year the young Charles V had been elected Holy Roman Emperor; and five years earlier the young François I had become King of France. The ambitions of these three rival sovereigns were to be intermingled in ways which brought the Ottomans into European politics diplomatically and no longer as merely the common enemy, especially when the King of France formed an alliance with the Sultan against Charles.

37 (*left*) 'Tuğra' of Süleyman 'the Magnificent'·

38 (*right*) The Venetian jewelled helmet of
Süleyman; anonymous 16th-century Venetian
engraving

Süleyman was certainly the most successful ruler of the three. To some
extent, he shared the characteristics of his two European compeers. Ener-
getic, wise and just (as was Charles at his best), Süleyman significantly won
the title of 'Lawgiver' from his own people. Only in Europe was he called
'the Magnificent', but the appellation catches that other aspect which
relates him to the sometimes rather flashy style of splendour cultivated by
François I.

'This Sultan', the Venetian diarist Sanudo noted in 1532, 'is fonder of
jewels than any of his predecessors.' That remark had been prompted by
seeing a gold helmet created in Venice specially for Süleyman, containing
four rubies, four diamonds, pearls, an emerald and a turquoise. More vivid
than any description is a contemporary engraving which re-creates this *38*
richly elaborate object, half-helmet, half-tiara, topped by an exotic aigrette
of various colours. Probably the Sultan never actually wore it but he had it
displayed on a special chair beside his own jewelled and gilded throne when
he wished to impress the ambassadors of Charles V's brother, King
Ferdinand. By itself the object must have crystallized all the magnificence
of Süleyman in European eyes, and although it had been made in Venice
it perfectly exemplifies the growing strain of uninhibited profusion in
Ottoman taste. At the same time, its richness – like its design – is a visual
expression of the Sultan's power and possessions. It is encircled by four
crowns to convey his kingdoms of Asia, Greece, Trebizond and Egypt. Its
blazing splendour is suitable for the ruler who wrote to François I in a tone

at once lofty and friendly, speaking as 'the Sultan of Sultans, king of kings
. . . God's shadow on earth, emperor and sovereign lord of the White Sea
and the Black Sea . . .'. Even the Most Christian King of France might feel
his status shrink before such steady, cosmic claims.

Before Süleyman, the sultans had perhaps dressed richly and lived in
refined surroundings, yet probably without enjoying quite the ostentation
and luxury which seem to have been encouraged under him and which
reach extremes in some of the later solid, emerald-hafted daggers, pearl-
tasselled pendants and topaz-studded gold thrones (954 topazes in one late
sixteenth-century item, as dutifully counted) still in the Topkapı Palace
Treasury. With the Venetian helmet sent to Süleyman went a jewel-
encrusted saddle-cloth and – though he did not wear the helmet – when the
Sultan rode out to war his turban was covered with diamonds. When he
besieged Vienna in 1529 the citizens could see the sumptuousness of his tent,
outstanding even amid the sumptuous array of the Ottoman encampment.
At Istanbul, Süleyman's able Greek favourite, the Grand Vizier Ibrahim,
lived in so splendid a style that he seemed almost to rival the Sultan; his
superb house was more like a Western-style palace, full of 'a world of
wealth and royall furniture' (in Knolles's words).

The almost totally tiled interior of the mosque built by Sinan for another
39, IV of Süleyman's grand viziers, Rüstem Pasha, suggests something of this age

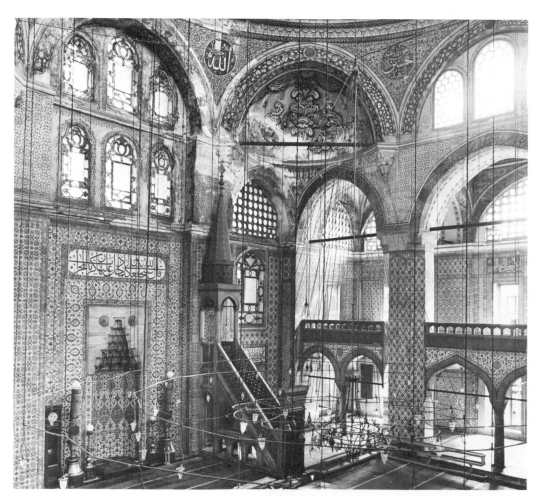

39 (*left*) Interior of the Rüstem Pasha mosque, built by Sinan

40 (*right*) Süleyman I's army in procession; miniature from the *Süleyman-Name*, 1579

of ostentation – justified, if justification is needed, by having so much to show in sheer art and in other achievements. Süleyman's combination of qualities, his long, prosperous reign and his good fortune in finding gifted men to serve the Empire were, in fact, never again to be equalled. Round him were both women and men involved with art as well as with power.

Sinan's mosques and tombs are in themselves monuments to moments of history and to personalities, commemorating such an event as the premature death of Süleyman's much-loved son, the Crown Prince Mehmed, or keeping alive the names of the great statesmen and famous seamen of the period (Rüstem Pasha, the plebeian financial genius with a Gladstonian attitude to public expenditure, who married the Sultan's daughter Mihrimah, herself commemorated by two of Sinan's mosques; Sokullu Mehmed Pasha, a Grand Vizier of Bosnian royal blood; the reformed pirate and brilliant admiral, Barbarossa). Süleyman himself is almost literally enshrined in the vast, forever dominant bulk of the Süleymaniye, with his own tomb and that of his wife, Roxelana, so close to each other near by. There is something amusingly incongruous in contemplating the unique richness of Rüstem Pasha's mosque while recalling his reputation for utter meanness; and something touching about the seldom-visited tomb of Prince Mehmed with its tiles of garden green, primrose and clear blue, blooming spring-like in the darkness.

The Sultan's normally successful campaigns form the subject of whole series of miniatures, showing the places involved – and the people – some-times depicted by artists who had accompanied him on these journeys. The documentation of Süleyman's career is both authentic and decorative. There are vivid scenes of his besieging brightly coloured cities, riding or

40

hunting with his courtiers, enthroned to receive homage under a bulbous floral tent and – perhaps most memorable of all – simply walking in old age in a garden, gaunt, stiff but still upright, attended only by two respectful

V pages (one clasping his sword) who keep at a discreet distance. Nigari, the artist of this penetrating miniature, was the outstanding painter of the reign, long-lived too, like Sinan. Having once been a sailor, he perhaps felt particular *rapport* when he came to portray the Grand Admiral Barbarossa, whom he shows as a typically bluff, robust, bushy-eyebrowed 'character', his red beard turned grey but otherwise untouched by time.

It is hard to decide whether we should be glad such positive figures existed to inspire art or whether it was not, rather, their good fortune to have great artists available to serve them. Nigari, has, as it were, encapsulated the personality and appearance of Barbarossa. Sinan also served the Admiral well, building for him a classically severe, no-nonsense tomb, entered from a pillared porch, among his earliest architectural commissions; and Barbarossa must have carefully selected its seashore site, close to where the fleet assembled (in an area where today a Barbarossa Boulevard, and a modern memorial, help to keep alive his fame).

Not all the history of Süleyman's reign can be traced in the monuments

41 created during the same period. A tomb (not usually open) and a large bathing establishment rather weakly convey the admittedly still ambiguous presence beside the Sultan of his wife, possibly Russian by birth and known in the West as Roxelana. Earlier sultans may have married, but marriage for the ruler had become untraditional. It is presumably one tribute to the forcefulness of Roxelana's personality, by no means content with the usual female role of submissive concubine, that she should have persuaded Süleyman to marry her. If not even she could break certain conventions – could not share, at least publicly, in ruling the Empire – it is hardly surprising that her activities appear in history as mere intrigue and meddling. In the Europe of her day she might have proved another Catherine de Médicis or Mary of Burgundy, the Regent of the Netherlands. Leaving aside the fact that she lived in a period of talented women rulers elsewhere, her existence at Istanbul is one more instance of the remarkable array of characters gathered at Süleyman's court.

And the achievement of her tomb, just as a fact, is no small one. Few if any later women were to be so honoured by a sultan, unless one happened to be his mother. After Roxelana only two other women are recorded as being legally married to sultans in the whole history of the dynasty; and both sultans were to be deposed, marriage being specified among their failings. But Süleyman is unanimously said to have loved Roxelana deeply. Like their first child Mehmed, she predeceased him. The untypical proximity of her tomb to the Sultan's own, smaller, simpler yet sharing the same broad platform, may symbolize her unique achievement but also his unique affection – affection which seems still bright in the tiled interior of intensest blue flowers and leaves interwoven against white, and with complete panels of black plum-tree boughs in white blossom against a background of blue. Only the latest and most virtuoso effects of Iznik ware, probably commissioned specially, would serve for the tomb of Süleyman's wife.

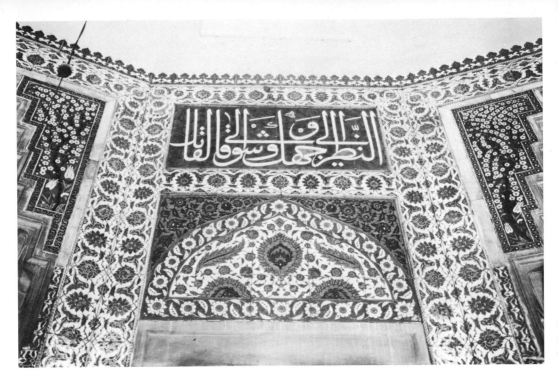

41 Tiled exterior of the tomb of Süleyman's wife, Roxelana (Hürrem Sultan)

By the date of her death (1558) it happens that Iznik ware was approaching its most brilliant phase. As so often in the history of art, technical advances – in this case the new material of white earthenware, more firmly controlled glazing and the greater variety of colours – had been accompanied, possibly stimulated, by artistic advances. The whole scale of patterns had grown bigger with the urge to cover not just a wall but a complete room with panels of tiles, and to conceive this decoration in a new, much more truly architectural-functional way.

Beautiful as are the tiles of the Green Mosque at Bursa, for example, or those in the tomb of Süleyman's son, Prince Mehmed, they remain very much applied decoration: tightly interwoven areas of colour, in which the actual semi-abstract pattern is not easily traced, situated flatly on walls almost like hangings or rugs. But the new style of Iznik tiling encouraged, first, some sort of illusionism. A wall could be treated in such a way that it suggested a series of large ogival window openings, through which might be seen whole flowering plants often clambering and as if spaliered, to fill the entire 'window' shape. Sometimes the illusion is slighter and the shape 42 frames a cascading shower of sharply defined leaves and flowers (often naturalistically observed though not necessarily naturalistically coloured) which seem centrifugally attracted to a central pineapple-bomb motif of purely decorative significance. Against pure, gleaming white ground, the tones of green and tomato-red, the touches of black and, above all, the ranging blues which deepen into a translucent, intense blaze as though stoked with crushed copper-sulphate crystals, have a sensuous clarity which is beautiful enough on the small scale of plate or jug, and quite thrilling on the scale of a complete interior. No other culture achieved quite this effect

of banishing the outside world by creating rooms of artificial garden-paradises, conservatories constructed out of faience though full of natural references.

Yet to apply these intoxicating effects simply to any surface might have been artistically dangerous. They were, to begin with, very much interior effects, and one may wonder if any elaborate exterior walls of tiles were intended. The usual outside decoration of even the grandest tomb (Süleyman's own, for instance) is a flanking pair of Iznik panels, sufficiently splendid as emphasizing the entrance but a mere foretaste of the richness inside. An important element of the tiled interior – whether of mosque, tomb or pavilion – is that the richness should be half-unexpected, paradoxically creating its splendour best in cramped conditions, conveying space, light and colour where otherwise little or none would exist. Nor merely is the effect a replacement of reality. It aims to be better than reality: patterned, ordered, designed with a perfection far beyond anything natural, and almost beyond complete comprehension by the human eye. There seems always some piece of pattern yet untraced, a border uncounted, an intricacy of design that eludes analysis. After the first sensuous impact, there should come contemplation, even study. Up the lines of tile that frame a doorway, round the pointed lunette above a window, across the sheets of tile that panel a wall or mihrab niche, the eye explores without perhaps ever exhausting the enfolding patterns and colour combinations. *29, 35, III* In comparison, the most accomplished mid-sixteenth-century Iznik dishes are so easily deciphered and appear rustic, nearly artless, despite their very real art.

Amid all the achievements of the period it is architecture, however, which not only takes first place but gives a literal framework often to the finest displays of tiling, as to the glittering segments of stained glass. The extent of Sinan's involvement in the selection of such things for buildings designed by him will probably never be established; but the careful planning of their use, as well as skilful variation in effect, suggests a strong co-ordinating hand – and his is the likeliest. The evidence is to be seen in his religious buildings, and mosque-complexes remain the major aspect of his architecture.

Yet he was also the architect of that Abode of Felicity, the Topkapı Saray, which under Süleyman became the Sultan's home and harem, in addition to being the seat of government. This change was one more instigated by Roxelana, perhaps her most lasting achievement. For the rest of the dynasty, the harem was to remain as an integral part of the palace. The rooms built, modified, redecorated or replaced over the centuries to accommodate the sultan's wives, children and his mother (and the vast entourage they required, down to the First Coffee Maker and the Mistress of Sherbet) are now among the most beautiful of the whole Saray. But it is largely a heterogeneous beauty. Little that Sinan built there can now be *IX* quite as he designed it. Only in the domed bedroom of the philoprogenitive Murad III, Süleyman's weak grandson, who was also an active builder of the Saray, does there seem an interior worthy of the architect of the greatest mosques.

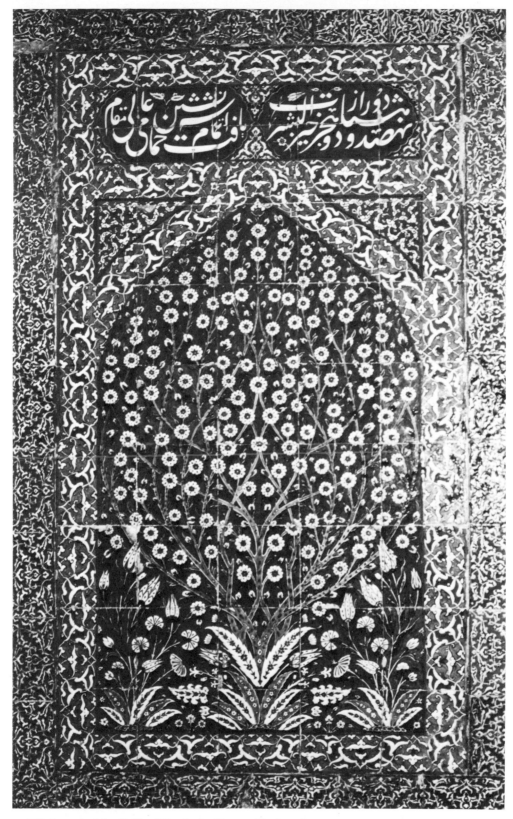

42 Tiled panel of the Golden Way in the Harem, Topkapı Saray

43 Chimneys of the kitchens, Topkapı Saray

Opportunities for grand-scale effects were never likely to be good in a palace planned for intimacy and always very much turned in on itself behind walls and amid gardens. Ogier de Busbecq, the Holy Roman Ambassador to Süleyman, was struck by the positive lack of grandeur of the Topkapı Saray seen from outside. At the time he was writing, in the middle of the century, Sinan had not created the most monumental addition to the Saray – giving it a sharply angular memorable silhouette –
43 in his line of ten double-domed kitchens with tall chimneys. Those buildings were badly needed. They replaced earlier, ill-ventilated kitchens which had, inevitably, caught fire. Their extent was justified by having to provide meals for a palace population of five thousand. Sinan's creation is essentially practical – reminding one that he was administrator and engineer, as well as architect – but also visually elegant, even witty.

In the autobiographical fragments Sinan dictated in old age he identified
44 his three major buildings with the major stages of his career: the Şehzade Mehmed mosque representing his apprenticeship, the Süleymaniye his maturity and the late Selimye at Edirne his masterpiece. If Sinan's achievements must be compressed into a single sentence, none could better convey the kernel of his genius. The trio of buildings suffices to show his range as well as his greatness; and his own evaluation of each can hardly be disputed (something not always true of artists' comments on their own work).

Fortunately, there was more to Sinan's career than his summing-up suggests. It omits so many other fine mosques by him, some quite small but brilliantly designed and wonderfully varied, with ingenious use of awkward sites, and it passes over altogether the lesser category of the tomb-structure where he was often at his most graceful and decorative.

Indeed, although there is some natural temptation to compare him with his fairly close Western contemporary Michelangelo, Sinan did not stop with creating two equivalents to St Peter's. His late group of mosques – for viziers, admirals and other high officials at court – are perhaps his most fascinating and free. The bulk of the Süleymaniye, so hugely dominating and so hugely popular with visitors, obscures smaller and more sympathetic structures, whose exteriors are now not always easily appreciated – or even located – but whose interiors reveal effortless, almost playful, mastery of space. Towards the end of his life Sinan threw off, as it were, the plan for the Muradiye mosque far away at Manisa: a triumph of simplicity, not elaboration, at once cogent and charming, set in no formal courtyard but amid trees and shrubs.

52

The architect who was to spend fifty years of his life creating the definitive masterpieces of Ottoman religious architecture was almost certainly Christian Greek by birth, remarkably slow to emerge as an architect at all and probably never trained as such. A Janissary recruit, he rose to become a distinguished soldier – Captain of the Royal Guard – and must have been known to the Sultan in this capacity before being appointed, abruptly, Royal Architect. That was in 1538, when he was already in his later forties.

Sinan's earliest architectural activity had probably begun while he was still a soldier, in the building of bridges on campaign and in other semi-engineering tasks. The permanent military requirements of 'man-management', an ability to organize and to delegate, would also prove useful to Sinan, whose career was thickly interspersed with labour problems, minor repairs, drainage arrangements and street obstructions: a constant, trivial, tiresome routine out of which were to soar the serene, spacious monuments of his architecture.

The first major opportunity he had in Istanbul came in 1543 with the premature death of the virtual Crown Prince, the Şehzade Mehmed. Although Süleyman had reigned for twenty-three years, he had apparently shown little or no interest so far in building (though he had completed

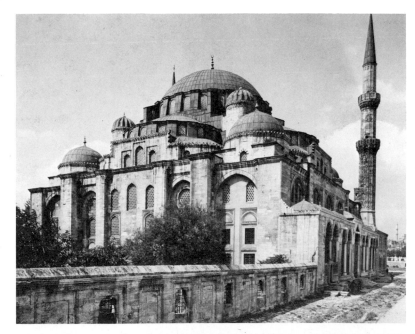

44 The Şehzade Mehmed mosque, Istanbul

his father's mosque soon after coming to the throne). Perhaps Sinan was necessary to show him what architecture could achieve; and it is possible also that Sinan's previous work for Roxelana, the Crown Prince's mother, had pleased sufficiently for the grieving parents to choose him to create a unique, outstanding monument to their eldest child. Sultans before had dutifully built complexes in memory of their fathers, but none had raised anything for a son comparable to the Şehzade complex – an achievement for which the real credit, however, must be the architect's.

It was more than half a century since the problem of a centralized dome had been tackled in the imperial mosque built for Beyazid II, Süleyman's grandfather. Sinan was – as he would afterwards emphasize – still learning at the Şehzade, but he may be said to have already known more than anyone else. Only in comparison with his own later mosques does this building seem rather ordinary and unexciting, an effect increased by its unusually flat, featureless setting. Not that it is lacking outside in grandiose scale, with a forceful, even exaggerated, massing of arcades, crested projecting walls, turrets, half-domes and buttresses, all capped by the central dome. Indeed, its complex, exterior bulk – visually much more complex than that of any previous mosque at Istanbul – is more remarkable than its straightforward, though notably spacious, interior; and it seems not merely fanciful to detect something of the beginner's wish to impress in the accumulation of features outside, combined with slightly fussy detail of a kind Sinan rarely attempted again.

Yet the interior is far more coherent and centralized, as well as in every sense lighter, than the somewhat stolid Beyazid interior (its ground-plan a square with wings). A new feeling for unity is apparent. Instead of experiencing any pressure to advance towards what is here the flat, unemphasized mihrab wall, the visitor is encouraged to take up a central position, in the mosque, under the dome supported by just four hefty pillars (their strength not altogether successfully softened by fluting). From this point each vista seems the same. They are indeed scarcely vistas but further assurances of having found one's place exactly at the centre of things, with no urge to move. Unusually, there are doorways on three sides, increasing the over-all sense of symmetry; the remaining wall contains, of course, the mihrab niche, itself easily read as a sort of fourth, honorary doorway. As one turns under the central dome, additional stability and buoyancy come from realizing that in each direction curve the half-blown bubbles of semi-domes, themselves undulating out – bubble-like again – into pairs of much smaller semi-domes. Within what is an exact square judged as floor area, Sinan creates a strongly centralized quatrefoil structure of curved surfaces and swinging arches, which even in defining space seems to release the spectator from any sense of constriction. Already adumbrated in the Şehzade mosque is the exhilaration achieved by the Selimye twenty-six years later.

III

IV

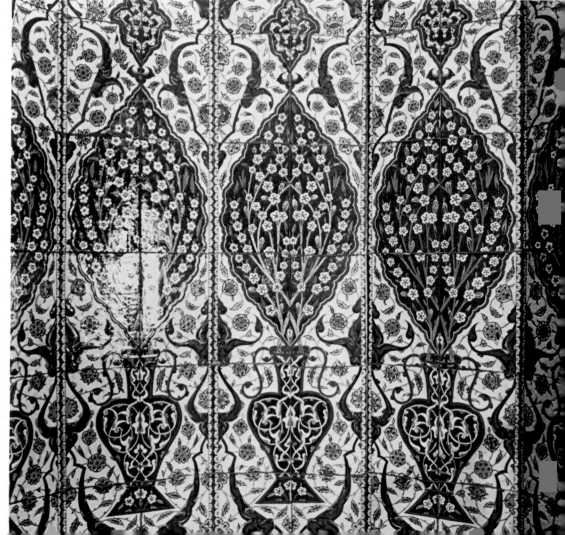

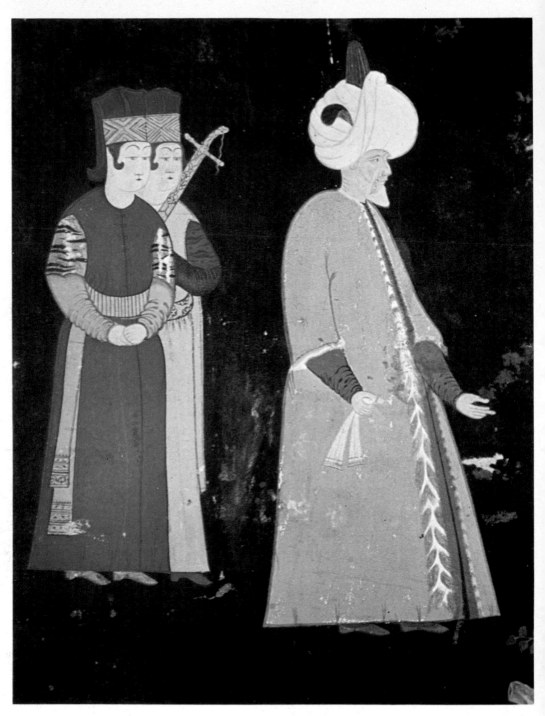

V

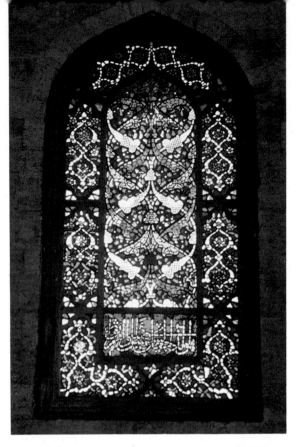

VI

VII

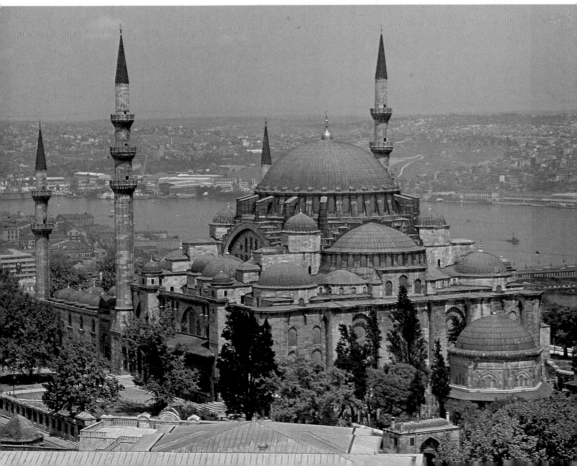

VIII

IX

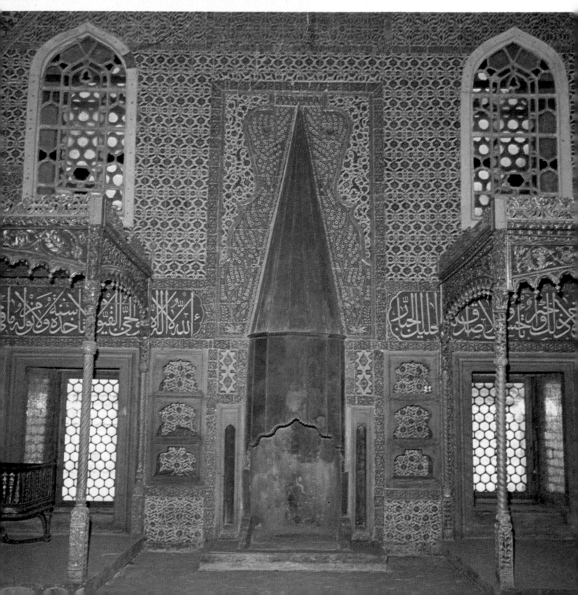

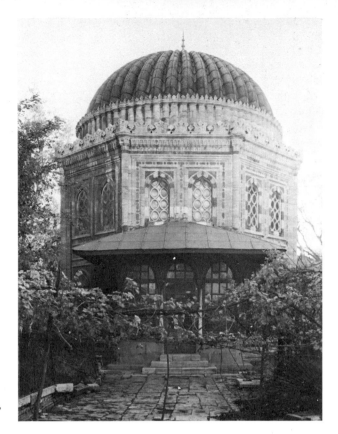

45 The tomb of
Şehzade Mehmed,
Istanbul

Sinan himself had still something to learn, and a great deal to do. At the
Şehzade complex the massive mosque with its twin, slim, tall minarets was
complemented behind by the elegant, octagonal pavilion which is the
Prince's tomb – a solitary gazebo, it might almost appear, in what must *45*
once have been a well-tended garden. The pavilion is still architecturally
beautiful and crisply elegant, though hopelessly barred against entry,
unsignposted and seldom visited, now just one of several tombs in a tattered
patch of railed-off ground close to the dusty road. For those who bother to
search it out, its interior of lime-green and blue tiles can vaguely be dis-
cerned through a broken window. And from the exterior at least, Süleyman
and his architect would recognize the consciously ornamental building
patterned in pink and white marble, pierced with latticed windows,
crested with a foam-like lace border of finials and covered with a delicately
fluted dome, on a fluted drum, that they set up to keep fresh the memory of
Prince Mehmed, much loved and prematurely dead.

It is sad, and absurd, that this exquisite small-scale monument of Sinan's
should remain unvisited, indeed scarcely visitable. Inside and out, it is
probably the most beautiful of all Ottoman tombs, more than worthy of
taking its place in the imperial cemetery at Bursa, where it might ironically
be also rather more accessible. An echo of Timur's tomb at Samarkand,
unexpected in Sinan, can be detected in the unusual crinkled dome –
potent grace-note of a graceful building. Even its very associations are
muddled by the *Guide Bleu* which states that Süleyman had strangled
Mehmed and built the Şehzade complex out of remorse. Perhaps this

historical carelessness hardly matters in a guidebook which gives no hint of the architect of the tomb or that, even if one cannot enter it, it is well worth looking at.

The success of the Şehzade confirmed Sinan's ability and doubtless convinced the Sultan that here was an architect fully capable of raising the grandest conceivable monument, commemorating suitably himself and his reign. In 1550 Sinan began the immense Süleymaniye complex, on a specially prepared high site overlooking the Golden Horn, dominating the whole city. Nothing has risen since to challenge its dominance.

Süleyman was fifty-four when his own monument was started. His greatest achievements as a ruler had been reached, though his reign lasted another sixteen years. In Europe by 1550 his ally François I was dead; the Emperor Charles V was soon to consider abdicating; a newly elected Pope, Julius III, was reconfirming the ageing Michelangelo as architect of the long-delayed St Peter's. Süleyman could not be untouched by fears of mortality – for his architect perhaps as much as for himself – and is traditionally said to have complained that Sinan's progress was too slow. Yet
46 the vast Süleymaniye complex (including theological colleges, a soup-kitchen, hospice and hospital, as well as the Sultan's tomb) was completed in seven years. Michelangelo, sighing in 1557 that lack of men and money still prevented his advancing with the troublesome fabric of St Peter's, might have envied Sinan the vast resources and support which came from a determined ruler of a vast, prosperous Empire.

Although the Süleymaniye complex is the Sultan's monument, it represents – and perhaps was always intended to represent – something more. The Şehzade is a half-private mausoleum (a Medici Chapel, as it were) in comparison with the giant St Peter's-cum-Escorial of the Süleymaniye which speaks of imperial Ottoman attainment and the triumph of Islam. Barely a century had elapsed since Constantinople had been taken by Süleyman's great-grandfather; a century before that, Orkhan and his sons (a Süleyman among them) had been busy forging the Empire out of a tribe and giving the Western world its first taste of Ottoman expansionism. In some two hundred years the Ottoman Empire had risen to take a forceful and nearly permanent place in the scheme of things, occupying an area stretching from Budapest to Basra. The holy war against Christianity continued to be waged, but could be said broadly to have long been won. Islam had conquered. No city could better symbolize that than Istanbul, where Sancta Sophia enshrined Christian imperial achievement but also that achievement's ultimate subservience to a stronger power: a famous, exposed, never-to-be-ransomed hostage.
VII The Süleymaniye complex is the product not of conquest but of consolidation. Its assurance is total. Its colossal scale is suitable for a global power and global faith (so closely entwined). In an age of great European architectural creativity, it contributes a new wonder to the world, in silhouette alone eclipsing Sancta Sophia and proclaiming Ottoman greatness in peace and the arts as much as in war. If the Sultan's palace continually surprised sixteenth-century Western visitors to Istanbul by its outward lack of monumental grandeur (rich though it was revealed to be within), the

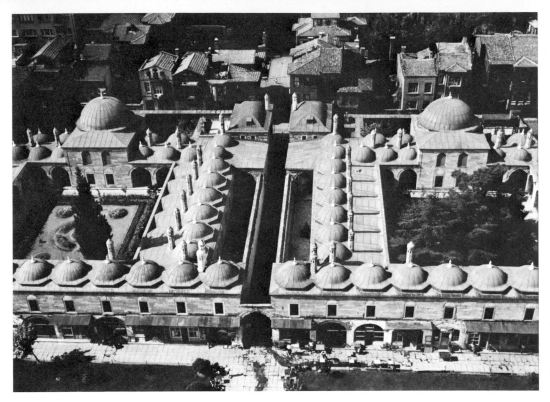

46 View over the Süleymaniye complex, Istanbul

Sultan's mosque exceeded any expectation by its massive extent and heroic proportions.

The result is astonishing, unparalleled but perhaps too public – and certainly too huge – to be entirely sympathetic. So vast is the layout of the complex, intersected with roads and placed on varying levels of the steep hilltop site, that one might easily overlook the fact that all the near-by buildings actually belong to it; even a short tour of the whole complex – omitting the central, mosque area – would occupy some considerable time. But though the relationship of one outlying group of buildings to another may best be appreciated only on a plan or aerial photograph, not on the ground, there can be no mistaking the relationship of each group to the tremendous, ubiquitous presence of the mosque itself, never lost sight of down an alley, or rising sheer over the regular lines of the shallow lesser domes of the medreses. Altogether, some four hundred domes are set round the great central dome. The concept of the mosque as focal point of any complex was traditional, but at the Süleymaniye it becomes inescapable, so carefully planned are the surrounding dependencies, and the ground itself, constantly bringing the eye back to that soaring, central mass with four tapering minarets marking the extent of its courtyard.

Yet, even while the mosque dominated its dependencies, those buildings exist very much in their own right and are perhaps more immediately assimilable. The clear-cut geometry of the symmetrical medreses facing the side of the mosque would in itself suggest the design of a master-architect; and part-use of these as shops, including cafés, adds to the sense

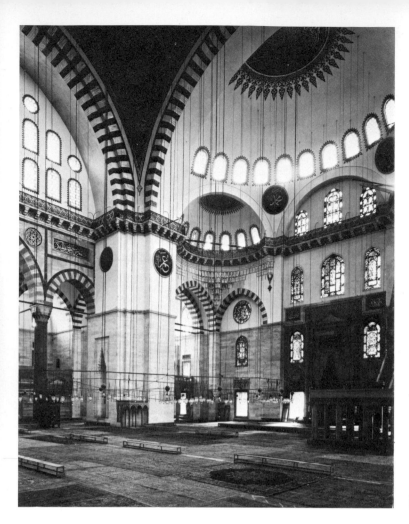

47 Interior of the
Süleymaniye mosque

of humanity. The original soup-kitchen is now a museum (of Islamic and
Turkish art), but one of enchanting intimacy and informality. Its arcaded
courtyard, with trees and fountain, has an air of garden-cloister – a more
than merely charming one, however, because of its serious, even strict,
design and skilfully organized arrangement of colonnades and domes.

The soup-kitchen, like the medreses, borders the piazza-style precinct of
the mosque. A vast space of precinct seems essential to accommodate the
mass consisting not only of that building but its large courtyard in front and
the even larger cemetery area behind, planned probably to hold only a
single tomb – Süleyman's own. Spaciousness in the mosque interior is thus
anticipated by the approach. The cliff-like high walls of grey-white masonry,
the almost chill grandeur of the austere courtyard and the thrillingly tall
main doorways increase a sense of awe as one draws nearer.

At the Şehzade there is colour and exuberant decoration. The Selimye
is built in warm sandstone and aims at something more subtle than to be
imposing. But the Süleymaniye reduces the visitor to instant insignificance.
He is overwhelmed by space and the comparative dimness. Although the
VI stained-glass windows glow, the effect of the interior is grey, surprisingly
undecorated and alien in its superhuman loftiness. Nothing can quite pre-

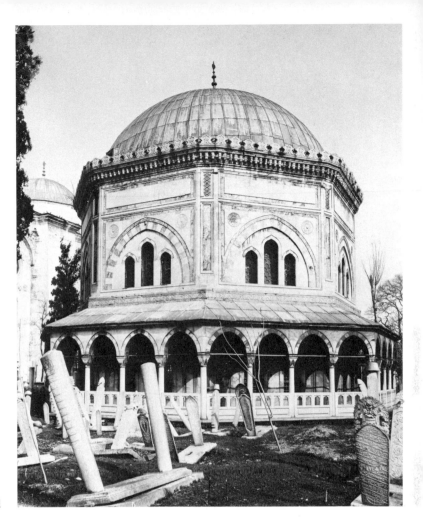

48 The tomb of
Süleyman I, Istanbul

pare one for the disorienting experience, comparable to entering Sancta
Sophia, of encountering so much covered-in space, where size seems the
criterion rather than beauty. Massive flat-faced piers support the main *47*
dome, but the concentration of the Şehzade is lost. Again prompting a
comparison with Sancta Sophia, lateral aisles replace half-domes left and
right – offering virtually retreats from the dizzying central void.

Ultimately there is something empty, and even uninteresting, amid the
undoubted vastness. For such an important mosque, the mihrab area is
oddly unarresting, treated to no special architectural effect and lacking the
stunning sheets of Iznik tiles which occur in most of Sinan's other buildings.
In that there is perhaps some reflection of Süleyman's growing taste away
from opulence. Ogier de Busbecq records the Sultan's increasing religious
scruples which led him – for example – to destroy his gold and jewelled
musical instruments. Certainly it would not be hard to find analogies
between the Sultan and his mosque, not least in hints of grimness under all
the grandeur.

Grandeur is rightly the note too of Süleyman's tomb. There, however, *48*
the scale is bearable, though the tomb itself is one of the most impressive
ever built, very much the memorial to an outstanding ruler. In its design it

is impossible not to feel some characterization, or contrast at least, following on his son Mehmed's tomb and emphasized by the plain exterior of Roxelana's tomb near by. She is placed forever in attendance, as it were, on her husband but greatly honoured by being given such proximity. No later Sultan built such a pair of tombs, evoking so untypically conjugal love. The interior of Roxelana's tomb (usually closed to the public) is scarcely less rich in tile-work than Süleyman's but it itself remains unostentatious where his asserts rank. And what was graceful (almost, one might say, youthful) for the Şehzade Mehmed is reinterpreted to express the powerful. A colonnaded veranda completely rings the octagonal building, as if to guard it. Triple sets of windows appear in place of the previous pairs, set more soberly in a façade less patterned yet still remarkably rich, crowned with a highly worked cornice like a heavy fringe in stone. Above that swells direct the curve of the dome.

Inside (an interior easily accessible, with opening hours and small fee) the outward splendour is reinforced. Past a porch with two prominent panels of strong red and blue Iznik tiling, one steps to confront almost the Sultan himself in the shape of his tilted sarcophagus crowned by a giant turban, originally resting alone in a setting where stained glass and marble and tiles and inlaid wood furnish what is more audience- than mortuary-chamber.

Here in 1566 the embalmed body of Süleyman returned after a long and extraordinary journey from the gates of Szigetvár, the Hungarian town he had been besieging when he died. His death was concealed from the army, even after Szigetvár had fallen, so as to allow the new Sultan to arrive from Asia Minor. The soldiers carried a litter containing their supposedly living ruler until the heir reached Belgrade and was revealed as Selim II. He was the son for whom Roxelana had conspired so fiercely, the successor designated by Süleyman; but his character is succinctly expressed by his epithet 'the Sot', and what was to be buried in Süleyman's tomb was the apogee of the Ottoman Empire, as well as its greatest ruler.

Selim 'the Sot', fat, drunken and dull-witted, stumbles through history with an eight-year reign notorious chiefly for the resounding defeat of his navy at Lepanto. Yet it is he who gave Sinan the commission for what proved his finest masterpiece, the Selimye at Edirne. In one direction at least Selim II must be granted ability, for he expressed confidence in an architect already in his late seventies – a confidence Sinan supremely rewarded – and by a stroke of initiative chose a site not in crowded hilly Istanbul but away in low-lying Edirne where no sultan had built a mosque since Beyazid 'the Pious'. Perhaps Selim thought it prudent not to challenge the dominance of his father's majestic foundation in the capital.

Owing to the generally flat terrain, and the slight rise of ground occupied by the Selimye mosque, it is seen on the road from Istanbul long before Edirne is reached. Its own quiet challenge is rapidly apparent, with cupola softly rising between four pointed needle-thin minarets – placed for the first time round the dome, like a hint of the strongly centralized area within. Only as the silhouette takes colour and detail does there become visible its yellowish stone and the fine fluting of its thrusting, rocket-like minarets. Almost gradually there unfolds its command over Edirne and the surround-

49

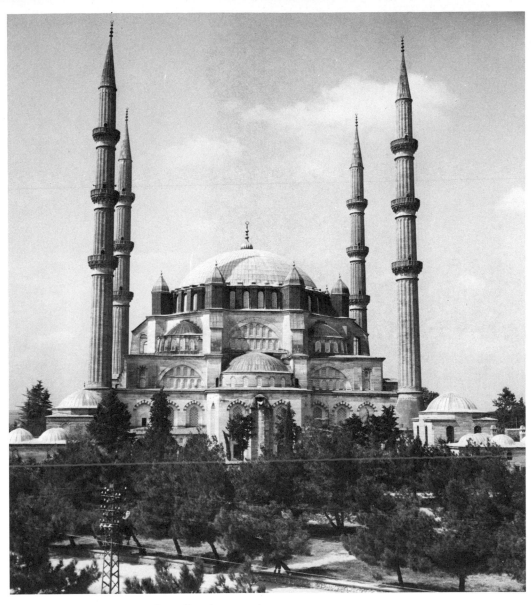

49 The Selimye mosque in Edirne, Sinan's masterpiece

ing landscape. Not quite in nor yet outside the city, it seems to establish its own scale unrelated to anything else. It does not even make an impact as particularly vast, although its dome is far larger than that of Sancta Sophia. Compared with the gigantic complex of the Süleymaniye, its few dependent buildings are disconcertingly modest. No sultan's tomb was required, and nothing distracts from the mosque itself – huge enough when seen close to, yet undaunting because of its logical, uncluttered lines and its tiers of many-windowed, light-seeming walls. The warm-coloured spacious courtyard shares the rest of the building's relaxed, welcoming quality; it is an easy step – literally – from it into the mosque. *50*

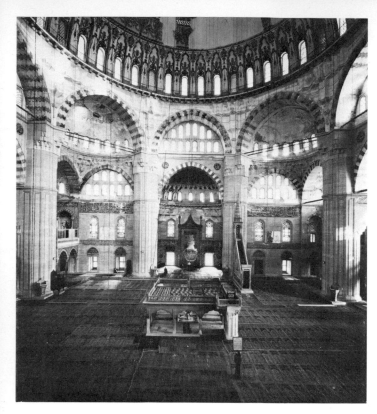

50 Interior of the Selimye

Sinan recorded his ambition here in the notes he later dictated about himself. It grieved him that the Christians should claim to have defeated Islam, since nothing had been built to rival the dome of Sancta Sophia and it was thought too difficult to build another dome equally large. 'I determined to build such a mosque. . . .' That touch of self-assertiveness necessary to the architect is utterly absent from his creation. Like determination and pride, vastness is irrelevant inside the Selimye.

Spaciousness and a sea of sparkling pinkish light wash through the clear shape of the building with irresistible effect. One is borne up on an exhilarating wave contained within what on first encounter seems a circular area, so totally does the high floating dome appear to govern the whole interior. This effect is increased by the withdrawal of the ring of grooved supporting piers into the surrounding skeletal fabric, leaving unimpeded the great central space beyond which gleams the recessed, richly tiled, radiant apse of the mihrab. Though it is there that the eye inevitably focuses – all the more since, apart from the Sultan's *loge*, the rest of the building is barely adorned – there is little urge to advance beyond that serene spherical envelope of atmosphere which virtually *is* the interior.

There is no mystery here, no dim corner, oppressive weight, or immeasurable height. By intention, presumably, the double rows of windows are glazed with uncoloured glass, dissolving walls and allowing strong light to pour on to and round the wonderfully warm sandstone shell of the structure, softened or faded to a pale rose tone. It is the eight lightly faceted pier shafts of pink stone that anchor the interior, rising smoothly to blend almost imperceptibly into archways supporting the luminous area of the dome –

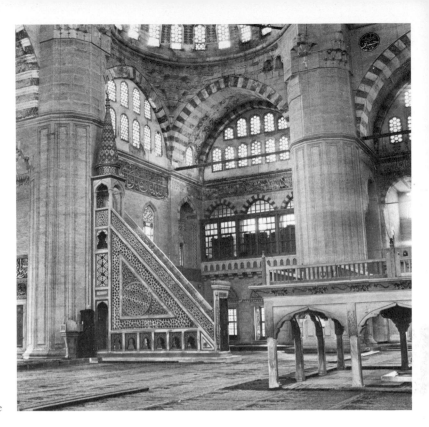

51 The marble
mimber of the Selimye

and not even disastrous, fortunately flaked, painting there can mar the over-
all harmony and clarity.

Within such a crystalline atmosphere only perfect decoration — or none
– is tolerable. The delicate marble 'mimber', or pulpit, might elsewhere be *51*
too ornate, but here its totally fretted, pierced sides and steep conical cap
of tiles provide a permissible flourish of extreme refinement. The tiles that
help define, as well as decorate, the deep recess containing the mihrab are
among the choicest ever produced at Iznik; and once again the Sultan seems
to deserve some personal credit, for these tiles are equalled only by the
shimmering accomplishment of those that line his *loge* and also perhaps by
the few panels remaining at Topkapı from his sumptuously tiled, now
destroyed, bathroom.

The imperial *loge* of the mosque suggests an almost sybaritic delight in the *1*
varied effects of tiling: from the strictly abstract blue and white zigzag
pattern along the skirting, through large wall-panels of regularly designed
foliage and flowers to the virtuosity of complete trees, whose willowy
branches are sprigged with thin leaves and blossom.

The building coincided with the most brilliant period of Iznik ware.
Commissions involving the Sultan would anyway have inspired the best the
factories could produce, and Sinan seems to have taken every advantage
of the medium, so sensuous and coolly shining – as well as coloured and
patterned – in contrast to stone. In the mihrab area of the Selimye the tiles
are predominantly blue and green; combined with their pure white ground,
they give an intensely cool effect in the warm-toned building. To make the
most of the medium, however, was not necessarily to use it profusely.

Where Sinan had his way, it seems reasonable to deduce, tiling played its part in strict obedience to architecture. By varying means it enhanced the splendour of mihrab areas, emphasized windows and, as supremely in the Sultan's *loge* at Edirne, was able to create out of low, simple doorways triumphal entrances not merely framed and lined with multi-patterned tiles but enlarged through expansion of them into overdoor panels of spiky elaboration – like two-dimensional embroidered canopies.

At Edirne the variations and intricacies deceive the eye and almost defy analysis, and yet the result is far from confused. Borders of circular white flowers on a blue ground; white borders edged with red and enlivened by alternating large turquoise flowers and serrated, knife-like green leaves; inset, arched, blue slabs thickly covered with curling red and white foliage; and the final, half-feathery crowning of the doorway where the vigorous surge of stems and virtually exploding leaf and flower motifs seem to have dictated the high, sharp-pointed ogee shape – all this is assembled, pruned of over-luxuriance, as tightly calculated in its over-all design as is the design of a single tile.

A great distance separates this sophistication from the tiles, choice in their day, available to Sinan when he had built the Şehzade Mehmed tomb. Their formal, closely woven patterns seem static, dense, almost oppressive, compared with the freedom evolved at Iznik whereby the glazed white ground can gleam through the richest twists of patterning, and the bold naturalistic patterns themselves can be boldly adapted to occupy complete walls and yet suggest screens of lattice rather than enveloping carpet.

The development is one reminder of how long Sinan had been active. And the Selimye by no means represented the close of his career. Selim II, the third sultan he had served, died in 1574 and was succeeded by his son Murad III, who commissioned from Sinan his father's tomb within the grounds of Sancta Sophia. A more important task awaited the now impressively aged architect, mentally still lively enough though no longer likely to travel far to oversee buildings in progress. The new Sultan had to decide the site of his imperial mosque – to be designed, almost inevitably, by Sinan.

52 Feeling perhaps that Edirne had become almost as crowded as Istanbul, Murad III chose Manisa for his own mosque. Although Sinan almost certainly never saw the resulting building, the Muradiye – no Selimye in scale and still less any echo of the Süleymaniye in extent – is marked by such clarity and authority of design that anyone might be prompted to inquire about its architect. A lifetime of issuing orders and organizing people was necessary, perhaps, for it to have been so successfully built by remote control, with such attention to detail as its doors, for example, reveal. A lifetime of wide architectural activity too was probably necessary to achieve the simple but skilful half-old-fashioned-seeming economy of the Muradiye, standing in a tree-filled garden and preceded by a graceful portico, with delicately thin pillars.

Sinan is always capable of – indeed fond of – the unexpected. A strongly rectangular prayer-hall, its centre spanned by a single dome, forms the interior of the mosque, planned so cleanly and lit so radiantly that

52 The Muradiye mosque,
Manisa

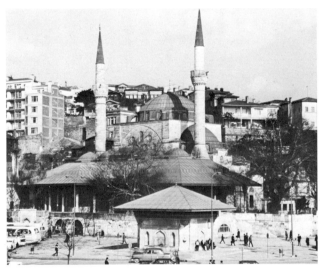

53 The Iskele ('Jetty')
mosque, built in Usküdar by
Sinan for Süleyman's
daughter, Mihrimah

54 Portico of the Rüstem
Pasha mosque, Istanbul

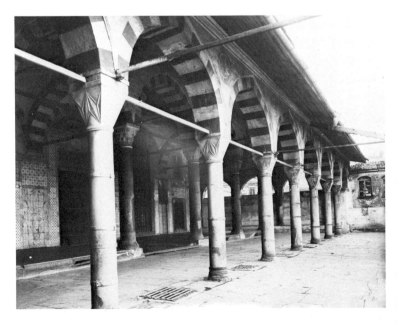

momentarily detail is neglected in enjoyment of the encounter. The beautifully placed tiled plaques of inscriptions and other touches – like the carved, dark gold ceiling under the Sultan's *loge* – seem only to increase the interior's lucid purity. It is a building that Palladio could have appreciated. The compliment might have appealed to Murad III, the son of a Venetian woman, who had another Venetian woman as his favourite wife.

For the sultans, Sinan had certainly worked well, but no less remarkable is what he had built over the years for grand viziers and their wives (often daughters of the sultan) and other personages at court. Seldom large but seldom perfunctory, these mosque-complexes possibly provided more exciting challenges to his ingenuity than grand-scale commissions. In Istanbul, where hills and sea dictated available space, he has left a series of mosques that ideally require to be visited in quick succession, so as to appreciate the difficulties solved in ways which become part of each building's individual character.

By a jetty or on a steep hillside, at the crowded heart of the city in what is now a noisy ironmongers' market, or out in what has remained suburban countryside, Sinan devised solutions which continually surprise. Sometimes the courtyard, portico or precinct prepares one for a more original interior than he produces. Thus his first mosque for Süleyman's daughter, Princess
53 Mihrimah, is strikingly sited – almost moored – along the quay at Üsküdar (on the Asian shore of Istanbul). Set up on a high platform which makes an attractive viewing-point, with a wide double portico and twin minarets (reminding one that this is a royal foundation), the mosque is all shady picturesque exterior; inside it is just dull. However, the Princess and her husband, the powerful but miserly Grand Vizier Rüstem Pasha, continued to patronize Sinan; and for both of them he later created interiors which make handsome reparation for the interior of the Iskele or Jetty mosque.

For Rüstem Pasha Sinan also built inns at Istanbul and at Edirne, the one lean and narrow owing to chronic lack of space, the other laid out more grandly, with the typical rows of cells ranged round a large courtyard. Rüstem Pasha's mosque at Istanbul was begun probably in 1561, the year he died, perhaps as a memorial by his widow. Placed well down the hillside from the Süleymaniye – not far from the foundation of the Sultan whom he had long served – his single-domed mosque is tantalizingly visible amid huddled roofs but at first apparently inaccessible. Presumably its site was always a busy market, and the first necessity therefore was to lift it high out of its everyday environment. There could be no major entrance, scarcely any ground-floor clue to its existence apart from a fountain and two small, ordinary doorways set between shops in the twisting alleys. Narrow stairways lead up to a surprisingly wide stretch of terrace and an almost
54 Italian early *quattrocento* arcaded portico inset with blue-and-white faience roundels – foretaste of the cool splendour and repose within the mosque itself. The interior is not large (photographs often exaggerate its size) but planned deftly to suggest space combined with solidity, strongly lit and
IV clad – pillars, walls, arches as well as actual mihrab niche – with tiles.

Such a uniquely stunning display helps to insulate the mosque yet further from ordinary existence. It becomes a secret place for meditation – its

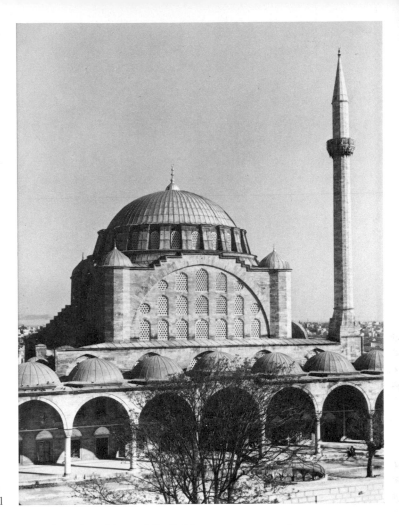

55 The Mihrimah
mosque in Istanbul

scale suggestive of an oratory rather than big public Friday mosque – and in its way a garden. Yet for all the multiple wild beauty of those flower patterns, now branches of white blossom against a sky-background of bright blue and now rapidly repeated bristling scarlet tulips on a background as sensuously white as packed, frozen snow, they are used to emphasize the building's structure, span of an arch or flank of a pier. It is significant that the pictorial effect of electric-blue and turquoise flower-filled vases is reserved for the mihrab niche; and only for the isolated panel at the top of the mimber is there a complete tree in white blossom.

Nevertheless, Sinan seems never to have cared to repeat over-all decoration of this kind. When he built a second complex for Princess Mihrimah, shortly after the Rüstem Pasha mosque, it was the clarity and light of what he had designed for her husband that he developed, as well as size. Hers was, too, on a much finer site, at the edge of the city, beside the Edirne Gate; and Sinan produced the grandest of effects, suitably enough, for Süleyman's daughter. Not until the seventeenth-century building activities of several sultan-mothers, often dominant ruling figures, did a woman have equal passion, or opportunity perhaps, for building so impressively. Although the interior of the mosque is more than usually disfigured with

55

91

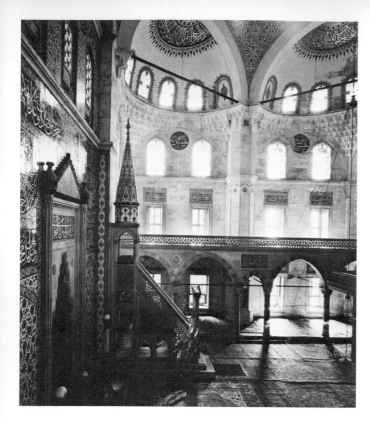

56, 57 Interior and exterior
(*below*) of the Sokullu Mehmed
Pasha mosque, Istanbul

ugly-coloured, fussy stencilling, that cannot spoil its intense luminosity. It is a high-arched hall with walls of windows, tier on tier: a crystal structure which, far from appearing fragile outside, has a sort of springing strength, with great arcs of stone framing on each side the expanse of window and raising the dome right up in an imposing but quite novel way.

These varied solutions for husband and wife by no means exhausted Sinan's ingenuity. Indeed, in the 1570s, with the Selimye in progress, he seems to have felt a new sense of freedom, even able to turn back – as in the mosque for the Grand Admiral Piyale Pasha – to the antiquated 'old

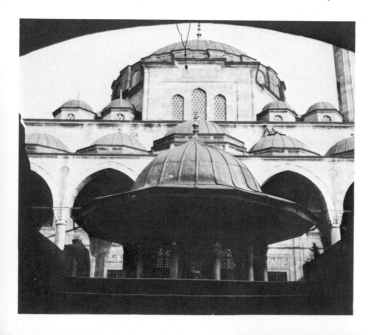

mosque' form of several equal cupolas covering the rectangle of prayer-hall. Something a little provincial and out of date is not unsuited to its deep countryside setting – still a good way beyond the familiar limits of Istanbul – where browsing goats and children playing in its ruined colonnade are more frequent than tourists. Perhaps Sinan's hand in it was only nominal, but the unimpeded interior space is sophisticated, not archaic, and the Admiral chose especially fine tiles – with bold red and blue flowers – to decorate it.

Definitely designed by Sinan are two outstanding mosques from the same decade, for a good patron of his, Süleyman's last and most faithful Grand Vizier, Sokullu Mehmed Pasha. It was he who had daringly concealed the Sultan's death at the siege of Szigetvár. Brave, intelligent, authoritative in appearance and action, he continued to serve as Grand Vizier under Selim II whose daughter he had previously married. For him Sinan had earlier begun the large complex at Lüleburgaz on the Istanbul–Edirne road, an impressive enhancement of what is otherwise more a large village than small town; there the mosque itself proves oddly small in relation to its broad handsome courtyard in the centre of which an undulating mushroom canopy over the fountain becomes not incongruous but very much part of the whole complex's rustic charm.

At Istanbul Sinan built the Grand Vizier a marvellous mosque close to his palace on the steep hillside below where Ahmed I's Blue Mosque now stands. The site was one of the most challenging even Sinan had faced, and the resulting creation probably his most exquisite and ingenious. As at Rüstem Pasha, the mosque and courtyard are built up on a platform, but approached by a covered central staircase from which is gradually disclosed the elegant cusp of the grilled courtyard fountain, with the domed portico rising beyond and above that the crowning dome of the mosque itself. 56, 57 64

The sense is of something at once more exciting and more refined than is encountered at Rüstem Pasha. Inside, the height of the immediately embracing dome is unexpected and the impact of the facing mihrab all the greater since no internal structural divisions exist – only two jutting piers, left and right. The Selimye has effectively intervened between Rüstem Pasha and this interior. Nearer also to the Selimye is the subtle use of tiling: not lining the actual mihrab niche, nor covering the complete wall, but inset in two tall panels flanking the marble area of the niche and soaring up towards the dome in a whirling efflorescence, predominantly emerald and red – a firework display of flowers.

The Grand Vizier could hardly expect Sinan to repeat this achievement, and yet highly personal effect characterizes the second mosque for Sokullu Mehmed, the Azapkapı, on the opposite side of the Golden Horn, close to the water's edge. Today the main traffic bridge bulks perilously over the mosque, though a piece of garden with a few willow trees still surrounds it; and there is a distinction about the ring of turrets round the sure swell of the dome. Once again, the approach is an ascent, rather like climbing through some warehouse cellar, to reach the glassed-in gallery on the main floor, preceding the mosque. And once again, there is inside a distinct echo of the

58 Sinan's tomb and fountain, Istanbul

Selimye with an apse and here free-standing, part-fluted pillars supporting the dome; lateral galleries, supported on slim pillars, somehow do not cramp space in what is throughout small-scale, intimate and clear cut, as well as clearly lit. Although some glass is coloured, colour comes more from the trees that press against the windows.

Sinan, who had worked so well and so long for others, did not fail to work also for himself. He had been the architect of several aqueducts and perhaps it was typical of his practical, pragmatic nature that he should put *58* up a small public fountain – a notable mark of his status, not to be repeated by later architects – though ironically he was accused of diverting the water-supply for his own purposes. Adjoining the fountain he built his own tomb, at the triangular tip of the garden of his house below but very close to the Süleymaniye. Original to the last, adept as ever at turning an awkward site into an advantage, he designed a unique open tomb structure, with ornamentally crenellated walls and lace-like grilles, leaving grass to grow round the tombstone carved with his turban.

If the Empire's zenith passed away with Süleyman, it is tempting to declare that Sinan's death in 1588 signalled artistic decline. But the parallel is too neat, though it is true that no genius comparable to Sinan would appear again in Ottoman art. Fine buildings continued to be built. In other media fine artists continued to be active. Far from ceasing, the demand for art may even have increased as visual opulence became one of the chief features Europe associated with the only very slowly sinking Empire.

4 Achievement amid decline

There was to be no steady pattern to the course of the Empire's decline. And if the ship of state was inevitably foundering – despite bursts of efficient government by grand viziers and even individual sultans – its going down was marked not only by guns trained fiercely on its enemies but by splendid firework displays. That was literally so, and fireworks became an admired Ottoman art form. But the seventeenth century's years of erratic uncertainty are marked too by solid artistic achievements, large-scale like the Blue Mosque, or small like the Baghdad Kiosk, both closely connected with political events.

A policy of what might be called blood and circuses characterized the methods of government. War was the chief solution to discontented Janissaries, poverty and threats of anarchy. Under the energetic though short-lived Sultan Murad IV, a true warrior-leader, it seemed a glorious solution. But war eventually was to show the Empire's weakness. Although Vienna was besieged in 1683, in the reign of Mehmed IV, the Ottoman army was decisively defeated; a few years later the Turks were driven from Greece by the Venetians (the occasion of the blowing-up of the Parthenon). Mehmed IV was deposed and the century closed with the Treaty of Carlowitz, Europe's united rebuttal of all Ottoman attempts at expansion. In the comparatively peaceful years which followed, Ahmed III and his court were free to create the graceful rococo climate of the 'Tulip Age'.

Throughout the seventeenth century – with its alternating military successes and defeats, its sultans deposed and even murdered – public festivals, processions and displays of splendour dazzled the people and, increasingly perhaps, amazed Western visitors. One can speak appropriately of circuses, since these spectacles were often held in the ancient Hippodrome area at Istanbul. War itself was splendidly waged. The sumptuous Ottoman tents shown today in spacious glory at Cracow convey the 59 physical luxuriance of the army which besieged Vienna – seen to be no fanciful depiction by the miniature painters. Yet most of this luxury was doomed to be captured; and its presence in Poland is no chance.

Within the Empire, it must have been hard to believe that any diminution threatened a power whose rulers always passed in vast and gorgeous cavalcades, and who traditionally celebrated the circumcision of their sons in sustained, month-long festivities at once oppressively opulent and imaginatively decorative, in, as it were, a cloud of jewels and carnival novelties, turned at nightfall into the explosive, jewelled rain of fireworks. Whatever the actual loss of territory or the failure of real sieges, in the enchanted ephemeral pageants created by fireworks castles were stormed, fortresses fired and sea–fights successfully won.

59 An Ottoman tent of the 17th century

In 1675, the year of a severe defeat of the Ottoman army by the famous Polish general John Sobieski, festivities of the most sumptuous kind were held at Edirne to celebrate the circumcision of Mehmed IV's heir. For a prince such ceremonies took on a national aspect: a recognition that here might well be a future ruler, whose symbolic entry on manhood was bound up with continuity of the dynasty and suitability to reign. At Edirne in that year the scene was almost of a coronation, with the streets crammed with people – men separated from women – to see the procession pass.

What unfolded was an ideal panorama of the Ottoman Empire, splendid, orderly, warlike, but also lively and popular. The official ceremonies for a royal circumcision included parades by the guilds with floats displaying their skills and specialities, often in amusing forms. Carnival kept blending with coronation overtones; the Edirne procession was full of what an English observer called frolics and fancies, as well as being deeply impressive as a visual affirmation that the Empire was unchanged and unchanging. The massed march of Janissaries, pages, armourers, judges and guards was interspersed with elaborate ornaments, carried on poles, of painted paper, wire and wax – designed no doubt by professional artists in the highly respected category of decorative painting. Finally came the Prince himself, dressed in silver and purple cloth of gold, with brooches of emeralds and rubies, riding on a horse which the same English observer described as 'in a manner nothing but jewels, pearls, gold and silver from head to tayle'.

Twenty years later, as Mustafa II, this resplendent figure ascended the throne, eager to give aggressive substance to the aura of power and riches exuded by his Empire. He declared his wish to lead the army in person in the holy war, having stigmatized the indolence of his immediate predecessors as sultan. His campaign opened with a victory; but this initial impetus was not sustained. A second campaign ended in overwhelming disaster for the Ottoman army and deeply disillusioned the Sultan. The indolence he had criticized in his predecessors began to exert its appeal over him. For his Empire the Treaty of Carlowitz was a significant humiliation; it was followed, a year or two later by Mustafa II's abdication.

Splendid or amusing festivities, and also more serious historical events (though never anything as unsettling as abdication), form the staple subject-matter of miniature-painting as it continued to be fostered at court, changing remarkably little in emphasis over the century-and-a-quarter between Murad III and Ahmed III. There too the message might seem to be that all was well. In scene after animated scene are preserved, enhanced, those ceremonies and celebrations which Western visitors liked to describe. They formed a luxurious record for the reigning sultan: whether seen at prayer or out hunting, receiving foreign homage, with his troops at war or present in the person of his grand vizier, or enthroned to witness the lively parade of the guilds.

Yet for all their piquant observation of behaviour, the miniaturists were themselves nearly always on parade where the sultan was concerned. Though he might be – and in the seventeenth century often was – pleasure-loving to the point of insanity, there was no urge to depict an indolent, amorous existence comparable to the lullingly idle climate of contemporary Deccan miniatures where the prince may be shown slumped in outdoor siesta or surrounded by wine, women and music, his tastes catered for down to a female attendant in Western male costume. At Istanbul the life of the harem remained unrecorded in painting – even for the sultan. Perhaps it was characteristic of the national temper that, though there might be erotomania, there should be virtually no erotic art.

It was probably the place, and indeed existence, of women as such in Ottoman life which inhibited their appearance in art – not an endemic trait of Islam, for the Deccan kingdoms were also Islamic. Although there are some late sixteenth-century drawings of houris (by a Persian painter, Velican, working at Istanbul), it was not perhaps until the eighteenth century that the essentially masculine tone and subject-matter of miniatures changed. Then, especially under Ahmed III, and his successor Mahmud I, court painters began to depict women dancing, playing music and even attending the public baths.

Nevertheless, the earlier miniatures are far from lacking their own strong sense of enjoyable activities, with notable delight in animals, and in men marching, hunting, fighting, working or just frolicking (often on swings) with a sort of clear-cut clockwork vivacity bordering on the satiric. It was not only the splendour of the festival devices at the circumcision of Murad III's heir that was recorded but also the activity of the sweepers, dutifully 60 tidying up and also displaying their corporate usefulness, conscious of

being directly under the sultan's eye. Even the carrying of the immensely
X tall, tiered candle-topped decorations, with their kaleidoscopic patterns,
tasselled pendants, perched birds and sprays of tulips, is made no mere
formal, staid scene. Not without jostling, and with some faces anxiously
upraised as if estimating the safety of the high, fragile structures, do the
decorations go forward – if indeed they all do, for the group of bearers at
the extreme right seem angered at enforced delay. Rather too many people
appear to have got involved with carrying the foreground decorations,
while those in the background – each borne by four men – advance both
smoothly and better spaced.

Murad III's patronage had perhaps stimulated fresh interest in the artistic
possibilities of miniature-painting. The period following the death of the
sailor-artist Nigari in 1574, the year Murad came to the throne, certainly
represented the high point in the art of illuminated books. Several known
painters were active, among them Osman whose atelier was responsible
for the *Sûrname* (book of festivals) illustrations. Of Osman himself little is
known, but the distinction he brought to the miniature is sufficiently
conveyed in the scene of the festival devices. For this painting he was
probably responsible himself.

No less remarkable than the observation is the subtle range of colour,
with scarlet predominating and yet discreetly used, and especially the skilful
placing of all the elements in the composition. Despite so much intricate
ornament, required by the subject and patently delighted in by the artist,
the total effect is of clarity, achieved without stiffness and indeed with a
narrative verve. The steep shapes of the decorations themselves, each similar
yet not exactly the same, are boldly printed up the page, dominating
though not obscuring the other patterns of dotted terrain, brick wall and
grilled windows. A sense of sharp pattern-making is equally apparent in the
composition of the sweepers who form unforcedly a circle, helping to
suggest also the space of the Hippodrome; and any formality of design is

60 (*far left*) Procession of sweepers in the Hippodrome; miniature from the *Sûrname* of Murad III by Osman

61 (*left*) A tortoise carried by two ducks; miniature from the *Hümayunname*

62 (*right*) Kenan Pasha's galleys in action; miniature from the *Pashaname*

light-heartedly broken by the single broom propped against the arena wall.

No less acutely do other miniatures catch the spirit of the different trades and occupations, as well as delight in the different shapes of their wares. The glaziers are pulled along in a wheeled vehicle hung with lancet and circular panes of glass. The taxidermists, if that is what they are, walk solemnly each holding aloft a staff topped with an enormous bird – making their own bold pattern across the composition.

Such miniatures enshrine some wonders of art, as well as being of course art in themselves. Other illuminated manuscripts dealt with the wonders of nature, often as told in long-established fables of Persian origin. Yet it was not so much the fabulous, exotic aspect which Ottoman artists stressed as, typically, the naturalistic element. Far from the results being prosaic, they possess their own amusing poetry. A pair of life-like leopards, father and son, inhabit and inspect a wonderfully wooded island which is to be bequeathed to the younger leopard. A convincing-looking type of stork is seen in a bare pink and grey landscape providing water from its beak for a variety of smaller birds during drought. Two well-observed red-beaked and red-legged ducks sail through the air with their friend, a tortoise, balanced on a stick held between them – to the understandably intense astonishment of some villagers. The touching story of how the tortoise and ducks could not bear to be parted, deciding to travel together when the lake by which they lived began to dry up, takes on greater resonance from the calm treatment of the ducks' ingenious solution; and the perfect, almost smug equilibrium of the tortoise (elsewhere depicted clutching the stick with its mouth) shows that keen grain of humour salting observation which constantly enlivens Ottoman painting.

There could be no place for humour in miniatures dealing with campaigns, sieges and audiences given by the sultan. But unmistakable delight is shown in the patterns to be made out of rows of tents and lines of cannon, city roofs and crenellated turrets, as well as in ranks of sloped muskets and

61

Janissaries' steep caps. Plans and maps and views of cities seemed always to have appealed to Ottoman artists and patrons. Obviously, they lend themselves to calligraphy, and the results are stylized, decorative and economic.

The *Pashaname* (of about 1630), a poem celebrating the exploits of Kenan Pasha, is illustrated by one brilliantly vivid miniature in which a corner of hilly coastline and walled seaport forms an intensely concentrated image, serving also to localize the main sea scene. Here the trio of slim red Ottoman galleys against the dark water predominates in a quite remarkable way. The effect oddly anticipates that of a typical Francesco Guardi view-picture, to such an extent has the human element dwindled in comparison with delighted depiction of rigging, masts, oars, sails and the expanse of greenish, inky sea itself. Elsewhere, Kenan Pasha is shown riding with his troops, in the established, conventional type of composition. His victory over Cossack pirates is conveyed by a bird's-eye view extending across sea and land – and even including two distant flying birds which increase the picture's aerial sense. Although the human figures are tiny, they are – as so often in Guardi – hectically animated. Even the drowned or drowning pirates look lively; while the Turkish sailors – especially the one perched gesticulating astride a furled sail – appear manning their ships with cartoon-like vivacity. This is no water frolic; but the exuberant pleasure of the artist in the scene's activity has given it an unexpected gaiety.

It would be hard to believe that whoever painted it had not seen some Western pictures, or possibly engravings. Even so, what he has made of any such influence is what matters. Western ideas may have vaguely affected the composition, but neat, calligraphic pattern-making combined with pungent detail relate the miniature back to a strong Ottoman tradition. The very clouds of blue-grey smoke the cannon emit assume upward-curling decorative whorls, not so far from the conventionalized cloud forms that appear on earlier Iznik pottery. At the same time, real gun-fire, as it were, can be detected behind the stylization: the Black Sea is cleared of infidel pirates and the Empire of the sultan is, at least temporarily, victorious.

Defeat, not victory, had at the beginning of the seventeenth century positively inspired a unique major architectural monument, the Blue Mosque, the mosque of Sultan Ahmed at Istanbul, which has probably achieved the greatest popularity of all mosques, except with scholars and connoisseurs. During the century architecture can serve to chart something of its character and mark at times some outstanding historical events.

Murad IV built kiosks at Topkapi to commemorate his capture of Erivan (1635) and Baghdad (1638). The large-scale Yeni Valide mosque, the last great complex of its kind, recalls the dominant place occupied by more than one sultan-mother in the period, particularly the Valide Turhan, mother of Mehmed IV who himself raised no royal mosque. At Topkapı, however, he did build considerably, as well as contributing to Sancta Sophia such embellishments as an enclosure for singing-birds. Much of the harem was rebuilt under Mehmed IV, and increasingly throughout the century the sultan's architectural interests turned inwards, away from monumental complexes like the Ahmediye to concentrate on small waterside pavilions and pleasure resorts down the Bosphorus.

62

63 The 'bower' of Sultan Ibrahim, on
the terrace at Topkapı

The builders of large complexes – and then usually away in the provinces
– were chiefly the Köprülü family, of Albanian descent, who provided no
fewer than four grand viziers in the second half of the century. More
significant than their number was their competence in governing, often in
marked contradistinction to the sultans they served. Through them and
their relatives arose handsome baths, arcades of shops, and caravanserais,
and in Istanbul also at least one important public library. The sultans are
better represented by such an exquisite but entirely private creation as the
howdah-like gilded cupola on four pillars, the 'bower' of Sultan Ibrahim, *63*
which this terrifyingly degenerate ruler, strayed from the pages of Krafft-
Ebing, placed on the terrace at Topkapı, providing himself with a beauti-
fully sited vantage-point high over the Bosphorus.

Factually, it is hard to exaggerate the growing tendency of the dynasty
to withdrawal – for all its occasional ceremonial show. While Mehmed
IV's army was advancing on Vienna in 1683, the Sultan was conducting a
personal battue near Edirne, involving thirty thousand peasants, many of
whom died along with the masses of slaughtered game. Yet Mehmed, if
carelessly cruel and idle in all activities except hunting, was a model of
sane moderation compared with his father Ibrahim.

At the beginning of the century, the young Ahmed I (who succeeded to
the throne at the age of fourteen) had certainly felt deeply the humiliation
of the Peace Treaty of Zsitva-Torok (1606) whereby he recognized the
Habsburg Emperor as his equal. His Blue Mosque was to placate God in a
disastrous year which might well seem to herald the collapse of those global
ambitions of his great-great-grandfather Süleyman 'the Magnificent',
dead just forty years earlier. Like so many of his predecessors and successors,
Ahmed I was devoted to hunting and the harem – to the point even of
causing scandal in the capital. But he seems to have had a distinct interest
also in building and was impatiently pressing for completion of his father's
tomb before he began his own mosque.

This project was disapproved of by powerful religious and legal leaders,
but the Sultan – who makes only fleeting and weak appearances in history –
was here firm. Indeed, his concern with the grandeur and quality of the
building became obsessive. In 1609 he personally cut the first turf for the
foundations. The following year he approached the Venetian government
to obtain specially beautiful coloured glass for the windows of the mosque,

and this was presented to him. The English poet and traveller George Sandys (who went abroad in 1610) refers to Christian slaves hewing marble daily in the quarries of Marmara for 'that magnificent mosque . . . now building . . . by this sultan'. The Sultan diverted almost the whole output of tiles from the Iznik factories for use in the building. In 1617, after much careful watching over its progress – and its accounts – he was able to go and pray there for the first time. He died after a short illness in November of the same year.

64 The Blue Mosque is a monument to Ahmed I's piety but also to his determination. Defeat, along with any accumulating suspicions of diminishing power, has been turned into victory and affirmation. The tradition of the great royal mosque-complex is not merely continued; it is crowned by the largest of all such complexes in Istanbul, splendidly sited, patently intended to predominate and proclaiming its uniqueness by six minarets (unparalleled in the capital or within the limits of present-day Turkey).

To find space for this ambitious, enormous project was challenging enough and costly. Selim II had preferred to build his great mosque at Edirne. Murad III, Ahmed's grandfather, had selected Manisa. The young Sultan took on, as it were, the past in other ways too, since unlike those two predecessors he lacked a proven genius for his architect.

Nevertheless, he proceeded to select an attractive and convenient hilltop site in the area of the Hippodrome, fairly close to, and on the axis of, the Topkapı Saray. It was already partly occupied by palaces, including that of Süleyman's great Vizier, Sokullu. These were pulled down. Space was created for a spreading complex occupying flat ground, laid out with none of the drama built up (literally) at the Süleymaniye and no violent changes of level. Access is encouragingly easy. The sense of approachability is strong as the exterior keeps composing into attractive silhouette at the close of each spacious vista. The note is everywhere of grace rather than force – an almost fluid quality of picturesque gracefulness, emphasized by surroundings of flower-gardens and trees; and the setting is permanently enhanced by the wide expanse of the Sea of Marmara stretching beyond.

Although its own setting is inevitably far from the sea, the closely contemporary Masjid-i-Shah at Isfahan comes to mind. Shah Abbas I, a great ruler and an effective leader in forcing Ottoman withdrawal from Persia, was creating a new and wonderful capital out of Isfahan. There, across the extent of the vast hippodrome-like area of the tree-lined maydan, the soaring minarets and high dome of the Masjid-i-Shah represent the culmination of Persian mosque-building – very much as does the Ahmediye in its tradition. Luxuriously tiled outside as well as inside, the Isfahan mosque is even more richly decorated, and more profoundly entitled to be described as blue. Otherwise opponents, the Shah and the Sultan were united in their affection for art; each was impatiently pressing on with a major building, though the Shah did not live to see his completed.

That Mehmed Ağa, the architect of the Ahmediye, had been a musician and worker in mother-of-pearl is really too neat a preparation, yet in the fluidity of the building there seems something musical, just as there was certainly a concern with highly finished detail in its furnishings. Mehmed

X Carrying of festival devices; miniature by Osman in the *Sûrname* of Murad III

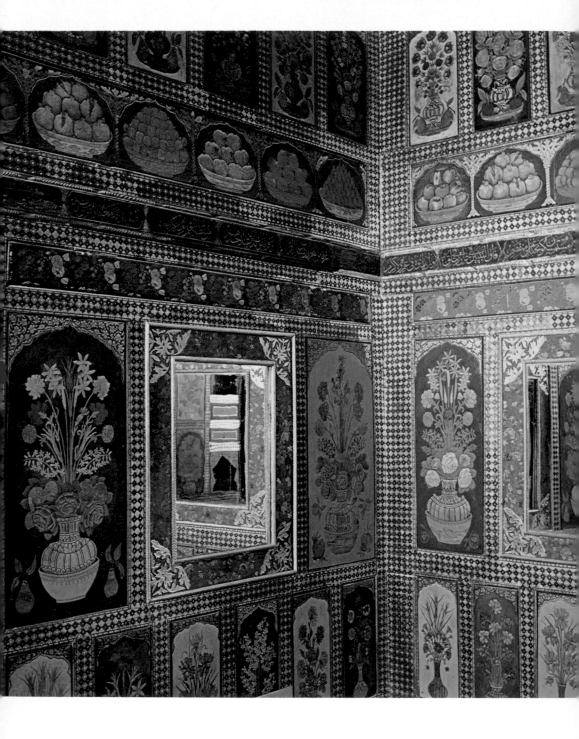

Ağa had built an inlaid throne for Ahmed I at the Saray and must have seen to it that all the inlaid work in the mosque was of the finest quality. The Venetian gift of glass for the windows has now gone, as have the ostrich eggs and crystal spheres originally suspended among the lamps. But the doors, the carved marble pulpit, and the positive museum-array of assorted tiles, remain. To the decoration provided by the massed patterns of so much tiling has been added blue stencilling, up pillars and over arches in a way strictly indefensible but by no means ineffective – and perhaps not entirely against the taste of the decorator-architect himself. If the blueness of the Blue Mosque is largely a later contrivance, it nevertheless seems clear that an elaborately ornamented interior was the intention of both Mehmed Ağa and his patron.

65

Mehmed Ağa had definitely known, and presumably been trained by, Sinan. It was almost inevitable that he would be deeply influenced by the much greater man. Round the Ahmediye hover hints of an anthology. The ground-plan is basically that of the Şehzade; the window-filled walls recall the mosque of Mihrimah; even the determination to cover most surfaces with tiling may be traced back to Rüstem Pasha.

Yet the result, inside as much as outside, is more than just restatement or pastiche. After the austerity of the Süleymaniye, and the firm mathematics of Sinan's best buildings, the interior of the Ahmediye is all shimmering, almost swaying – despite its four massive though fluted pillars – in bursts of strong light and colour. Extensive patterning and glass everywhere, even round the mihrab, help to dissolve the fabric of the walls. Higher up, space seems not so much consciously defined and contained, as with Sinan, but loosely organized in ways that set the eye wandering. Segments of half-dome excitingly curve and intersect; sharply pointed, deeply recessed archways form the window embrasures and provide their own vistas. Just because the central dome is not quite large enough to assert itself as dominant over the whole structure, there is perhaps a lack of calm – even a loss of coherence – when the interior is compared with sixteenth-century achievements.

At least some of this difference seems conscious. To call Mehmed Ağa Borromini to Sinan's Palladio would be ludicrously misleading flattery, yet even in linking thus the two great Italian architects of two different centuries there may lie some hint of the need to appreciate Sultan Ahmed's mosque as an achievement in its own right. Sinan's inheritance could never be rejected by Ottoman architects, but the best of later architecture deserves to be approached as more than an echo of him. Indeed, encountered without experience of Sinan's work, the mosque of Sultan Ahmed *is* beautiful and striking, as most uninstructed visitors feel – so perhaps it is a pity if greater knowledge tends to diminish legitimate pleasure. And while justice should be done to the efflorescent and almost casual grandeur the Ahmediye represents architecturally, some areas of its tiled decoration must also be recognized as among the most virtuoso displays of Iznik manufacture.

66

If something of clarity and intense sensuousness has gone by this period from the quality of the individual tiles, there is compensation in the luxuriance and spread of the designs. Almost for the last time within a

XI Ahmed III's 'fruit-room' at Topkapı

64 The 'Blue Mosque' of Ahmed I in Istanbul

mosque, the walls create patches of paradise garden, in half-abstract patterns similar to those of the sixteenth century and in more patently representational ones – including a cypress-tree motif – typical of the new century, and perhaps borrowed from carpet designs. Red is much less apparent; and the blues and greens are becoming misty, more charming than daring in juxtaposition. Sprigged branches appear vertically striping complete panels, or complementing big fan-shaped displays of denser colour resembling peacock tails. A boldly designed whirling pattern of leaves and flowers, with floral medallion centre – like a carpet hung on the wall – may be flanked by narrow panels, each edged with a fretted framework suggestive of a doorway and filled by a slim cypress in stylized tub. These designs are often overlaid in turn by rambling stems which twine round and across the tall pointing cone of cypress, piercing its way upwards through a graceful entanglement of tracery.

Comparably feathery effects – light for all their intricacy – are found in other, later schemes of tiling, notably in the Sultan-Mother's bedroom at Topkapı. Already there is perhaps a touch of rococo prettiness about the Sultan Ahmed tiles; and though it is normal to lament the decline of Iznik heralded by them, it is really more useful to appreciate the last delicate refinements of the style, still capable certainly of adding enchantment to an interior, though its most vigorous effects could never be revived.

A more important tradition seemed to be closing with the completion of Sultan Ahmed's mosque – built, after all, against the strong wishes of the religious establishment. The foundation of an imperial mosque by each

65 An interior view of the 'Blue Mosque' 66 Tile panels in the 'Blue Mosque'

successive sultan had already been interrupted. Ahmed's immediate successors – his brother Mustafa I and his son Osman II – were scarcely to have leisure or opportunity to build anything, or indeed to affect the arts at all. Mustafa was rapidly dethroned to make way for his nephew, whose four-year reign saw a rich train of presents – from elephants to illuminated manuscripts – brought to Istanbul by the Persian Ambassador, the rare occurrence of the Bosphorus frozen over and a violent revolt of Janissaries which resulted in the Sultan's assassination. After the now-deranged Mustafa had been briefly restored and again deposed, Ahmed I's younger son, a boy of eleven, was in 1623 proclaimed Sultan as Murad IV.

Although Murad developed into a great warrior and great builder, a mixture typical of his dynasty too in being actively interested in the arts, a sadist and a poet, he built no mosque. On his premature death in 1640 he was succeeded by the decadent Ibrahim, whose best monument is that elegant, gilded, look-out 'bower' on the terrace at Topkapı. It was Ibrahim's widow – a determined woman revealing remarkable ability in surviving horrors of all kinds, including her husband – who in the mid-seventeenth century decided to build what proved to be one of the last great royal mosque-complexes. Hers was a literal resumption of tradition, for she took over the foundations – and the plans – of an earlier sultan-mother, Ahmed I's grandmother, sent into retirement on his accession in 1603, leaving incomplete her grandiose concept beside the Golden Horn.

Of all the big mosques, the Yeni Valide ('new' sultan-mother) must be 67 the most frequently passed, if not so often visited, given its position on the

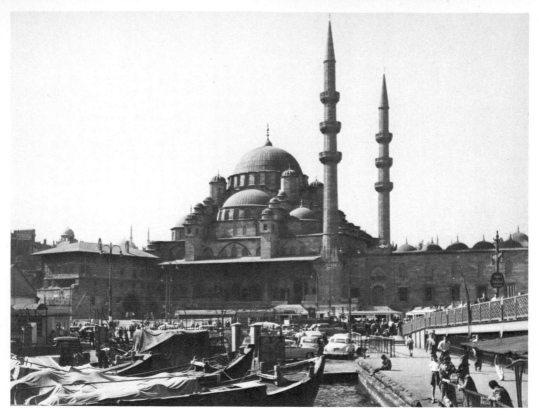

67 The Yeni Valide mosque and the Sultan-Mother's pavilion, Istanbul

busy waterfront just where the sole pedestrian bridge links the two Euro-
pean sides of Istanbul. While its size makes it impossible to overlook – it
remains the fourth largest mosque in the city – there is something rather
forbidding and gloomy about its massive profile approached from the
quay. Yet its interior, despite some dingy, monotonous geometrical tiling,
is unexpectedly fine and clear-cut, far from novel with its four free-standing
piers but the last fully effective statement of Sinan's principles.

Not that the mosque is without novelties, subsidiary yet significant ones
which serve as reminders of the period in which it was actually built. Its
rectangular courtyard contains a richly carved, grilled, domed fountain,
almost a toy structure, of a type which was soon to develop into complete
independent shady kiosks of mixed metalwork and stone set up all over the
capital. Even where such elegant new fountains were not built, the oppor-
tunity was taken to add sometimes curving, sometimes pointed, canopies to
older fountains in mosque courtyards (as at Lüleburgaz), with enchanting
effect.

More obviously novel at the Yeni Valide mosque, and half-hidden away
in access, is another equally elegant but strong hint of future developments:
the Sultan-Mother's pavilion. This plain-looking building stands adjoining
the mosque at the left and is entered up a long ramp from an unobtrusive
doorway at the back of the complex. Perhaps the Valide Turhan originally
had the pavilion built as a survey-point during the construction of the
mosque and its dependencies.

From this quiet retreat today one can gaze down to the crowded quays, the bridge and the steamers, all so physically close at hand yet strangely remote from its small, ravishingly painted rooms, a bower empty of furniture but filled with gilt wood, stained glass, and varied tiles, among them a panelled row of green and blue cypresses. Although the imperial *loge* of the mosque is reached near by, the pavilion suggests a retreat for pleasure rather than for prayer. It looks forward to those slight, graceful, summer pavilions to be built in the subsequent century by Ahmed III and his courtiers, choosing sites, however, far down the Golden Horn, where water and real trees could contribute their charm to the mood of relaxation.

In itself, the Valide's pavilion is one further indication of artistic achievement during the fluctuating middle years of the century. Changes of taste, not lack of confidence, explain the shift it typifies towards the small scale and the elaborately wrought. That this was so is made patent by the brief though brilliant reign of Murad IV.

He showed that the Empire was still a tremendously effective force when controlled by an energetic and ruthless personality. At home, he reformed the court, re-established discipline among the different bodies of troops and legislated – for all his extreme acts of individual cruelty – to protect the peasantry. Abroad, he personally led the army against Persia, conquering Erivan on one campaign and recapturing, on a later one, Baghdad. When he returned to Istanbul, it was to receive perhaps the most tumultuous – and certainly the final – triumphal reception of any sultan. The Bosphorus seemed ablaze with ships firing salutes; the housetops were packed with excited people, eager to witness his magnificent entry into the city in a procession where even prisoners wore fetters of gold, and the victorious soldiers were burdened under the weight of their booty.

That entry symbolized one aspect of Murad IV's achievement – the historical aspect. But the history books are silent over the other aspect by which his conquests were commemorated. Two kiosks built at Topkapı, named Revan and Baghdad respectively, keep alive in the most attractive form the actually appalling events involved. Thousands of ordinary citizens, as well as most of its garrison, had been massacred when Murad eventually gained Baghdad. The kiosk named from it is the quintessence of Ottoman culture and probably the most perfect secular building since the Tiled Kiosk in the late fifteenth century. Indeed, it is like a compression of that into a single-domed room with four symmetrical alcoves. Everything in it (its decoration mainly survives intact) breathes a calm, nicely calculated, never excessive, refinement. Reconstructing its builder's character from the evidence of it alone, one would scarcely postulate his raging aggression and ceaseless appetite for bloodshed.

But Murad IV, who enjoyed practising his bowmanship on living targets, must be given the credit for his artistic pleasures – and for the fact that these were not only unaggressive but small-scale, unlike the man himself who was huge. Perhaps it is partly an accident that the Sultan's campaigns are not recorded in surviving illuminated manuscripts, since that which won Erivan was undoubtedly the subject of illustration by one leading artist of the time, Pehlevan Ali. Yet it may also be that the Sultan preferred to seek

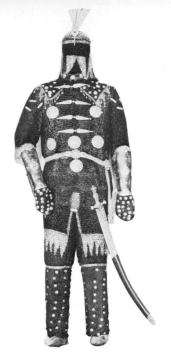

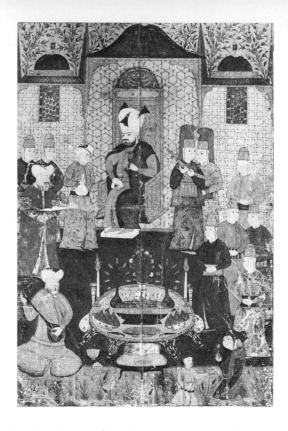

68 Chain-mail suit of armour worn by Murad IV

69 Murad IV enthroned and surrounded by
courtiers; anonymous 17th-century miniature

in art a relaxation from his official, and even from his conquering, role. It is
easy to associate him with the concept of warrior-leader; art could lend
itself to that too, in creating the splendid, brooch-studded suit of chain-mail
68 which Murad wore. But the more hedonistic side of his nature is suggested
by an entry in the imperial tailors' notebooks for 1631 (about the time he
came of age), itemizing as made for him 133 different costumes.

It is not perhaps an accident therefore that one of the most relaxed and
intimate depictions of any sultan should be of Murad IV, shown amid his
69 courtiers. Even here he remains the dominant figure and he remains
enthroned. By the side of the seventeenth-century Deccan miniatures
mentioned earlier in this chapter, the effect is still formal. No women are
present and nobody except the Sultan seems to be much enjoying himself.
Nevertheless, by Ottoman standards of art and etiquette the scene is almost
shockingly free. There can be few other paintings of sultans clasping – not a
flower but a wine-glass (a frank touch of realism here, for drunkenness was
high among Murad's vices). Other senses are delicately catered for too in
this pavilion in a garden setting: musicians play, grouped about a round
table arranged with vases of flowers as well as with fruit, while a servant
with wine-flask thoughtfully approaches the Sultan to fill up his glass.

Such a life-style certainly accords with the mood of the Revan and
especially the Baghdad Kiosk, though the first, the less elaborate and slightly
less interesting, was apparently designed for religious retreat or meditation.
Whatever its original purpose, it is bound now to appear something of a
trial effort towards the full and perfect achievement of the later and larger
kiosk. Still, it has its own quiet charm, set away over the tulip garden and

furnished with sofas, a tall, typically hooded fireplace and inlaid shutters. It represented perhaps the furthest withdrawal of Murad IV, into nearly total isolation, before the Baghdad Kiosk was put up.

That building occupied the last area of raised ground at Seraglio Point, *70* its now glazed arcaded porch providing views across the expanse of the Bosphorus over towards Asia and down the Golden Horn. In sunlight its broad eaves suggest a summer-house and its interior is cool, yet radiant, with fresh-coloured floral tiles, turquoise, blue and white, alternating with shutters and cupboard doors of fine mother-of-pearl inlay, all lit by wide, frequent windows of patterned, coloured glass. On a misty winter day, the interior is not so much spacious as shadowy and wonderfully protective; the low sofas deep in the window embrasures, the decorated red dome overhead, the central brazier, as well as the pointed bronze chimney-piece, serve no less effectively to create a mood of intimacy and exclude the out-side world.

The Baghdad Kiosk is the culmination of all Ottoman attempts to suspend time. It is the complete crystallization of the concept of 'a stately pleasure dome'. More than two hundred years earlier, the builders of the Green Mosque at Bursa had inscribed that as being a reflection 'of the Infinite Garden of Delight'. Something similar, if more secular, could be claimed for the perfection captured in the Baghdad Kiosk with its starlike layout, its clarity, its symmetry and its marriage of materials, all making it the ideal habitation at all seasons – for ever.

If the seventeenth century produced no other work but this, it would still have made its contribution to Ottoman art. In fact, it had a good deal to show, as has been seen, though nothing else which expressed so splendidly a great political achievement through a great artistic one.

70 Interior of the 17th-century Baghdad Kiosk, Topkapı

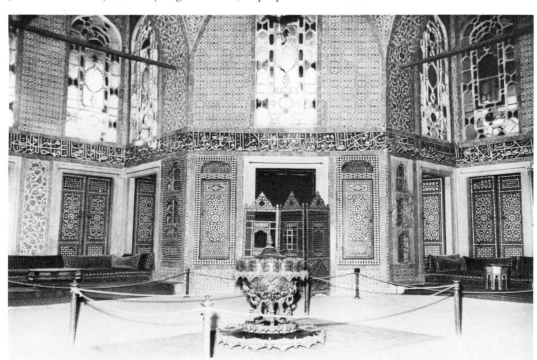

5 Intimations of Rococo

In Europe the coming of the 18th century brought a marked delight in exotic modes and exotic artistic styles which did not fail to include the Turkish. The *turquerie* became – especially in France – a popular category of picture. Turkish costumes and even Turkish-style buildings were fashionable. Music *alla turca* was a recognized diversion. And for plays, ballets and operas, the stage was filled with magnanimous pashas, jealous sultans, beautiful slaves and harem attendants.

Meanwhile, the Ottoman court was growing increasingly fascinated by European styles of art and culture. Not only were European-influenced pavilions built, but the mid-eighteenth-century Nuruosmaniye mosque was meant to be – and is – something very novel: a Westernized building. European costume was to follow. In 1808, about the time that Byron (not yet having travelled outside England) was ordering a rich Turkish costume for a masquerade in Nottingham, a new Sultan, Mahmud II, came to the throne; he was to be the first of his dynasty to adopt European dress and compel officials of all kinds to do so. A picturesque aspect of Ottoman culture was extinguished.

The eighteenth-century exchange and mingling of influences was, on neither side, just accidental or merely playful. Certainly there was attraction in spicing the familiar and the traditional with novelty. Both cultures were, after all, highly sophisticated. But by the eighteenth century each was anxious to perfect, in its own way, a climate of *douceur de vivre*, where pursuit of agreeable sensations, rather than glory, might be thought a reasonable, laudable ambition. Ottoman sultans had long recognized that small rooms made the most pleasant setting for their private lives. Louis XV and Madame de Pompadour were in effect taking the hint in building themselves modest pavilions and small apartments; and Louis XV's father-in-law, Stanislas of Lorraine, was directly influenced in creating kiosks by earlier captivity in Turkey.

It is a genuine tragedy of the Ottoman Empire that the very qualities of being enlightened, peace-loving and Westernized should have appeared faults in the eighteenth-century sultans and that when their state was at its least aggressive some European power, or Russia, should usually choose to attack it. Thus the century is framed within two depositions – and not of insane, bloodthirsty tyrants. Ahmed III, deposed in 1730, was a great artistic patron, an idle ruler no doubt but one with a wise Grand Vizier. Selim III, educated by European tutors, liberal, humane, was active in the cause of peace and eager to reform abuses, above all those symbolized by the Janissaries; he was deposed in 1807 and murdered the following year.

The appeal of Turkish things to Europe was – on a serious level – only one aspect of awareness that the non-Christian world was not necessarily inferior or evil; it might, on examination, be more tolerant, more civilized than one's own world. Turkey perhaps represented the extreme paradox. *Le Turc généreux* was the title of just one mid-eighteenth-century ballet. At the end of Mozart's opera *Die Entführung aus dem Serail*, the Turkish Pasha Selim behaves in a noble, high-minded way that is shown contrasting strongly with Christian tendencies; and he teaches a lesson in magnanimity to the Spanish Christian hero: 'should you become at least more humane [*menschlicher*] than your father, my action will be rewarded.' It could almost be Selim III speaking.

Yet, at the same time, the appeal of European things to Turkey was based very much on a similar premise. Instead of representing merely the traditional infidel foe, Europe now came to stand in court eyes for certain refinements which the Empire had lacked. It was not only a question of bottles of Burgundy and plans of princely French gardens or pavilions. Printing was introduced by the government for the first time in the eighteenth century; and in 1729 appeared the first secular book printed at Istanbul, an Arab-Turkish dictionary. Knowledge was encouraged, with the building of libraries, as well as new schools, during Ahmed III's reign. Enlightened opinion suggested that strangulation or imprisonment of one's brothers, and other male relations, on becoming ruler was no longer fashionable in Europe. Before the end of the eighteenth century the Conqueror's code of legal fratricide had been set aside; Selim III owed his life and reign to the fact that his uncle Abdül Hamid I refused to behave so barbarously. Very tentatively, under Selim III, was to be produced a quite startling innovation, a small newspaper – in French. Another followed under his successor Mahmud II, whose own innovations included founding an up-to-date medical school.

Since eighteenth-century Europe took much of its civilized tone from France, it was almost inevitable that French art and culture should be the most significant influences on the Ottoman Empire. There was also the tradition of the alliance with France, going back to the time of Süleyman 'the Magnificent' and François I. During the eighteenth century, that was to be warmly revived and interrupted only briefly by Napoleon's invasion of Egypt. Several of the sultans were strongly Francophile. That fact is established without needing to rely on the romantic legend of the captured French girl who supposedly entered the harem and rose to become Valide Sultan in the late eighteenth century.

Most fundamentally relevant, for art and artistic exchanges, is the fact that a style fostered in France early in the century – rococo, *rocaille* or *style Louis quinze*, as it might be – chimed so well with Ottoman ideals at the same period. Painting had to be graceful; and at Ahmed III's court the painter Levni created sinuously swaying, etiolated figures, floating if not positively dancing, whatever their actual occupation. Much of the architecture required was small scale, whether library, fountain or pavilion. Nature itself was in fashion, though nature adorned and improved. In France Madame de Pompadour might order a winter garden of porcelain

flowers. At Istanbul, to celebrate his sons' circumcision, the Sultan had a parterre of different-coloured sweets made from which the child-guests doubtless took their pick.

Some interiors particularly could almost present problems of origin: are they European variations on a Ottoman theme or Ottoman adaptation of the European? Just how perfectly matched the two cultures could become is shown by the slight yet striking example of the rococo brazier standing so suitably in the rococo glass room of the Sofa Kiosk at Topkapı. The room is Ottoman-cum-Oriental, tinged with Western awareness in its windows and pilasters. The swirling, gilded brazier, designed with a touch of Eastern extravagance, was one of a pair made by the elder Jean-Claude Duplessis, as a gift for the Ottoman Ambassador from Louis XV. And elsewhere at Topkapı such rococo blends occur, not always so neatly, but still charmingly.

There must have been much more of this style than unfortunately survives, at least round Istanbul. Away from Topkapı painted wooden pavilions could easily be left to moulder from neglect, even when not deliberately destroyed. Almost more exquisite than anything perhaps actually in existence are the descriptions by Lady Mary Wortley Montagu of the houses and pavilions she visited in 1717–18, when her husband was English Ambassador at the sultan's court. She mentions the ceilings of Turkish houses as 'generally inlaid or painted and gilded', and describes the typical wooden wainscoting, 'set off with silver nails or painted with flowers'. Purely rococo seems the decoration of one kiosk she visited, where the roof was 'painted with all sorts of flowers, falling out of gilded baskets, that seemed tumbling down'. Nowhere, probably, does anything so virtuoso and illusionistic in effect exist today. The closest is Ahmed III's small 'Fruit Room', where the rows of painted vases of flowers are as delightful as the piled-up bowls of painted fruit. Combined with the flower-sprinkled, lace-like fireplace, the ensemble represents a quintessence of Ottoman rococo.

It conveys well enough the charming character of art fostered at court during the reign of Ahmed III – someone who seemed to Lady Mary Wortley Montagu, scrutinizing him as he rode past her window, 'a handsome man of about forty, with a very graceful air, but something severe in his countenance, his eyes very full and black'. In fact, the Sultan was rather older than forty, but perhaps the *douceur de vivre* generated around him affected even his appearance agreeably.

Poetry, painting and feasting – all of the choicest kind – were encouraged by his Grand Vizier, Ibrahim, at least as much as by the Sultan himself. After the Peace of Passarowitz in 1718, the Empire, itself apparently quiescent, was left undisturbed. Outside the enchanted circle of the Sultan and the Grand Vizier, rising prices and discontented Janissaries, allied to a growing hatred of the court's luxury and Western ways, might presage a stormy future. Within it, the business of the day was to devise yet another fête, purchase tulips, or arrange a pleasure-trip down the Bosphorus to some waterside pavilion. The great lyric poet of the period, Nedim, wrote of his love as coming holding a rose in one hand, a cup in the other; and that

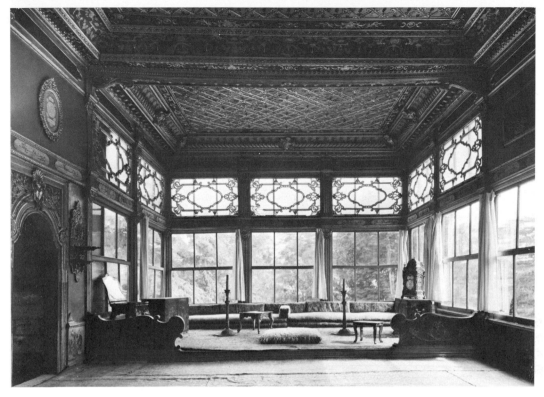

71 18th-century interior of the Sofa Kiosk, Topkapı

about sums up the fashionable attitude to life. Even his sons' first day at school provided Ahmed III with the opportunity for festivities, given in the now-destroyed, hardly educational-sounding Pearl Kiosk.

If Ahmed III was living dangerously, without knowing it, he was also living in a reasonably civilized way. A tulip-fête on an April night in the gardens of Topkapı – with coloured lights and carefully selected colours for the guests' costumes – was more inventive and closer to a work of art than the colossal, dreary slaughter of men and animals caused by Ahmed's father, Mehmed IV, on his hunting expeditions, not to mention the insane violence of the Sultan Ibrahim, Ahmed's grandfather.

Some of the feasts and entertainments enjoyed by Ahmed III survive in the lively medium of miniatures. Many of these are sharp and vivid enough. Others, however, are really more interesting for documentary than artistic quality. There is something a little mechanical even in their vivacity when compared with the very similar-style scenes painted late in the sixteenth century for Murad III. Nor is this so surprising; the convention had been in existence long enough to be growing stale.

A new and typically rococo breath of sophistication entered Ottoman painting with the work of Levni, who became Court Painter to Ahmed III and who is said – according to some modern accounts – to have died in poverty shortly after Ahmed's deposition in 1730. Although plenty of painters went on being employed, he is really the last distinct personality in Ottoman art. Levni himself painted some of the finer festive scenes involving the Sultan; and it was probably his pupils who produced the others.

72 Girl dancing; by Levni, Court Painter to Ahmed III

But his particular style was at its most personal in larger-scale, usually single figures of dancers and musicians, of girls carrying water or doing their hair. In contrast to the carefully detailed setting of festival pictures, these figures are placed with the minimum of distraction on the bare page. Animated by wiry, graceful lines, they express an extreme of refinement which is characteristically rococo also in its wit.

Levni seems intentionally amusing when he depicts a large lady smelling a carnation with one hand while with the other raising a fold of her voluminous robes. No less gently satiric seems the depiction of a very young court official, lightly clasping a halberd and gesturing with almost affected elegance. These are both identified portraits – not caricatures or stereotypes. That in itself is a novelty for Ottoman art, since neither person is high ranking or important. They are part of the evidence for the sense of a more humane, relaxed and openly enjoyable atmosphere introduced in art and life, under Ahmed III.

The buildings associated with that Sultan certainly do not contradict such ideas. They are as elegant as Levni's creations: ideal structures for the use and pleasure of graceful, casual, unpreoccupied people. And what was launched under Ahmed III continued to be typical of the century. The rococo was too perfectly suited to Ottoman taste to disappear when it dwindled and disappeared in Europe. Gilt shells and scrolls, pieces of mirror, painted landscapes and flowers, fretted and curved glittering decoration of all kinds – all the manifestations of rococo, with a Turkish accent, remained for the sultans in fashion up to 1800, if not later. Louis XV might have died twenty-five years before but vague concepts of the *style Louis quinze* still represented the height of sophistication at Istanbul.

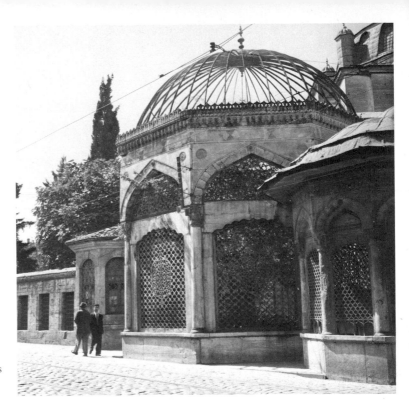

Selim III, who came to the throne in 1789, the year of the French Revolution, could pay his mother no more affectionate tribute than to redecorate her apartments at Topkapı in a riot of rococo, regardless of any rules of taste, but enchanting in its uninhibited, playful fantasy.

Indeed, rococo of that kind (sometimes with odd *chinoiserie* flourishes) was never quite to die out in Ottoman art as long as the Empire lasted. It would always touch a chord left unstirred by the severities of classicism or neo-classicism. It was, after all, a style opulent as well as graceful, and nicely fitted to serve not only for interior decoration but for the small-scale monument, gateway, fountain or tomb.

Ahmed III did not build a mosque for himself. It was his mother whom he honoured with a mosque at Üsküdar, situated still among shady trees, not far from the Jetty mosque of Süleyman's daughter, Mihrimah. More memorable than the elegant Valide mosque itself is the Sultan-Mother's tomb at the left of the entrance to the complex: like a giant, rococo bird-cage, with fine filigree grillework, supported by a few arches, encircling an expanse of grass open to the rain and sun. It is perhaps the most frankly pretty and fragile looking of all Ottoman tombs, less substantial than many an eighteenth-century fountain though preluding them in its gracefulness. Ahmed III was to receive no tomb of his own (dying deposed, disgraced, and virtually imprisoned), but in this large yet airy structure poetically mingling art and nature he, as much as his mother, is commemorated.

More consciously commemorative, privately and publicly, are the Library and the fountain built by him at Topkapı. His Library is, in effect, a kiosk of a new kind, small-scale yet the very opposite of cramped, and

73

74

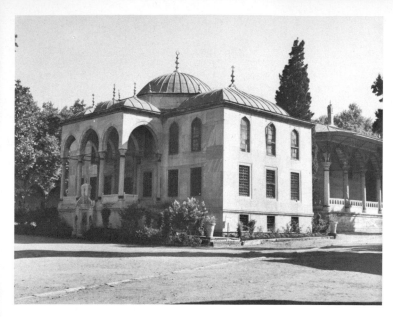

74 The Ahmed III Library, Topkapı

constructed out of the most durable materials, marble as well as stone. This is no temporary pavilion, still less some huddled, hastily redecorated harem apartment. Standing prominently on its own in the centre of the third courtyard, the Library virtually steals the thunder of the near-by throne-room itself. Flights of steps lead up on both sides – in faint echo perhaps of the raised approach to the Tiled Kiosk – to the domed tripartite interior, divided by pillars into wide reading-bays which are seen on examination to be in fact unequal, though undisconcertingly so.

75 Luminosity, suitably enough, seems the aim of what is really a single airy arched room. Its windows are filled not with thickly patterned, plaster-set, stained glass, but with large transparent panes, enlivened by just a few thin, serpentine ribbons of colour, more suggestive of Viennese *art nouveau* than of anything endemically Ottoman. The room is far from lacking in character, but its character – like its charm – is cosmopolitan

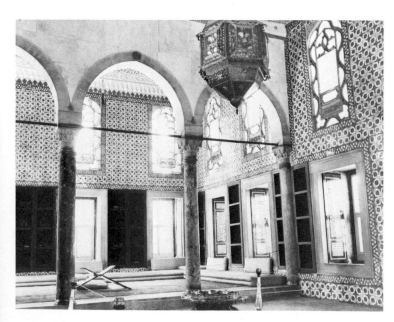

75 Interior of the Ahmed III Library

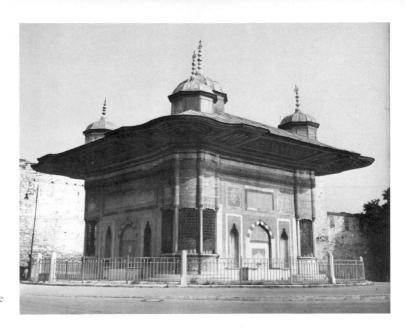

76 Fountain built by Ahmed III outside the gateway at Topkapı

and distinctly novel. This easy, uncluttered and light-filled style of interior reappears at its most graceful in the Sofa Kiosk, a pavilion of glass framed in wood, half-Japanese teahouse and half-rococo coach without wheels. The achievement of Ahmed III's Library is to catch the same buoyant light and lighthearted mood in a much more solid, seriously architectural structure – an achievement not exactly duplicated even by the architecture-loving sultans who followed him. Other libraries, however, were to be built in his reign; and the arcaded entrance courtyard of the Library complex founded near the Şehzade mosque by his Grand Vizier, Ibrahim, continues the new, relaxed style, the unforbidding scale and the sense of invitation to linger.

In the concept of the public fountain, all that was to be concentrated. Ahmed III began the fashion for creating, on ambitious scale, no mere wall-fountains but free-standing, broad-eaved, turreted buildings. The one put up by him just outside the gateway at Topkapı was personal to the *76* extent of bearing a verse chronogram specially composed by him, and it remains the finest of its elegant kind. The principle is that of the pavilion or even tomb – a complete shrine to water, which cannot actually be entered but which provides both a natural gathering-place and a public benefit.

The invitation to linger is enhanced by the panels of decoration, where lightly incised patterns of fruit and flowers remind one of water's life-giving property. Every surface is ornamented, carved with calligraphy, inset with tiling, intended to be gilded – all turning the walls insubstantial. The four corners of the building are curved in a truly rococo way, and lightened further by being treated as almost separate minute fountain-kiosks of their own, with thin pillars separating the high, lace-like grilles.

The Sultan himself becomes associated with what he has set up for the public good. This aspect of enlightenment was old and traditional by Otto-man standards, compared with Western Europe, where it was a novelty in the mid–eighteenth century to have, for example, a statue to a monarch

without captives at his feet. The Topkapı fountain is Ahmed III's imperial monument. It is positively useful – not merely self-glorifying – and at the same time richly beautiful. In gathering to enjoy it, the public are asked by its creator to remember him. His chronogram conjures the user to, 'Drink . . . and say a prayer for Sultan Ahmed.' Its date is 1728. Two years later the Sultan was deposed and his nephew, Mahmud I, was placed on the throne.

If the Janissaries, who had forced Ahmed III to sacrifice his liberal, cultivated Grand Vizier before they had forced his own deposition, believed that the new Sultan would prove a more conventionally aggressive character, they were mistaken. Addicted to peace, clemency and the arts, Mahmud I continued, indeed increased, the cultured tenor of his uncle's reign. A treaty was signed with France and the Ottoman Ambassador received by Louis XV at Versailles. At Istanbul, Western influences grew more patent – in culture and in methods of warfare. It was in Mahmud I's reign that the Sofa Kiosk was redecorated to its present perfection and that Louis XV's gift of two braziers designed by Duplessis arrived, as well as a group of French gunners. The Sultan's taste for opulence is conveyed by his commissioning of a silver throne and by the jewel-sheathed, emerald-
77 hafted dagger (probably now the most famous item in the Treasury at Topkapı) which was intended as a gift for the Shah of Persia but which Mahmud I was doubtless not sorry to recover when the Shah was murdered before receiving it.

Although Mahmud I built several fountains, among them the large, faintly Indian-looking one at Tophane, it was leading figures at his court who were responsible for smaller and even more graceful, almost playful fountain constructions – sometimes scarcely more than a screen of grilles and a minute circular pavilion (no bigger than a modern newspaper kiosk or refreshment stall) with pointed, undulating or turreted roof. The idea of a shrine was often reinforced by combining the tomb of the founder and his relations with the fountain. This is done in probably the most enchanting of all these virtually weightless, musically fluid rococo structures, the

77 The emerald dagger of Mahmud I

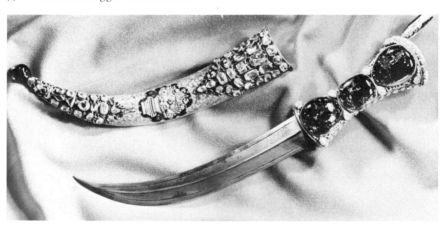

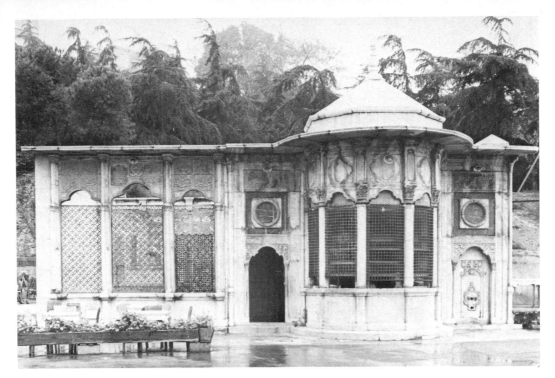

78 The Hacı Mehmed Emin Fountain, Dolmabahçe

Hacı Mehmed Emin Fountain at Dolmabahçe, built in 1740. That today 78
this has become a small café seems utterly right for its mood, which – as
usual where Ottoman tombs are concerned – is without any morbid over-
tones.

The Hacı Emin open-air kiosk (which is really what it is) could suitably
take its place among European garden pavilions. It would not be incon-
gruous in the grounds of Nymphenburg or Versailles. If there it might seem
a cheerful *capriccio* variation on a vaguely Oriental theme, at Dolmabahçe
the effect is more of Turkish architecture dancing to a Western measure.
Use of Corinthian columns, with suggestions of scroll-work and shell in
the exuberant, highly decorated areas of wall (lacking only inset mirrors to
complete the effect of interior turned exterior) increases the structure's
hybrid, international rococo character. It is resolutely un-grand and un-
solemn, but – on a deliberately minute scale – totally accomplished.

Hardly less hybrid but vast in comparison was the major building begun
by the Sultan: the Nuruosmaniye mosque. With that Mahmud I re- 79
established the tradition of the imperial mosque – and at least two of his
successors were also to create mosques that are works of art. Mahmud I
is said to have wished his mosque to be built in Western style but was
dissuaded from this by the religious establishment. However, if the story is
true, the Sultan seems to have largely had his way, for the resulting com-
plex is more Western than traditionally Ottoman. Indeed, it is as radical a
break as possible with rectangular ground-plans; and though the actual
mosque itself had to remain a square, covered by a single dome, its court-
yard is a boldly sweeping horseshoe shape.

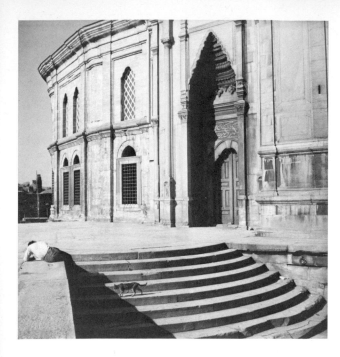

79 (*left*) View of the Nuruosmaniye mosque in Istanbul

80 (*right*) Osman III's kiosk, Topkapı

To enter that theatrical space, laid out on a broad raised platform, is to become immediately aware of aims quite startlingly novel. Its unknown architect, encouraged doubtless by his patron, seems to be straining everywhere to melt straight lines into curves. Inside the mosque the mihrab niche has become a great curved apse. Springing movement is felt in the steep curve of arches, cluster of galleries over arcades and a general flamboyance of detail – well prepared for by the main gateway. Only strong religious conservatism, one suspects, prevented the mosque itself from being circular or even oval. In a single building, all the aspirations of monumental Ottoman architecture to become baroque are grandly realized. Splendour of material – marble throughout – is joined to splendid decoration. Rococo delight in gilded grilles, and curved corners, along with love of swelling roofs and undulating eaves, has here been fulfilled on a dramatically big scale. All that is lacking is a proper angle from which the impact of the whole complex can be appreciated. Most photographs of it are from the air; only thus, in a crowded city, can its full bravura be seen. Perhaps the Sultan dreamed of clearing more space round his highly personal creation, which anyway perhaps needed a city such as Rome to do it full justice. But Mahmud I died before the building was completed, and its eventual name commemorates his successor and brother, Osman III.

The completion of the mosque represents publicly the cultural achievement of Osman's three-year reign. Privately, his brief period as Sultan is
80 represented by the unexpected exquisiteness of the wooden kiosk he built for himself at Topkapı, perched high over the Bosphorus. Little is known of Osman III's character except that he seems to have disapproved of most pleasures (including music) – though apparently fond of eating and building. It is as if no eighteenth-century sultan could fail to encourage this last activity. None could leave the harem apartments at Topkapı as he found them. If not positively rebuilt or extensively added to, the rooms (down to,

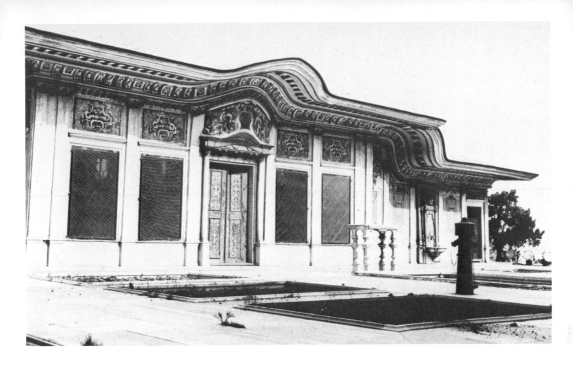

often particularly, the bathrooms) underwent increasingly Westernized redecoration.

Building and decoration retained their vitality, while the other arts at last began to show distinct signs of expiring. In miniature-painting the Ottoman tradition virtually ceased with Levni. Osman III employed as Court Painter an Armenian called Raphael, whose name might raise in the West expectations not fulfilled by his work. At Iznik the tile workshops had long ceased to produce anything fine or original. Admittedly, a new style of pottery was started at Kütahya in the eighteenth century – with scattered, pretty flower patterns – but it was really one minor, final breath from what had once been a wonderfully vigorous artistic organism. For the fountain of Ahmed III tiles were manufactured at an Istanbul workshop set up earlier during the Sultan's reign; but the results seem rapidly to have been recognized as feeble, and the workshop was closed. At least some types of carpet also lost originality and depth of colour. The demand at court for rich and highly wrought *objets d'art* had naturally not ceased; but the least puritan taste must grow a little uneasy before the spectacle of Chinese porcelain specially studded with jewels. There are times, too, when even the largest uncut emerald cannot quite excuse a lack of artistry in its setting. Diamond-sprinkled coffee-cups were not perhaps a feature of court life until Abdül Hamid II in the late nineteenth century, but lavishness of that haphazard, rather desperate kind was gradually taking over from any stylistic discipline.

Only architecture – in the widest sense – continued to evolve. The Nuruosmaniye was a positive inspiration when Ahmed III's son, Mustafa III, succeeded Osman in 1757. From his father he had inherited a fondness for the arts and to them he added a distinct interest in theology and the occult. His reign was long (until 1774) but politically disturbed by the deliberate provocation of Russia under Catherine the Great – a foretaste of

sustained pressure on the Ottoman Empire throughout the subsequent century. Dramatic physical disturbance came to Istanbul in 1766 with an earthquake which brought down almost all of Mehmed 'the Conqueror's' mosque and also Mustafa III's newly built Laleli (Tulip) Mosque.

81 The Nuruosmaniye design had already, in simplified form, been transported across the water to Üsküdar, where on the hill behind Mustafa III founded a mosque in honour of his mother. In the Laleli Mosque lie more echoes of the Nuruosmaniye – though not of its courtyard which remained uncopied – including its position on a raised platform, approached by flights of steps. By accident, the Laleli complex associates together the three last eighteenth-century sultans. After long remaining in ruined state, it was restored in 1783 by Mustafa's successor Abdül Hamid I – and to this fact perhaps it partly owes its lighter treatment in comparison with the earlier, more heavily baroque building. Mustafa's tomb, at the gateway of the Laleli complex, catches again that swelling, forceful baroque; and there his deposed, murdered son, Selim III, was also to be buried.

Mustafa III's imperial mosque thus has connotations for much of the century. If in certain ways it looks back to the Nuruosmaniye, in others its pierced façade of many windows and open arcades, and its shallow buttressed dome, look forward to Selim III's own imperial mosque at Haydarpaşa (where he might have been expected to be buried, and surely would in less hectic times). Decorative elements of nearly distracting and disparate kinds help to enliven the Laleli Mosque's silhouette and general effect. Its minarets terminate in amusing bulbous shapes of almost mock-Oriental character. Pepperpot turrets sprout with something of the freedom of urns, say, on the façade. At Selim III's mosque urns were to be used. The compact sense of earlier architecture is broken up in a consciously picturesque way, as if preparing for incorporation in romantic vignettes and engravings.

As we see it today, the Laleli Mosque seems 'restored' to the taste of the later years of the eighteenth century, when Abdül Hamid and his ill-fated successor Selim III were struggling to create a more liberal, reformed and enlightened climate. They did not succeed in political terms, but what Selim especially had attempted was to be firmly achieved in the early nineteenth century by Mahmud II. Indeed, the Sultan deposed by the Janissaries was aptly revenged when Mahmud II suppressed them bloodily and for ever.

One single mood of graceful baroque – a sort of rococo shading into Regency – extends across the chronological divide of the two centuries, though it is convenient to exclude Mahmud II's reign from this chapter. The lure of the West was all the time increasing. Foreign architects began to be summoned and employed. Soon, some of the more disastrous aspects of Western approaches – the palace that is truly palatial in size, with décor of grand hotel impersonality – would influence a move from the cramped yet still enchanted bowers of Topkapı. Big white marble palaces in a style defying any exact descriptive adjective would rise along the Bosphorus.

It does not at all follow that the withering of indigenous elements in itself caused a decline – still less that some of the later bizarre buildings must be either bad or uninteresting because they were built by non-Turkish

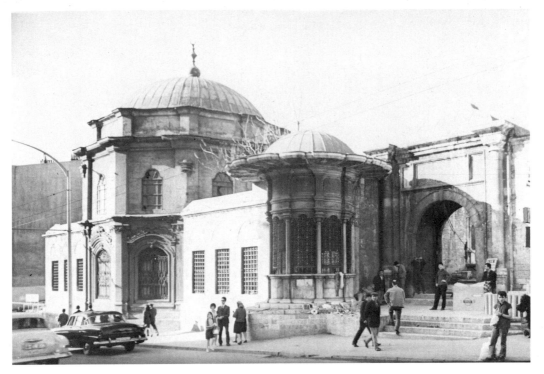

81 The Laleli complex, Istanbul

architects. But a certain stylish gracefulness, not unconnected with *douceur de vivre*, was to disappear in Turkey (as, indeed, elsewhere) under the heavy tread of the advancing nineteenth century. In Turkey the irony was perhaps the greater, owing to time-lag. When the sultans were planning massive European palaces which it might have daunted even Louis XIV to inhabit, European monarchs like Queen Victoria were seeking homely retreats in such places as Osborne, called by her – in good Ottoman fashion – a 'little Paradise'.

At the end of the eighteenth century that was still the environment the sultans created for themselves and for those members of the imperial family – chiefly women – whom they wished to honour. Above all, the Valide Sultan might enjoy apartments decorated in what was to prove the last, if not the latest, style – since these decorations were never to be re-placed. In death she could expect an equally elegant tomb, probably attached to a complete mosque-complex; and in one of the largest, as well as most crisply ornamented, Mahmud II buried his mother Nakşedil Sultan.

Abdül Hamid I had honoured his mother, Rabia Sultan, with a mosque at the village of Beylerbey, not merely beside the Bosphorus but utilizing and including the wide setting of water and quay in a new picturesque way. Combined with the equally new prominence given to the line of raised-up royal apartments (in effect masking the mosque façade as it is seen from the quayside), the result is almost more palace than religious building. Selim III's mother, Mihrişah Sultan, was herself responsible, apparently, for her complex out at Eyüp, built in the very last years of the century, and far

82 Selim III's salon, Topkapı

more ornately elegant in all its detail than the plain white mosque near by, rebuilt by her son.

As Valide, Mihrişah seems to have shown a distinct fondness for building. Several fountains were put up by her, some very slight though one at least – that on the shore of the Bosphorus at Göksu – 'extremely elegant in design and elaborately ornamented with arabesques' in the words of Miss Julia Pardoe (whose book *The City of the Sultan* records enthusiastic impressions of Istanbul in 1836).

Much the same words might be applied to the Valide's apartments and those of Selim III at Topkapı. There, amid curlicues of richly gilded wood, panels of tiles, mirrors and fanciful landscape views, a final rococo enchantment is fused out of Islamic and European elements. In the salon of Selim III, with its writhing, almost dripping gilt fronds and green paintwork, framing the shell-decorated, fountain-like fireplace, the style seems to reach its crescendo. Beyond this extreme of fluidity, fixed precariously,

there can be only a dying-away or total deliquescence. What has been created in rooms like this is the ultimate retreat from reality: as far removed from that as some marine grotto, which Selim III's salon resembles.

Amid the artistic enchantments it is not altogether too fanciful to detect a certain ennui in the actual life-style. Painted landscapes have to serve as windows on an unvisited world – or one seen only fleetingly from a latticed carriage or between the curtains of a fast-moving caique. No amount of art can quite banish the ubiquitous sense of claustrophobia – and even possibly a faint touch of Ludwig of Bavaria's unbalanced fantasy in the cocooning against outside pressures. Still, such retrospective feelings about the daily existence of the most privileged people in Ottoman society would probably have amazed the creators and inhabitants of these beautiful rooms.

Selim III was energetically enlightened. He promulgated a 'New Order' which should reform the government, improve methods of taxation and substitute for the Janissaries a new, European-style army. He was a monarch of the kind to win Voltaire's approval. Though his fate was no better than Louis XVI's, he ought to have become an Ottoman Frederick the Great. And, after all, Frederick had also managed to create the exquisite, civilized setting of Sans-Souci, in some of the earlier interiors of which lie perhaps the closest parallels to Selim's Topkapı apartments of some forty years later. Strangely, it is not hard to see in Selim III fiction turned into fact: the Pasha Selim of Mozart's *Die Entführung aus dem Serail*, who is not only magnanimous, optimistic and upright but devoted to building, immediately welcoming into his service the opera's European hero because he comes in the guise of an architect.

The opera ends with a Janissary chorus wishing long life to their master. Reality proved less amenable. The 'New Order' provoked in 1807 the deposition of the Sultan, effected by the Janissaries and supported by the religious establishment. After an uprising in his favour, Selim III was strangled, not far from those frail-seeming, glittering rococo rooms – surviving today as the best record of all his endeavours.

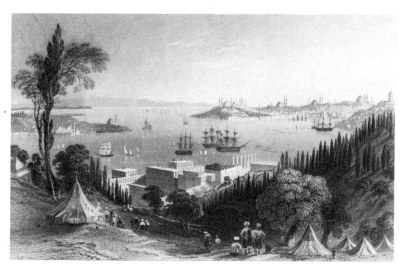

83–85
Three 19th-century
views:
the summer palace at
Beylerbey, Yalis along
the Bosphorus, and the
'new' palace at Beşiktaş

6 The exotic West

When in 1599 Thomas Dallam entered the Sultan's presence, to play the organ built and brought by him as an English royal gift, he had encountered such dazzling alien splendour that it 'did make me almoste to thinke that I was in another worlde'. And if Dallam is discounted as somehow too humble or impressionable a witness (though as an Elizabethan not unacquainted, presumably, with splendid sights), the Earl of Winchilsea – writing of his reception as Ambassador – was scarcely less awe-struck at the exotic scene, just over sixty years later. White marble pavements, a 'pleasant fountain of water', a suspended ball of gold studded with diamonds, 'and above it chaines of rich pearle', were mere preludes to the room, 'embroidered with golden wire' and covered in carpets and crimson velvet, where the sultan sat. Later in the seventeenth century, in October 1688, the *London Gazette* (which published a good deal of detailed Ottoman news) reported the no less sumptuous state in which the new English Ambassador was received by the new Sultan Süleyman II, seated 'upon a Throne in the form of a Bed, covered also with a Silver Embroidered Crimson Velvet, set with Pearls. He wore a great Turbant [sic] with Heron Feathers set in Jewels of great value and covered (as well as his Vest) with Diamonds.'

By the early nineteenth century the tradition of such splendour had not waned. But what was drastically changing was the style through which it was expressed. In fact, increasingly, there was no distinct Ottoman style at all – only, as far as the court was concerned, a confused luxury of effect which drew on the outside world to a much greater extent than on the Empire. Where once it was the finest Iznik ware which alone served for the sultan, it was now more likely to be Sèvres (and by no means always the finest of that).

When the sultans quitted Topkapı, they virtually signalled surrender of their native artistic culture, without substituting anything individual or profound to replace it. Western princes lived in palaces that – sadly – had come to seem exotic and desirable. Topkapı, with a residual exoticness and beauty still overwhelming today, became a symbol of the out-of-date and the primitive. Along with the railway, corsets and female sovereigns, Western artefacts had taken on an awful allure merely by being different, distant or novel.

It is a minor irony of the situation that the disintegrating Empire really needed Western technology, governmental reform and financial reorganization yet basically resisted them, whereas it scarcely needed to import the 'civilization' it so eagerly embraced in the form of the gaselier,

overblown ormulu furniture and the cuckoo-clock. But Paris and Vienna represented in Turkish eyes the equivalent of, say, Samarkand to the West. Perhaps England seemed, rightly, less fashionable. Nevertheless, British exports to Turkey increased steeply in the period 1825–52; by the middle of the century they were four times as large as Great Britain's imports from Turkey.

83 Well before then Miss Pardoe had visited the state apartments of the summer palace at Beylerbey on the Bosphorus. What she found there sounds like a miniature international exhibition of the kind so enjoyed by the nineteenth century – and her description contrasts piquantly with those of such earlier visitors as Dallam and Lord Winchilsea. 'The Turkish divans of brocade and embroidered velvet are relieved by sofas and lounges of European fashion,' she wrote, '– bijouterie from Geneva – porcelain from Sèvres – marbles from Italy – gems from Pompeii – Persian carpets – English hangings . . .'. Russia too was represented in this feverish and heterogeneous display; six pier-glasses, framed in silver-gilt, and bearing the united arms of the two empires, were a gift from the emperor to the sultan. The result certainly reads expensively enough (even omitting the sporting Cupids of a fountain in the private apartments), but it is more the setting of a Rothschild as envisaged by Disraeli than anything any longer distinctively Ottoman.

Of course, imports from the West were as old as Mehmed the Conqueror – who had positively imported Gentile Bellini. For Süleyman 'the Magnificent' Venetian goldsmiths had created that specially sumptuous helmet. Ahmed I had begged for Venetian glass for his new mosque. Yet these imports were absorbed into an Ottoman context. Duplessis's braziers, presented to Mahmud I in the mid-eighteenth century, were a mere token of that period of artistic *rapport* when rococo had equal validity whether manifested in European *turqueries* or in Ottoman interpretations of Western style.

What, by the nineteenth century, had the West to offer in artistic terms? Courts like Queen Victoria's, Franz Josef's and Napoleon III's might be cosy or luxurious; they were scarcely power-houses of original taste, partly because they were floundering between echoes of the artistic past and lack of clarity about art's future. Such rulers' palaces lacked any distinctive character. Bric-à-brac, hunting-trophies and photographs were their ideas of furnishing a room, so it is hardly surprising if by Abdül Hamid II's reign, in the last quarter of the century, the harem quarters were also full of gimcrack objects. A gold-framed, carefully executed oil-painting just about summed up 'art' in the West. Ottoman painting had once had its own proud tradition, unsuited in every way to vast reception-rooms and banquet-halls. In one way, it is almost sad that the Ottoman Ambassador in Paris in the mid-nineteenth century should need to buy Ingres's *Le Bain turc* – the erotic dream of a painter who had never been near Turkey.

Abdül Hamid himself seems to have wisely seized on two of the more lively aspects of nineteenth-century European culture: the music of Offenbach and detective novels. He preserved, too, touches of the traditionally exotic, if not necessarily the tasteful, when the occasion required it.

His small daughters thus presented the visiting German Empress in 1889 with a bouquet consisting entirely of precious stones – like something out of the *Arabian Nights*, the Empress remarked, using her favourite comparison.

In fact, however, any *Arabian Nights* atmosphere was by then rapidly evaporating. The Ottoman Empire was breaking up in the complex process of turning into a nation and a republic. The twentieth century would see the sultanate reduced to a spiritual sovereignty, the caliphate; and then the caliphate in turn was to be abolished. Istanbul ceased to be the capital. It was replaced by the then deeply primitive Ankara, where for a while Atatürk –at his emancipated wife's insistence – required dinner-guests to appear in evening-dress. A palm-court orchestra played on one such occasion. The next step would be the dance – of men with women for the first time in Turkish life – and the strains of the fox-trot.

But the nineteenth century had not been all stylistic dilution and utter artistic decline. For one thing, the West could not significantly alter, though it might influence, the basic concept of the mosque. Conservative Islam proved a far more powerfully rooted force than the Ottoman Empire as such, when it came to reforms (as Atatürk was to discover and as certain sultans could have told him). The tradition of the imperial mosque remained. And then, there were grace-notes still to be sounded in the life-style not only of some of the sultans but of their more prosperous subjects.

The projecting wooden houses in the centres of Istanbul and Izmir (Smyrna), and especially the summer residences, the painted yalıs, along the Bosphorus, went on being built and inhabited quite unselfconsciously. There, close to the water and amid the gardens, Ottoman style lingered perhaps longest. Low, well-windowed rooms, propped on stilts and at times almost floating in their proximity to the water, were decorated usually with panels of flowers and carved or gilded ceilings. A chimney-piece, long divans, some open cupboards, a carpet – and the furnishing was virtually complete for sitting-room, dining-room or bedroom. However grandiose some of the sultans' palaces, culminating in the vast pile of Dolmabahçe, love of a waterside setting, as of pools and gardens, remained endemic. Indeed, Dolmabahçe itself is only the final extension of Seljuk delight in siting the ruler's palace beside a lake.

The new century opened effectively in 1808 with the accession of Mahmud II, who reigned until 1839. The deposition of Selim III had been followed by the Janissaries' call to Mustafa IV, Mahmud's elder brother, to ascend the throne. Deposed in turn and killed after a reign of a few months, Mustafa was replaced by the sole surviving member of the dynasty, arguably the last great sultan and certainly the most effective reformer.

Mahmud's reforms included not only the establishment of the first official Turkish newspaper and the wearing of European clothes (the turban being abolished in favour of the fez that Atatürk, just over a century later, would abolish in favour of the hat) but for himself adoption of European manners and a European setting. European portraits also, in engraved form, belonged to him. One of the numerous English visitors who published accounts of their travels, Thomas Thornton (*The Present State of Turkey*, 1809), records seeing a pocketbook belonging to the Sultan, 'containing

84

91

portraits of the most distinguished characters of our own times', including a print of Louis XVI. In plain uniform, not sultan's robes, Mahmud set himself to break with all Ottoman tradition even in minor though significant ways, like receiving not merely ambassadors but their wives.

83 The character of the Beylerbey apartments at the end of his reign were described by Miss Pardoe in the passage already quoted. Elsewhere, she mentions that the Sultan possessed fifty-seven palaces, of which that at
85 Beşiktaş 'is the last . . . but decidedly the least picturesque and elegant'. Yet this now-destroyed building was Mahmud's most patent piece of Europeanized architecture. Its site was that of a pleasure-pavilion of Selim III's, necessarily destroyed during the extensive operations of building the huge new palace in international, vaguely neo-classical style, with its façade over the Bosphorus a pillared portico in white marble. Nothing could more clearly have symbolized Mahmud II's often ruthless replacement of the old artistic order. And a few years after his death, in another of his now-destroyed palaces, the Çirağan, yet another English visitor, Charles White (*Three Years in Constantinople*, 1845), approvingly found the Sultan's apartments 'fitted up nearly in the European style.'

2, 86 If such buildings indicated the private aspects of Mahmud's policy, a more public aspect is commemorated in his fortunately surviving Nusretiye (the 'Divine Victory') mosque, marking by its eventual name his victorious suppression of the Janissaries. That victory could justifiably be called divine, since he had unfurled the banner of the Prophet to inspire his own army in its wholesale destruction of a force which had grown from a once-loyal bodyguard into a permanent threat to every sultan.

The flauntingly graceful, part-gilded building rising with attendant kiosks on a high stepped platform at the sea's edge is free from any associations of bloodshed and not burdened by any strong religious sense. In mood and style – as in date – it seems surprisingly akin to the Pavilion buildings Nash was creating at Brighton for George IV. Only its position hints at Mahmud's reforms; as well as being close to the water, it was close to the parade-ground of the artillery barracks.

Miss Pardoe speaks of its slender minarets, 'dipped in gold for a third of their height'. Although that is no longer so, these wonderfully slim, skeletal minarets – like tall stone wands in their slimness – need no gilding to draw the eye. Gilding is now reserved for the bulbous finials surrounding the unexpectedly deep dome – bright today compared with the faded gilt on the grilles of the pair of subordinate kiosks, themselves undulating rococo fancies, caprice variations to accompany the only slightly more sober theme of the main mosque building.

The over-all effect is of still intensely stylish architecture. An economical elegance has refined the high arcades, sharpened the very turret caps and in places pared away the actual material of stone in its aspiration towards almost physical buoyancy. Even the wettest day cannot dampen the exhilaration of its capricious kiosks where stone seems to simulate wood in its carved swags, ribbons and flutings, or its fountain-structure, standing in the unwalled expanse of open courtyard: a circle of slight columns topped by the steepest of pointed roofs – like some miniature roundabout.

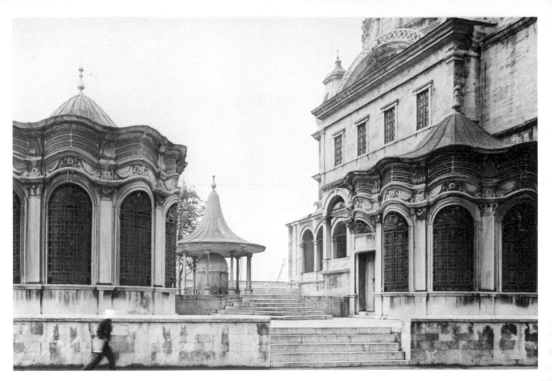

86 The Nusretiye complex, Istanbul

However lightly graceful the mood of the Nusretiye complex, its artistic *86*
seriousness cannot be concealed. Its Armenian architect, Kirkor Balian,
probably never again created anything so perfectly balanced of its kind.
He and his numerous family were to become the favoured architects of
future sultans, occasionally building in slighter ways and producing at
other times the ornate ponderousness enshrined ultimately in the Dol- *91*
mabahçe Palace. The Nusretiye avoids both extremes, but escapes any
sense of compromise. It is perhaps the last mosque which Sinan would be
able to recognize not merely as within his concept of the Ottoman tradition
but as a true work of art. Within it survives another aspect of that tradition,
too, for the raised marble inscription running round the walls is the work
of probably the last great calligrapher, Rakım. If something of earlier
boldness had gone from this art, a new elegance was the compensation; and
the Nusretiye was the ideal setting for such a display.

Perhaps nothing else commissioned by Mahmud II achieved the distinc-
tive quality of his imperial and indeed triumphal mosque. But the Sultan's
interest in building remained constant. He himself seems to have planned
his own tomb on the main thoroughfare of the Divan Yolu: a graceful,
domed building within the same rococo-Regency idiom as his mosque,
but more patently Western, almost Parisian. It was designed by one of the
second generation of the Balian family, Karabet Balian, Kirkor's son.
Although neither father nor son is definitely established as having studied
in the West, three members of the family in the next generation were
Paris-trained; and one of them was apparently influenced by the mid-
nineteenth-century French architect Henri Labrouste, a pioneer in the

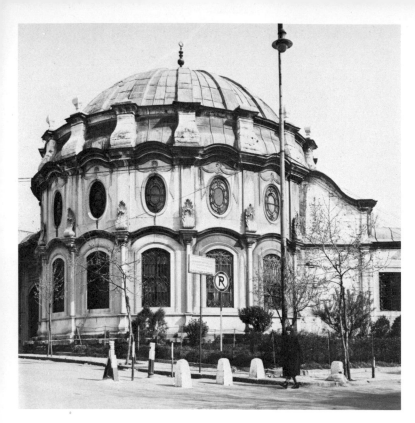

87 Nakşedil Sultan
tomb, Istanbul

undisguised use of iron structures. Labrouste's basically rational, even
puritan, approach is far from the increasingly florid, showy manner the
Balians were encouraged by the last sultans to display. To say that their
palaces looked like grand hotels and their mosques resembled casinos may
be unfair, since no doubt inflated Italianate and pseudo-Oriental, Moorish,
styles developed independently in Western Europe.

Nevertheless, marked individuality of style, and stylishness, were dying
throughout the Ottoman Empire. Hints of Byzantine as well as Western
style began to appear. Even Gothic and Indian elements became noticeable.
This very eclecticism suggests a lack of any driving force of originality.
Mahmud II's tomb is attractive enough, but nothing like as lively and
87 elegant as the one he had built about 1817 for his mother. That in turn may
be traced back in design to the fully eighteenth-century tomb of three
sultans at the Laleli complex. As if Mahmud II's tomb marked a symbolic
close of the dynasty, in addition to close of the Ottoman style, it was to be
the burial place for the two last effective rulers, Abdül Aziz and Abdül
Hamid II. The latter, deposed in 1909, did not die until 1918.

Only one other sultan needs to be mentioned, Mahmud II's eldest son
and successor, Abdül Mecid. Barely seventeen at his father's death in 1839,
the new Sultan may not have inherited resoluteness of purpose but he
showed a positive mania for building – borrowing recklessly from France
and England to meet his enormous expenditure. Although often rather
harshly judged as ruined by wanton debauch, it is more likely that he was
ruined fundamentally by tuberculosis which shortened his life and drove
him to feverish excesses, but not to cruelty. Personally kind, progressive,

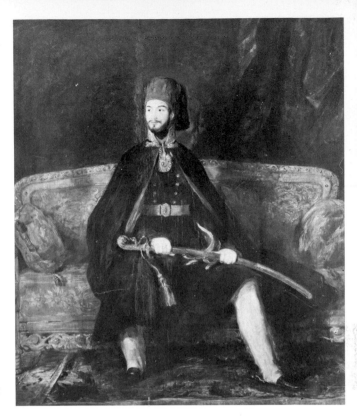

88 Sultan Abdül Mecid; portrait
by Sir David Wilkie

conscious of the need to bring his Empire up to date, Abdül Mecid lacked
only the force of character to turn aspiration into fact. Perhaps it was easier
to build palaces than to govern. The West, which was to fight the Crimean
War in alliance with the Sultan, appeared to him perhaps basically in the
guise of a giant emporium-cum-bank.

Some vivid early glimpses of him as courteous, accessible and generous
come from the painter Wilkie, who arrived at Istanbul in 1840 and sought
to paint his portrait. Not since Gentile Bellini, perhaps, had a Western *88*
painter been permitted to take a likeness of any sultan. When Wilkie
arrived, Abdül Mecid was in fact sitting to a Prussian artist, but he shortly
afterwards agreed to sit to Wilkie as an act of 'consideration for the Queen
of Great Britain'. Possibly through some idiosyncratic idea of etiquette, or
because of his obsessive concern with cleanliness, the Sultan insisted on
being portrayed wearing white gloves. More striking was his distinct
pleasure in the relaxed rather than grandiose finished picture, an intimate,
amiable, essentially private view of the ruler whom Wilkie had first
wished to paint 'sitting on the throne as Sultan, receiving people presented'.
Abdül Mecid asked for a copy of the picture, and at the final sitting gave
the painter a gold and enamel snuff-box with a diamond flower on its lid.
So overcome was Wilkie by emotion as he unwrapped the present that he
fell on his knees to thank the young Sultan.

On both sides, the incident was isolated but it serves to point to Abdül
Mecid's early Westernized tastes. He had taken more than a polite interest in
Wilkie's portrait, suggested alterations and generally behaved very much
as would any other high-ranking sitter. To two infidel artists he had sat for

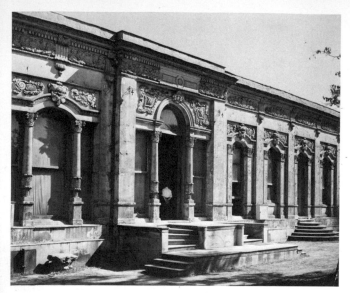

89 (*left*) The Abdül Mecid kiosk
at Topkapı

90 (*right*) The main gateway of
the Dolmabahçe Palace

91 (*below right*) Dolmabahçe
Palace from the sea

his likeness. His father had broken several of the conventions which hedged
a sultan, and not long before his death Abdül Mecid was to break another,
publicly, by attending a ball at a foreign embassy, the British one.

What he built was inevitably coloured by what he knew or believed
about Western princes and their palaces. It was he who left Topkapı to
live in his own creation, designed by the Balian family, of Dolmabahçe.
Yet, before that was begun, he had added his contribution to Topkapı in
89 one last, quite large pavilion-kiosk, at the furthest extremity of the peri-
meter, looking out over the Sea of Marmara. It is an entirely European-
style, Frenchified, building of stucco, simple and far more sober than many a
Riviera villa. Its incongruousness at Topkapı is softened by its distance
from the kiosks and other buildings once inhabited by Abdül Mecid's
ancestors – and yet emphasized perhaps by its use today as a visitors'
refreshment-room. It is only a pity that the main rooms of the kiosk are
not open.

For all his Westernization, the Sultan did not fail to build several mosques.
His own particular skill was as a calligrapher and at least one of his mosques
(the Hırkai Şerif, built to house a robe of the Prophet's) contains examples of
his work. Two other mosques of the period – both work by the Balian
family – are along the water's edge on each side of Dolmabahçe. This was
the area to be developed especially under Abdül Mecid. His father's
elegant Nusretiye mosque marked, in effect, the beginning of the develop-
ment full in the city itself; and further down the European shore Mahmud
II had begun his Çirağan Palace. Just inland from that Abdül Mecid
built a kiosk or two in the wide, hilly expanses of Yıldız Park. Today Yıldız
is altogether difficult to visit and the Çirağan Palace is destroyed. What not
merely survives but positively proclaims itself by sea and by land is Abdül
Mecid's largest and most opulent palace, that of Dolmabahçe. Here the
Balian family, working fast as well as hard, raised the finest monument of
their heterogeneous manner. They satisfied the Sultan, but within this
white, gigantic mausoleum they virtually, doubtless accidentally, buried
Ottoman art.

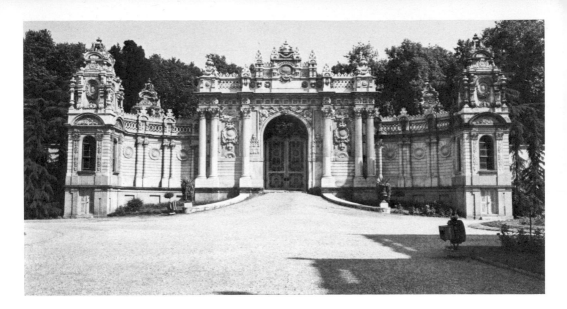

The site was long established for an imperial residence: 'filled in' (as its name implies) originally under Ahmed I early in the seventeenth century. An accidental fire destroyed in 1840 the scattered kiosks built there by Ahmed III and gave Abdül Mecid the opportunity for a modern replacement. Towering in height but narrow, with its central block occupied by one single, domed throne-room, the faintly Palladian palace is at once absurd and impressive.

By land there is little to see of it and its gardens behind the huge walls, but its gateways – especially the main one – convey scarcely less grandeur *90* than the palace itself. The great white, iron-wrought gates set in the colossal fabric of pillared white archway, dramatically swept back from the road and crowned by sugar-icing crenellations and urn-like protuberances, have the fantasy height and effect of Hollywood-Oriental style, whether for a film or a film star's home. Marble Arch and the Arc de Triomphe shrivel by comparison to insignificance. The Balian family appears here almost

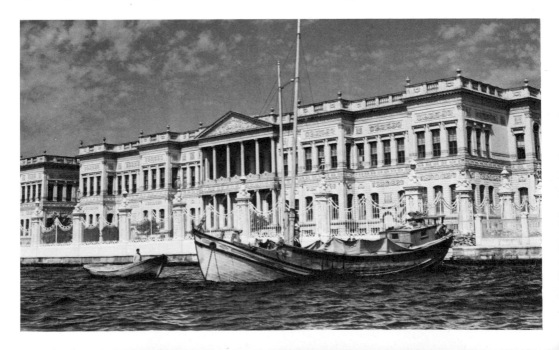

inebriated by their opportunity and unwilling to forego any device that will aid impressiveness. The result could seem European only to someone who had never visited Western Europe, while equally it has no relation to the earlier centuries of Ottoman art. Yet the extraordinary blend has its own vigour and conviction. Its gateways are probably the most successful part of the whole concept.

91 Seen from the water, with the long line of its landing-stage, water-gates and row of gleaming ornamental lamp-standards, Dolmabahçe has a romantic aspect, mitigating the otherwise heavy, somewhat overblown effect of its façade. Steps, balustrades, pediments, rustication and Corinthian pilasters make up an anthology, to which Italy, France and England all seem architecturally to have contributed. Inside, the international contributions are even more positive and lavish: from the English chandeliers and clocks to the Sèvres vases stamped with Abdül Mecid's monogram, via Italian mosaics and Russian bearskins. However many of these objects were presents, the Sultan had yet to meet the colossal expense of providing their setting – a setting also for himself as ruler, become one more *de luxe* object on display. In fact, he failed to find the money, borrowed heavily abroad and left his country on the verge of bankruptcy.

The modest throne-room at Topkapı had actually expressed the greatest possible pride. The sultan was almost too sacred to be seen, at least by infidels. One single, exquisite, suspended jewel had then been sufficient to symbolize the total global power of 'God's shadow on earth, the occupant of the Sublime Sultanate and the dignity of the Great Caliphate.' Only in the nineteenth century, when the Ottoman Empire had shrunk to become the 'sick man of Europe' (in the famous acute phrase of Tsar Nicholas I of Russia), was the ostentation of Dolmabahçe necessary. It was built too late and claimed too much. As a royal showcase its existence was limited to some seventy years; as an inhabited royal residence its duration was far shorter still.

After Abdül Mecid's death in 1861, it was to be lived in only by his brother and successor Abdül Aziz who died in 1876. For him the lure of the West was non-existent, apart from its usefulness in lending money. Yet, ironically, this commonplace, unprogressive if not reactionary Sultan was compelled to be the first of his dynasty to visit Paris and London, and – scarcely less startling to his subjects – receive the visit of a female sovereign in the person of the Empress Eugénie. Peculiar rather than exotic is probably how the West appeared to Abdül Aziz, given an *Arabian Nights'* entertainment by Napoleon III and his Empress, and a review of the Fleet by Queen Victoria – as well as the Order of the Garter. The latter was at his insistence; the Queen had felt the Star of India would have been more suitable. The naval review caused the Sultan constant seasickness, but he had made a good impression on his hostess at a previous luncheon by possessing splendid eyes, eating well and refusing wine ('which I was glad to see', she noted afterwards).

Abdül Aziz proved as Sultan no less extravagant than his predecessor and no less addicted to building. The Balian family continued to be fully employed. They rebuilt the Çirağan Palace, close to the water like Dolma-

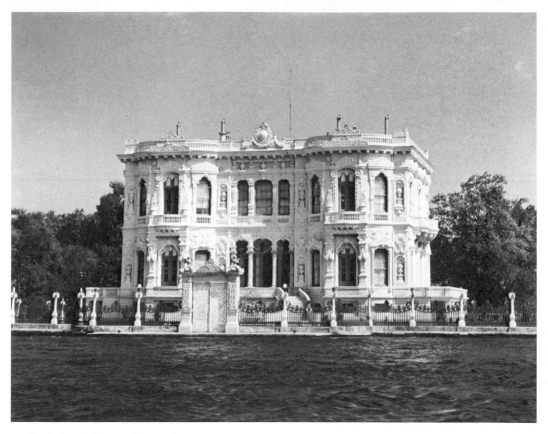

92 Beylerbey Palace on the Bosphorus

bahçe, and the still-surviving Beylerbey Palace on the Asiatic shores of the *92*
Bosphorus (where the Empress Eugénie was accommodated). Beylerbey
is like a dessert in comparison with the heavy entrée of Dolmabahçe – a
confection of spun-sugar, appetizing in its smaller scale and its utter
insouciance. But the character of the Sultan was probably better indicated
by the religious-dynastic emphasis of much that was built or restored in
his reign. Thus he rebuilt the mosque in the small hill-town of Söğüt, where
was buried the father of Osman I, the founder of the dynasty. At the Seljuk
capital of Konya he created an imperial, large-scale mosque, with lantern-
like minarets, in a hybrid style which is, however, less ornate and 'Euro-
pean' than the typical Balian-family mosques at Istanbul. India and Egypt,
rather than France or England, seem to have influenced its design – perhaps
in deliberate reaction against the corrupting diffusion of Western styles and
ideas.

The Valide Sultan Pertevniyal, herself a strong reactionary, built her own
mosque – last in the long tradition of sultan-mothers' complexes – in a sort *93*
of Indian-Gothic style, probably to be interpreted as yet another assertion
of the good old Ottoman ways. Isolated on a busy corner in the centre of
Istanbul today, and with its courtyard ruthlessly curtailed by broad traffic
boulevards, the tall Pertevniyal Valide mosque appears a compressed and
studied oddity, an exercise in the vaguely Oriental, betraying its nineteenth-
century origin. Linear vertical effects make awkward-looking its obligatory

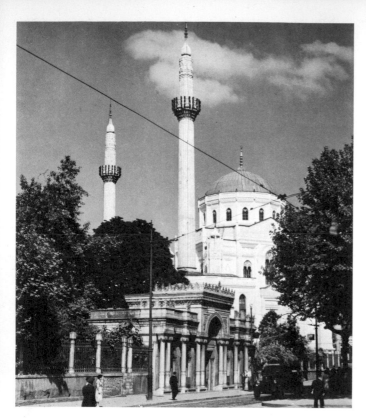

93 The Pertevniyal Valide
mosque, Istanbul, as originally
built

surmounting dome, which reads almost as an afterthought. But its rejection of European motifs and its lack of baroque swagger are unmistakable. Its direction is away from the West.

Such turning-away, politically and culturally, is what characterizes the last effective ruler, Abdül Hamid II. He had accompanied his uncle Abdül Aziz on his European tour of 1867, but – for all his pleasure in Offenbach and, later, in Sherlock Holmes – seems to have remained suspicious of its civilization and certainly of its democratic, constitutional tendencies. In 1876 Abdül Aziz's refusal to accept reforms led to his deposition. His elder nephew, 'liberal' by reputation, acceded briefly as Murad V, but displayed signs of mental instability so great that he had to be deposed. Thus Abdül Hamid came to the throne.

His complex character was a puzzle even to his contemporaries, but it is at least clear that he began his reign in a bout of almost mystical religious fervour and that his primary determination was to remain the sole ruler of an intact Empire. His insane brother was secluded in the Çirağan Palace. He himself left the ornate splendour of Dolmabahçe and retired to the heights of Yıldız where he constructed one last extensive Ottoman paradise in the sense of beautiful gardens containing a series of pavilions. It was a sort of refashioned Topkapı, still less accessible to the people (for he deeply feared assassination) and, if architecturally less distinguished, more enchanting in its setting of miniature lakes, waterfalls and bridges, with aviaries, swans and gazelle. Inside these pavilions something traditional lingered, not entirely obscured by Western imports. Patternings, inlay, carved woods, recall the long history of the dynasty's concern with art.

94

94 Interior at Yıldız

Here Abdül Hamid, when he wished to charm a visitor (male or female), became the embodiment of Ottoman culture: polite to the point of prodigality, humane, nature-loving and lavish, able to offer on occasion Brown Windsor soup, coffee in diamond-studded cups or – as for the German Empress – a complete bouquet of jewels. The food might not be superb but, typically, the conservatory glowed with coloured lamps. In the tradition of his predecessors he set up – late in his reign – a public fountain, with wide eaves shading some rather fussy and yet recognizably Ottoman decoration. Like his ancestors too he had his trade – perhaps the most patently artistic of all, for he practised skilled carpentry. Some of the tables at Yıldız, inlaid delicately and traditionally in mother-of-pearl, were his work. Like so much about him, they were noted approvingly by the English Ambassador's wife, Enid Layard, who first met the Sultan in 1877. For her at least he remained a potentate and a gentleman. His last gift to her was of diamonds; and her last act as ambassadress was reluctantly to decline them when Layard was abruptly recalled by Gladstone.

Yıldız may have suggested a magical, hillside Regent's Park, but it was the seat of an intensely formal court and a still sacred Empire. The Sultan was ringed round not only with soldiers, gardeners, children and animals but with palace eunuchs and harem women. Near-divinity still hedged him. The carpet he trod could not be trodden by anyone else. When he drove to prayer at a mosque, took his part in a religious ceremony, or appeared at all in public, his supreme office obscured any human failing. The awe which surrounded him had hardly dimmed from the days when Dallam entered the Sultan's presence and bowed his head as low as his knee. The treasures of Topkapı remained his, as did all the other palaces he did not dare visit. He was the living descendant of Osman I, the successor of Süleyman 'the Magnificent' and for the majority of his people he perhaps never ceased to be the shadow of God on earth, the Sultan of Sultans and Caliph.

95 Gold and pink crystal compote set (19th century); from the Treasury at Topkapı

96 Abdül Hamid II driving through Istanbul

His own tenacious belief in being exactly those things probably helped to keep the Ottoman Empire alive for a quarter of a century after it would otherwise have passed away. When he left Yıldız for exile in 1909 the substance crumbled, and all the splendour and illusion which had accrued about the sultan and his Empire for centuries was preserved only in art.

Perhaps there is some symbolic suitability in the fact that the last member of the dynasty to occupy a position in Turkey, Abdül Mecid (II), caliph without being sultan, revealed an artistic nature comparable to that of many of his forbears but turned so positively Western that one of his pictures was exhibited at the Salon in Paris. For centuries, Atatürk was to declare, the Turks had 'always walked from the East in the direction of the West'. That was one of his reasons for abolishing the hindrance of the caliphate. To have exhibited a painting at the Salon proved an inadequate gesture by the ex-Caliph, deposed and soon himself travelling in a westerly direction, to Switzerland. He left Istanbul, for ever, on a Tuesday, the day that Mehmed the Conqueror had first entered it; and the coincidence was noted by superstitious people.

In other parts of the world dynasties may have favoured certain artistic styles and religious faiths inspired particular types of art. Yet seldom, perhaps, has one artistic style been so closely allied, and for so long, to one form of political-theocratic government as Ottoman art was to the

Ottoman Empire. Struggling and declining – like the Empire – throughout the nineteenth century, the art could not outlive overthrow of the whole system. Even the continuity of the faith of Islam was not artistically inspiring, to judge by the lifeless quality of the most ambitious modern mosques, for example, that at Şişli in Istanbul: competent but chill, and utterly inexpressive.

One is more at ease in the less inhibited atmosphere of some village mosque with tiny minaret tiled bright green. There, or in the bazaars of Bergama, Izmir and Bursa, amid floral linoleum, brightly coloured scent-bottles and even brighter trinkets, something truly Ottoman lingers. To dare respond to such images – not to mention the essential but more respectable elements of countryside, flowers and water – is to be prepared already for the world of Ottoman art. Luxury as well as gravity is there, and a pursuit of the visually sensuous that will go to any extreme it feels necessary for its effect – as art must do. Although Atatürk would probably not have liked to think it, there was more than a touch of Ottoman taste momentarily resurrected when in 1928 the Turkish National Assembly presented him, as a token of gratitude for his introducing Latin script, with a golden board on which the new alphabet letters were carved in relief. Objects more bizarre are to be found in the Sultan's Treasury at Topkapı.

That so much survives is perhaps the final wonderful thing about Ottoman art. Dynasty and Empire disappeared without one of those tidal waves of destructive hatred against every monument and every work of art associated with them – so often the price of justified revolution. But not all the art is as accessible, even now, as it should be; and the great fame of just one or two buildings obscures many others deserving to be appreciated. For years the prestige of Byzantine Constantinople virtually concealed the existence of Ottoman Istanbul. Yet Istanbul itself is only a part of the story of Ottoman art – a great part, no doubt, though lacking after all the finest example of Sinan's genius, as it lacks inevitably the beautiful monuments from the early years of the dynasty.

In charting the great artistic territory which developed first at Bursa and gradually spread as Ottoman conquest spread, this book has done no more than offer at best a rough sketch-map. Scholarship and expert knowledge are steadily working to produce fuller and more professional studies, necessarily more detailed, marking in with extreme accuracy the most minor facts. The final result should be a cartographer's triumph of learned mapping, but probably it will not essentially affect the purpose of a book like this, which is to encourage visual – and indeed physical – exploration by anyone who cares at all for art. Gaps on the map offered here may be filled in at choice; and the discovery one makes for oneself is always part of the pleasure of looking.

Nowadays the world of Ottoman art is far more penetrable, in every way, than it was in the past, but it retains all those elements that excited the imagination of generations of previous visitors: still novel, monumental, alluring and splendid. It is merely waiting to be seen.

Glossary

CAMI	Large Friday mosque, with a pulpit	MINARET	Tower for giving call to prayer, either part of or closely adjoining a mosque
CARAVANSERAI	Lodging-place for caravans		
ÇARŞI	Market	MÜEZZIN	Mosque official who publicly calls to prayer
ÇESME	Drinking-fountain		
HAMAM	Bath, often an elaborate public foundation	NASKHI	Elegant cursive Islamic script which replaced Kufic; a form with elongated shafts of vertical letters was called *thuluth*
HAN	Inn, usually in a town		
IMARET	Soup-kitchen for students and the poor	SARAY	Palace (Topkapı Saray = Gun-Gate Palace)
KÖSK	Kiosk or pavilion	SEBIL	Public fountain
KUFIC	Angular style of Islamic script, traditionally originating at Kufa in Iraq	TABHANE	A hospice or guest-house for travellers, normally part of a large mosque-complex
MEDRESE	Institution for the teaching of Islamic theology	TUĞRA (TUGHRA)	Stylized calligraphic symbol of the sultan
MESCID	Oratory, usually small, not used for Friday noon prayer and therefore lacking a pulpit	TÜRBE	Tomb or mausoleum
		VAKFIYE	Pious endowment, governed by a trust
MIHRAB	Niche in the wall of a mosque indicating the direction of Mecca; often richly tiled	VEZIR (Vizier)	Minister of state (Grand Vizier = Chief Minister)
		YALI	House on shores of the Bosphorus
MIMBER (*minber*)	Pulpit approached by long stairs in a mosque, from which Friday sermon is preached	YOL	Road (Altın Yol = Golden Road, in the harem at Topkapı)

Brief Historical Outline

Sultans' Reigns	Political Events	Artistic Achievements	Chapter
Osman I 1281 – 1324(?)			
Orkhan 1324 – 1362	Fall of Bursa (1326); Capture of Edirne (1361)	First mosques, etc., built at Bursa, and 'Silver Tomb' of Osman. Hacı Özbek mosque, Iznik	Introduction and Chapter 1
Murad I 1362 – 1389	Capture of Sofia (1385)	'Hüdavendigar' mosque, Bursa	Chapter 1
Beyazid I 1389 – 1402 ('the Thunderbolt')	Victory over Crusaders at Nicopolis (1396): Defeat of Sultan by Timur at Ankara (1402) and deposition	'Great' mosque, Bursa; 'Thunderbolt' complex, Bursa	Chapter 1
	Fratricidal wars between Beyazid's sons (1402–13)		Chapter 1
Mehmed I 1413 – 1421	Re-establishment of unified Ottoman state	Green Mosque and Tomb, Bursa, begun	Chapter 1
Murad II 1421 – 1444 1446 – 1451	Voluntary abdication of Sultan (1444–46) but compelled to return to throne	Muradiye complex, Bursa; Palace at Edirne begun; 'Three-balconied Mosque', Edirne	Chapter 1
Mehmed II 1444 – 1446 ('the Conqueror') 1451 – 1481	Capture and renaming of Constantinople (1453); Ottoman army reach Otranto (1480)	Rumeli Hissar, Bosphorus; Fatih complex, Istanbul; patronage of painters; Tiled Kiosk, Topkapı.	Chapter 2
Beyazid II 1481 – 1512 ('the Pious')	Capture of Lepanto (1499); Earthquake at Istanbul (1509)	Beyazid complex, Edirne; Beyazid mosque, Istanbul; Sheikh Hamdullah's practice of calligraphy	Chapter 2
Selim I 1512 – 1520 ('the Grim')	Conquest of Syria and Egypt; title of 'Caliph' added to 'Sultan'		Chapter 2
Süleyman I 1520 – 1566 ('the Lawgiver')	Capture of Belgrade (1521) and Buda (1526); Siege of Vienna (1529)	Activity of Sinan: Şehzade complex begun, 1543; Süleymaniye, Istanbul, begun 1550. Development of Iznik ware; Illustrated chronicles of Ottoman history; Miniatures by Nigari	Chapter 3
Selim II 1566 – 1574 ('the Sot')	Ottoman defeat at Lepanto (1571)	Selimye, Edirne	Chapter 3
Murad III 1574 – 1595	Mutiny of Janissaries (1589)	Muradiye, Manisa; Murad III bedroom, Topkapı; Sinan's Tomb, Istanbul	Chapter 3

Sultans' Reigns	Political Events	Artistic Achievements	Chapter
Mehmed III 1595 – 1603	War against Austria; Revolt of Janissaries (1603)	Miniatures by Osman; Yeni Valide mosque, Istanbul, begun 1597	Chapter 4
Ahmed I 1603 – 1617	Peace Treaty of Zsitva-Torok (1606)	Activity of Mehmed Ağa; Blue Mosque, Istanbul, completed 1616	Chapter 4
Mustafa I 1617 – 1618 1622 – 1623	Deposition of Sultan (1618); Reinstated and deposed (1623); Peace with Poland (1623)		
Osman II 1618 – 1622	Deposition of Sultan by Janissaries (1622)		
Murad IV 1623 – 1640	Capture of Erivan (1635); Capture of Baghdad (1638); Peace with Persia (1639)	*Pashaname* miniatures; Revan and Baghdad Kiosks, Topkapı	Chapter 4
Ibrahim 1640 – 1648	War with Venice begun (1645); Deposition and execution of the Sultan (1648)	Sultan's 'bower', Topkapı	Chapter 4
Mehmed IV 1648 – 1687	Köprülü Medmed Pasha, Grand Vizier (1656–61); Peace with Venice (1669); Ottoman siege of Vienna (1683); Deposition of the Sultan (1687)	Modifications and additions to harem at Topkapı; completion of Yeni Valide mosque, 1663	Chapter 4
Süleyman II 1687 – 1691	Loss of Belgrade (1688); recovered (1690)		Chapter 4
Ahmed II 1691 – 1695	Wars with Poland, Austria, Russia and Venice		Chapter 4
Mustafa II 1695 – 1703	Peace of Carlowitz (1699); Abdication of Sultan (1703)		Chapter 4
Ahmed III 1703 – 1730	Treaty of Edirne (1713); Peace of Passarowitz (1718); Abdication of Sultan (1730)	'Tulip Age'. First printing-press at Istanbul, 1724. Libraries founded; Ahmed III Fountain, 1728; Activity of Levni; Valide complex, Üsküdar	Chapter 5
Mahmud I 1730 – 1754	Peace of Belgrade (1739)	Mahmud I Fountain, Tophane; Hacı Mehmed Emin Fountain; Nuruosmaniye mosque begun, 1748	Chapter 5
Osman III 1754 – 1757		Completion of Nuruosmaniye mosque, 1755; Kiosk of Osman III, Topkapı	Chapter 5
Mustafa III 1757 – 1774	Earthquake at Istanbul (1766); War with Russia (1768–74)	Laleli complex begun; Rebuilding of 'The Conqueror's' mosque	Chapter 5
Abdül Hamid I 1774 – 1789	Armistice with Russia (1774); War against Austria and Russia (1787)	Valide mosque, Beylerbey	Chapter 5

Sultans' Reigns	Political Events	Artistic Achievements	Chapter
Selim III 1789 – 1807	Peace of Zistowa (1791); Peace of Jassy (1792); 'New Order' by Sultan; Revolt of the Janissaries and deposition of the Sultan (1807); War with Russia and England	Mihrişah Sultan complex, Eyüp; Selimye Barracks; Selimye mosque, Haydarpaşa; Redecoration of Sultan-Mother's apartments, Topkapı	Chapter 5
Mustafa IV 1807 – 1808	Sultan deposed and executed (1808)		
Mahmud II 1808 – 1839	Peace of Bucarest (1812); Greek revolt (1820); Suppression of the Janissaries (1826); Treaty of Edirne (1829); Treaty of Hunkiar Iskelesi (1833)	Sultan-Mother's tomb, 1817; Beylerbey Palace; Nusretiye complex, 1826; Mahmud II tomb	Chapter 6
Abdül Mecid 1839 – 1861	Crimean War (1853–56)	Sultan's patronage of Wilkie, 1840; Dolmabahçe Palace and mosque; Abdül Mecid Kiosk, Topkapı	Chapter 6
Abdül Aziz 1861 – 1876	Balkan uprisings; Deposition of the Sultan and suicide (1876)	Rebuilding of Çirağan and Beylerbey Palaces; Pertevniyal Valide mosque	Chapter 6
Murad V 1876	Rapid deposition of the Sultan on grounds of insanity (1876)		
Abdül Hamid II 1876 – 1909	Sultan promulgated a Constitution (two-chamber Parliament), (1876); prorogued it *sine die* (1878); Rise of the Young Turks; Deposition and exile of the Sultan (1909)	Enlargement and establishment of Yıldız as Sultan's residence; Furniture factory at Yıldız; Sultan's activity as carpenter	Chapter 6
Mehmed V 1909 – 1918	Turkey enters First World War on German side (1914)		Chapter 6
Mehmed VI 1918 – 1922	Flight and deposition of the Sultan, and abolition of the sultanate (1922)	Prince Abdül Mecid (future Caliph) exhibits one of his paintings at the Salon in Paris	Chapter 6
Abdül Mecid II 1922 – 1924 (Caliph only)	Deposition of the Caliph and abolition of the caliphate (1924)		Chapter 6

Books for further reading

Valuable articles on the sultans and other Ottoman figures, as well as palaces, etc., are in *The Encyclopaedia of Islam*, complete edition 1913–38; new edition, 1960– (three vols. so far published at the time of writing).

This list is deliberately restricted and selective, of a few books that are reliable, reasonably accessible and preferably in English.

ART

BOOKS DEALING WITH ONE OR MORE ASPECTS OF OTTOMAN ART WITHIN THE CONTEXT OF ISLAMIC ART

M.S. Dimand *A Handbook of Muhammedan Art* (Metropolitan Museum Collections), 1958 ed.
M.S. Dimand and J. Mailey *Oriental Rugs in the Metropolitan Museum of Art*, 1973
C.J. Du Ry *Art of Islam* (transl. A. Brown), 1970
G. Fehérvári *Islamic Pottery, a comprehensive study based on the Barlow Collection*, 1973
E.J. Grube *The World of Islam*, 1966
J.D. Hoag *Western Islamic Architecture*, 1968 ed.
D. James *Islamic Art, an Introduction*, 1974
H. Kirketerp-Møller *Det Islamiske Bogmaleri*, 1974
E. Kühnel *Islamic Art and Architecture* (transl. K. Watson), 1966
A. Lane *Early Islamic Pottery*, 1947
A. Lane *Later Islamic Pottery*, 1957
G. Migeon *Les Arts Musulmans*, 1926
D. Talbot Rice *Islamic Art*, 1965

SPECIFIC STUDIES

C.E. Arseven *Les arts décoratifs turcs*, 1952
O. Aslanapa *Türkische Fliesen und Keramik in Anatolien*, 1965
O. Aslanapa *Turkish Art and Architecture*, 1971
A. Boppe *Les Peintres du Bosphore au XVIIIe siècle*, 1911
E. Egli *Sinan der Baumeister osmanischer Glanzzeit*, 1954
R. Ettinghausen, M.S. Ipşiroğlu, S. Eyboğlu *Turkey – Ancient Miniatures*, 1961
A. Gabriel *Châteaux turcs du Bosphore*, 1943
A. Gabriel *Une Capitale turque: Brousse-Bursa*, 1958
G. Goodwin *A History of Ottoman Architecture*, 1971
G.M. Meredith-Owens *Turkish Miniatures* (British Museum), 1969 ed.
K. Otto-Dorn *Türkische Keramik*, 1957

I. Stchoukine *La Peinture turque d'après les manuscrits illustrés*, Pt. I: *De Sulayman I à Osman II...*, 1966; Pt. II: *De Murad IV à Mustafa III...*, 1971
B. Ünsal *Turkish Islamic Architecture*, 1970
U. Vogt-Göknil *Living Architecture: Ottoman*, 1966
K. Yetkin *L'ancienne Peinture turque du XIIe au XIIIe siècle*, 1970

HISTORICAL BACKGROUND

The Central Islamic Lands (Cambridge History of Islam, Vol. I), 1970, ed. P.M. Holt, A.K.S. Lambton and B. Lewis
A.D. Alderson *The Structure of the Ottoman Dynasty*, 1956
F. Babinger *Mehmed der Eroberer und seine Zeit*, 1953; French ed., 1954
L. Cassells *The Struggle for the Ottoman Empire 1717–40*, 1966
E.S. Creasy *History of the Ottoman Turks*, 1878 ed.
Lord Eversley *The Turkish Empire*, 1923
J. von Hammer-Purgstall *Histoire de l'Empire Ottomane* (transl. J.J. Hellert), 1835–43
J. Haslip *The Sultan, the life of Abdul Hamid II*, 1973 ed.
H. Inalcik *The Ottoman Empire (the Classical Age 1300–1600)*, 1973
Vicomte de la Jonquière *Histoire de l'empire Ottomane*, 1914 ed.
Lord Kinross *Atatürk, the rebirth of a nation*, 1964
S. Lane-Poole *Turkey (a history)*, 1888
R. Lewis *Everyday life in Ottoman Turkey*, 1971
A.H. Lyber *The Government of the Ottoman Empire in the time of Suleiman the Magnificent*, 1913
R.B. Merriman *Suleiman the Magnificent*, 1944
D.E. Pitcher *An historical geography of the Ottoman Empire (to end of the sixteenth century)*, 1972
S. Runciman *The Fall of Constantinople, 1453*, 1969 ed.
S.J. Shaw *Between Old and New: the Ottoman Empire under Sultan Selim III, 1789–1807*, 1971
G. Williams *Turkey, A traveller's guide and history*, 1967

Sources of Illustrations

Chester Beatty Library, Dublin 40; Photo Emmanuel Boudot-Lamotte 1, 2, 34, 49, 63, 67, 73, 74, 76, 79, 89; British Library, London 61, 62; British Museum, London 28; Photo Camera Press 72; Photo Deutsches Archäologisches Institut, Istanbul 48, 54, 87; Fitzwilliam Museum, Cambridge 29; Photo Olga Ford I, 41, 42, 66; Photo Giraudon 20; Photo Godfrey Goodwin 8, 9, 25; Photo Sonia Halliday V, VI, VII, VIII, IX, 5, 24, 31, 43, 53, 95; Photo Martin Hürlimann 55, 58, 65; Metropolitan Museum of Art, Gift of Joseph V. McMullan, 1958 36; Photo Antonello Perissinotto 3, 51, 52; Photo Radio Times Hulton Picture Library 96; Royal Collection, reproduced by gracious permission of Her Majesty the Queen 88; Staatliche Museen, Berlin II; Photo Michael Stewart Thompson 33, 45, 81, 86; Topkapı Saray Library, Istanbul V, X, 20, 23, 26, 27, 30, 32, 37, 60, 68, 69, 70, 72, 75, 76, 80; Photo Turkish Ministry of Tourism 17, 19, 78; Photo Eileen Tweedy III; Victoria and Albert Museum, London III, 35; Wawel State Collection of Art, Cracow 59; Photo Eduard Widmer IV, XI, 7, 10, 12, 14, 18, 39, 44, 46, 47, 50, 56, 57, 71, 90, 94; Photo Yan 4, 6, 11, 13, 15, 16, 22, 64, 82, 91, 92, 93; Engravings from J. Pardoe, *Beauties of the Bosphorus* (London 1838) 83, 84, 85

Index

Numerals in italics refer to monochrome illustrations;
italic roman numerals indicate colour plates